Lee Miller | Portraits from a Life

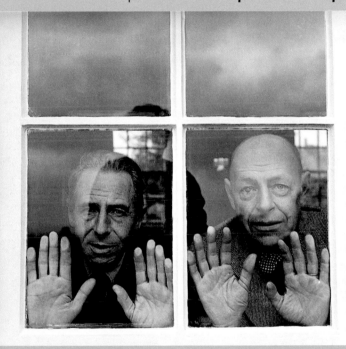

Lee Miller | Portraits from a Life

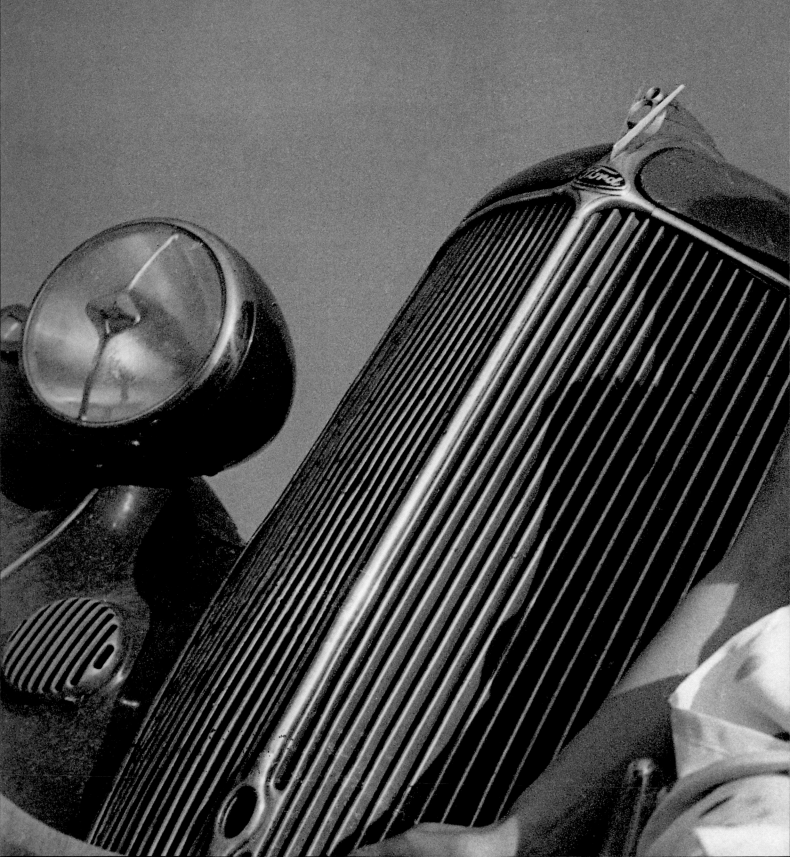

Richard Calvocoressi

Thames & Hudson

Text © 2002 Richard Calvocoressi
Photographs © 2002 Lee Miller Archives

All Rights Reserved. No part of this publication may be
reproduced or transmitted in any form or by any means,
electronic or mechanical, including photocopy, recording or
any other information storage and retrieval system, without
prior permission in writing from the publisher.

First published in hardcover in the United States of America
in 2002 by Thames & Hudson Inc., 500 Fifth Avenue,
New York, New York 10110

thamesandhudsonusa.com

Library of Congress Catalog Card Number 2002101757
ISBN 0-500-54260-0

Printed and bound in Italy by Conti Tipocolor

{half-title} **Georges Limbour and Jean Dubuffet,
Sussex, 1955**
Limbour, the poet, and Dubuffet, the painter and collector
of 'art brut', visited Farley Farm, the home of Lee Miller and
Roland Penrose, at the time of Dubuffet's exhibition at the
ICA in London. Miller's reflection is visible in the window.

{title page} **Nusch Eluard,** Mougins, France, 1937
Nusch, the wife of Paul Eluard, the surrealist poet, is seated
on the bumper of Roland Penrose's Ford V8. The Eluards
were holidaying with Picasso and Dora Maar, Man Ray and
Ady Fidelin, and Miller and Penrose in the south of France.

Contents

An Unflinching Eye

'There were lots of things, touching, poignant or queer
I wanted to photograph...'

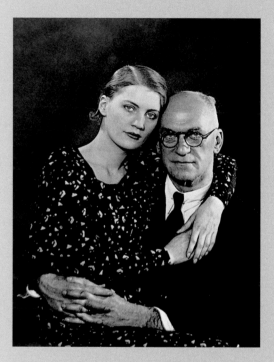

Lee Miller with her father Theodore Miller,
Paris, 1931 (Man Ray)

Lee Miller was one of the most extraordinary photographers of
the twentieth century. In a career spanning more than three decades, she
illuminated that century's darkest and most shameful episodes as well
as portraying many of its creative and liberating geniuses. And yet until
recently her work was relatively unknown. There are three main reasons
for this. First, her long association with *Vogue* magazine, where the
majority of her photographs were published, was certainly the making
of her as an artist but it also inhibited her from developing an independent
reputation. Having outgrown *Vogue* by the 1950s, she never really found an
alternative platform; and by the time the Sunday supplements, which might
have proved a natural outlet for her vision, appeared on the scene in the
1960s, she had more or less given up photography. Second, although one
of her photographs was included in Edward Steichen's famous *Family of
Man* exhibition at the Museum of Modern Art, New York, in 1955, she
did little to promote her work: her only solo show during her lifetime took
place in 1933, when she was twenty-five. In later years she was reticent,
even dismissive, about her past achievements. With the exception of two
morale-boosting books of her photoreportage which came out during
World War II, nothing was published on her work until after death.

The third, and perhaps most significant, reason for her neglect is
due to the fascination exerted by her unconventional personality. Her
legendary beauty, memorably recorded in photographs by Steichen,
Hoyningen-Huene and, most sensually, Man Ray, her childhood sexual
abuse by the son of a family friend, her peculiarly intimate relationship
with her father, numerous love affairs, and mid-life cycle of danger, drink
and depression have proved irresistible to the media, obscuring a true
appreciation of her photographic legacy and artistic gifts.

Since the facts and myths of Lee Miller's unorthodox life have been
recounted in detail elsewhere, we need only recall them here in outline.

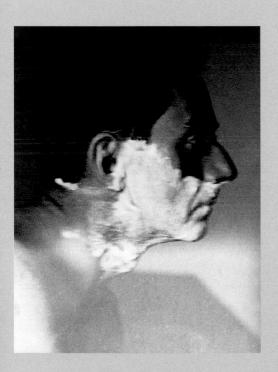

Man Ray Shaving, Paris, c. 1929 (Lee Miller)

She was born at Poughkeepsie, New York State, in 1907. Her father, Theodore Miller, was an engineer-inventor and an accomplished amateur photographer who had a decisive influence on his only daughter. At the age of eighteen she went to Paris for a year to study lighting, costume and theatre design, returning to the USA in 1926. She continued these studies the following year at the Art Students' League in New York, where, the story goes, she was saved from being run over in the street one day by Condé Nast, who gave Miller her first job modelling for American *Vogue*. From that moment she seems never to have looked back. She was photographed by, and learned from, some of the great American fashion photographers of the day, including Steichen, Nickolas Muray and Arnold Genthe. In 1929 she went back to Europe, spending time in Florence and Rome studying Italian art, before settling in Paris. There she became a pupil of the American dada-surrealist artist and photographer Man Ray who, she later recalled, taught her everything in her first year: '…fashion pictures…portraits…the whole technique of what he did.' In 1930 she opened her own studio in Montparnasse, earning assignments from top fashion designers such as Schiaparelli and Chanel.

Miller moved back to New York in 1932 and for the next eighteen months worked as a freelance photographer from a studio in East 48th Street. In 1934 she married the Egyptian industrialist Aziz Eloui Bey and went to live in Cairo. Over the next few years she made few portraits but explored and photographed the Egyptian desert. She travelled to Paris in 1937 where she took up again with her artist friends – Picasso, Ernst, Eluard, Cocteau, Man Ray – and met her future second husband, the English painter, collector and champion of Surrealism, Roland Penrose.

In 1940 Miller joined British *Vogue* as a freelance and was given portrait and fashion assignments. Her work entered a more intensive and morally committed phase, however, when she started photographing the effect of the Blitz on London and its citizens. In 1942 she applied to the US army for accreditation as a war correspondent and was accepted. For the next couple of years she travelled around Britain documenting women engaged in war work, both military and civilian; during this time she continued to take portraits for *Vogue*. In July 1944 she flew into Normandy on the first of a series of photographic assignments to cover the slow, costly Allied advance through France and Germany; these were published every month in *Vogue*, accompanied by her own direct, unsentimental prose focussing on the local human stories rather than the high military drama that was unfolding. In 1945, while still following the infantry, she changed her accreditation to the US Air Force, which

gave her greater freedom of movement. Her unflinching photographs of the evidence of Nazi war crimes at Buchenwald and Dachau are etched indelibly on the public consciousness. After the war in Europe ended, Miller continued to report on its painful aftermath until early 1946, when she returned to Penrose in London. In 1949 they began to make a home at Farley Farm in East Sussex where Penrose eventually installed his outstanding collection of modern art. Miller accepted the occasional assignment for *Vogue* but restricted her photography to portraits of friends, including Picasso. She died of cancer in 1977.

Although the distinction is not always an obvious one, Lee Miller was an artist first and a documentary photographer second. Interviewed

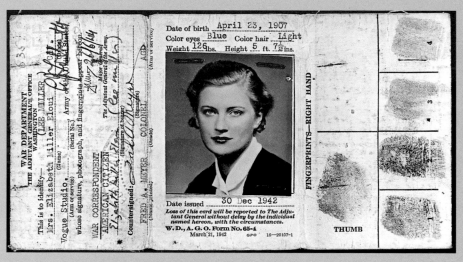

Miller's US War Correspondent identity card, 1942

about her life on American radio after the war, she confessed that she had originally 'wanted to be an artist, a painter that is, and I went to Italy one summer to study. I saw every ruin and picture in the country'. In terms of composition, lighting and choice of subject, her photographs powerfully suggest someone who looked and thought instinctively as a painter – a painter of strong, frontal images like Magritte, for instance. She composed her written dispatches in an equally graphic style, while being acutely sensitive to colour and sometimes comparing what she saw to different schools of landscape painting, the work of certain Old Masters, primitive art, and so on. She also wrote about the work of some of her contemporaries, notably Picasso. Her surrealist training with Man Ray gave her a sharp eye for the telling but overlooked detail, odd pairings or combinations of unrelated objects, and dramatic or quirky viewpoints. During her first assignment in France she was immediately struck by some of the bizarre sights and black humour generated by warfare: 'We passed litter-bearing jeeps, the wounded in racks across the hood, ammunition trucks with cynical names such as "Sudden Death", "Amen" or "You've had it". There were lots of things, touching, poignant or queer I wanted to photograph but we couldn't stop….' Above all, she possessed an imagination that was quick to make visual analogies – that could read an object as two different things simultaneously or transform the inanimate into a living being and vice versa: these qualities are particularly evident in her photographs of London in the Blitz. Working in fashion and advertising helped to add immediacy and wit to her images.

A clue to Miller's artistic sensibility emerges in an article she published in *Vogue* in 1956 (one of her last) on the subject of cinema. It is hard to overestimate the importance of cinema for the dada-surrealist generation, a number of whom made pioneering experimental films. Miller was captivated by the cinema. At the age of seven she was taken to see her first 'Motion Picture' at the Poughkeepsie Opera House. 'The hero,' she wrote revealingly, 'was the intrepid cameraman himself who wore his cap backwards, and was paid "danger money".' In Paris in 1930 she took part in Cocteau's first film *The Blood of a Poet*, playing a classical draped statue with broken arms. (She was fascinated in a de Chiricoesque way by statues, which feature prominently in her work.) What she particularly

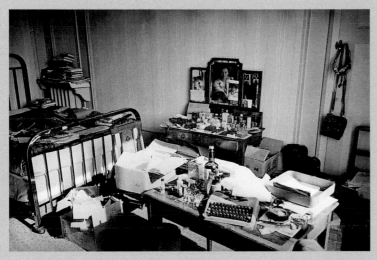

Lee Miller's Room (no. 412) at the Hôtel Scribe,
Paris, 1944 (David E. Scherman)

responded to in film, she wrote in *Vogue*, was '...melodrama, ambiguity, inaccuracy and all, as long as the heroes are close-up close and the background has panoramic splendour'. She described Cocteau's film as 'a poem' and claimed, 'There is a flash of poetry in every motion picture; often it is born of motion, alone. It might be the way an arm moves, a shadow falls, or some dust settles.' In this sense her own photographs may be compared to film stills.

The 'flash of poetry' Miller admired in cinema can be found in her own work and especially in her portraits. She began her career as a portraitist, in a heightened, iconic style influenced by Man Ray, and portraits, or pictures of people, account for about two-thirds of her total output: there are over 1,000 photographs alone of Picasso and his immediate circle. It is important to distinguish several kinds of portraiture in her work. First, there are the sophisticated studio portraits of actors, film stars, models and society figures, usually commissioned (for example by *Vogue*); secondly, more informal portraits of artists (both visual and performing), writers, scientists and other intellectuals shot on location for *Vogue*; thirdly, private portraits of friends, usually artists and their partners, shown individually or together; fourth, portraits of people engaged in war work (often women) or in action (men), their identities often unknown, taken on assignment in various locations and published in *Vogue* or in commissioned books such as *Wrens in Camera* (sometimes in both); fifth, pictures of civilians, including victims or survivors of Nazi oppression (as well as their persecutors); and sixth – the smallest category – more oblique portraits of absent individuals whose occupation or character is evoked by objects associated with them. Much of the fourth and fifth categories belongs

to Miller's intensive wartime activity as a combat photoreporter when she was constantly on the move, the picture had to be taken quickly, and the subject wasn't always aware of being photographed. Conditions were in other respects equally unpromising. Although she was able to benefit from new, lightweight camera equipment, her Rolleiflex had no telephoto lens, auto-wind or built-in light meter, and each film allowed only twelve shots; as a precaution, she carried two cameras. By today's standards, photographs in *Vogue* were reproduced on a surprisingly small scale: some of the portraits in this book were originally printed not much bigger than passport-size, punctuating a column of text or dominating an eye-catching layout by the magazine's designer, Alex Kroll.

Portraying women doing war work, especially the kinds of technical and mechanical work usually reserved for men, became something of a speciality for Miller, who admired the women's quiet dedication and skill. From 1941 British *Vogue* published a stream of features on various non-combatant women's jobs: pilots (ATA), firefighters (NFS), country house hostesses for worn-out Civil Defence workers, searchlight crews (ATS), nurses (both VAD and US Army), Timber Corps, land girls, Home Defence Corps, factory workers, boat builders, Wrens, WAAFs and WVS. All were illustrated with Miller's photographs. The June 1945 issue of *Vogue* ran a piece recalling and celebrating 'The Women Who Went to War' through twenty-four miniature double-page spreads from these features. 'It is up to all women to see to it that there is no regression – that they go right on from here,' urged the magazine. Under Audrey Withers's inspired editorship, *Vogue* was at the forefront of reporting

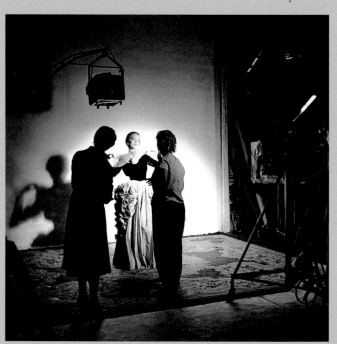

Miller (right) working at the 'Vogue' studios, London, *c.* 1941 (Unknown)

not only the potential for social change but also the revelations of Nazi atrocities. Miller was of course instrumental in this, cabling Withers from Germany: 'I don't usually take pictures of horrors. But don't think that every town and every area isn't rich with them. I hope *Vogue* will feel that it can publish these pictures.' It did.

Miller continued to identify with women once she became attached to the American forces on the Continent in the summer of 1944. Her first dispatch, from an American Evacuation Hospital in Normandy, included poignant photographs of exhausted off-duty nurses. The plight of women (and their children) in Nazi-occupied Europe, whether innocent civilians caught up in the conflict, resistance fighters, collaborators, liberated slave-labourers or high-ranking Nazis, moved, interested and repelled her by turns. The day after photographing appalling scenes at Dachau she was

taken to see Eva Braun's villa in Munich. Miller's word portrait of this unremarkable woman (who was already dead in Berlin) appeared in *Vogue* in the summer of 1945, accompanied by her photographs of the equally ordinary villa interiors: '...strictly department store like everything else in the Nazi regime: impersonal and in good, average, slightly artistic taste'. It is a classic account of the banality of the Hitlerian evil.

All this occasionally affected Miller's capacity to feel compassion. 'I drove through Germany encased in a wall of hate and disgust,' she wrote in a dispatch published in *Vogue* in July 1945. 'For several months I had held my eyes so rigid and my mouth so frozen that I could scarcely manage a smile for a Belgian being repatriated or a family of Alsatians trekking across country, hopefully looking forward to a home which was probably as shattered as the ex-slave-owners' cities they were leaving behind.' As she pressed on through war-torn Austria, Hungary and Romania, however, her cynicism softened as she met recently politicised women trying to reawaken other women to their responsibilities in reconstructing their destroyed societies. In Denmark she found a sophisticated women's network, well educated in the psychology of occupation, which had done much to unite the women

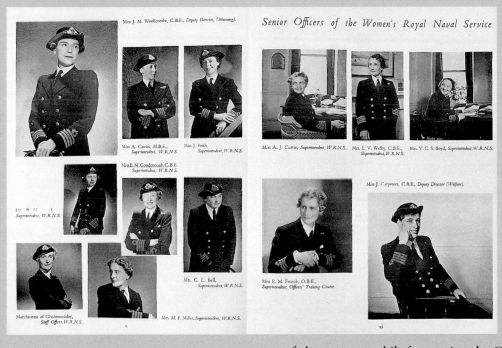

Portraits of senior officers, from Lee Miller's book 'Wrens in Camera', London, 1945

of the country while frustrating the Germans. Nothing, however, could erase the indignation Miller felt in Vienna, a city operated by a surreal conjunction of a paralyzing Four-Power bureaucracy and a vibrant black market, where history was officially being rewritten. 'We are committed to alliance with the Austrians,' she scribbled in one of her notebooks, '"in good faith" we must forget that they welcomed Hitler, that they hoped to profit by their rich marriage with Germany. In keeping with our bargain we must ignore that Austria had...SS who were not more noticeably interested in surrender than the Germans during the fighting.' Anger turned to despair when she visited the city's 'beautiful children's hospital with its nursery rhymed walls', which had everything except life-saving drugs. Miller's 'Report from Vienna' (British *Vogue*, November 1945) is a heavily edited version of her original dispatch, omitting her harrowing account

of the death of a young child, whom she photographed ('For an hour I watched a baby die…'). Nevertheless, *Vogue* did print her observation that the 'psychic depression' suffered by child survivors of the war, which she claimed had reached epidemic proportions, was ultimately a greater problem than malnutrition and disease.

In her wartime reports for *Vogue*, Miller increasingly alludes to early Netherlandish and Flemish painting, especially Bosch and Bruegel. The further she penetrated inside Nazi-occupied Europe, the more she must have wondered whether she hadn't entered one of Bosch's phantasmagoric visions of hell, or perhaps Bruegel's macabre *Triumph of Death*. As a Surrealist she would have been conditioned to expect, even cultivate, madness, abnormality, nightmare. During the gruelling Alsace campaign she gradually realised that: 'We've all been conditioned wrong…we should have been exposed to nightclubs and sleep-snatching and alarms and excursions to prepare us for this, our life.' But nothing could have prepared her for the complete inversion of all civilized values – the world turned upside down – that she encountered in the concentration camps. In this sense Dachau was her defining moment, imposing on her an obligation to bear witness, in photographs and words, to what she saw. 'Germany is a beautiful landscape dotted with jewel-like villages, blotched with ruined cities, and inhabited by schizophrenics,' begins her most accusatory dispatch, in which incomprehension and outrage are barely concealed beneath a mask of icy sarcasm. '… Little girls in white dresses and garlands promenade after their first communion. The children have stilts and marbles and tops and hoops, and they play with dolls. Mothers sew and sweep and bake, and farmers plough and harrow; all just like real people. But they aren't.' With a Surrealist's taste for unlikely or shocking juxtapositions, a photograph of healthy, well-fed German children is reproduced beside one depicting the charred remains of starved prisoners; while another pair contrasts 'orderly' patterned villages with 'orderly' furnaces for burning bodies.

The ultimate surrealist conceit, however, is the photograph showing Miller soaping herself in Hitler's bath in Munich, between a portrait of the Führer in crisp military uniform and a classical nude statuette of the type appropriated by the Nazis as 'Aryan'. Miller's combat boots, smeared with the ash-strewn dust of Dachau, stand on the dirty bathmat. This collaborative, staged photograph, taken by Miller's travelling companion David Scherman a few hours after they had left the concentration camp, can be read on a number of levels – not least as the scoop of the entire war.

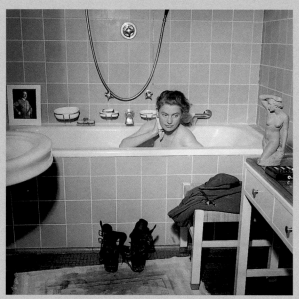

Lee Miller in Hitler's Bath, Munich, 1 May 1945
(David E. Scherman)

But in juxtaposing different ideals of beauty and military prowess with the obscenity of Dachau and with the 'evil machine-monster' who had created it, Miller's subversive mind produced an image that was more iconoclastic than anything her surrealist friends might have concocted.

Miller was fascinated by people's faces, which she often scrutinises in detail in her written reports for *Vogue*. She was surprised to discover that the inhabitants of continental Europe, after the years of Nazi occupation, showed 'no visible signs or changes in manner'. Nevertheless, she wrote, 'they are ill – some kind of hidden and devitalizing microbe. The mental malnutrition of the last four years has sapped their strength.' In 1953, drawing on her physiognomic observations as well as her knowledge

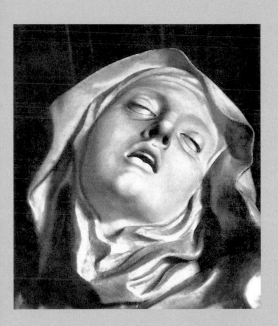

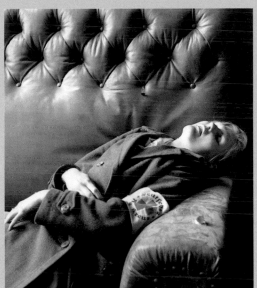

of popular culture, she collaborated with her husband on an exhibition entitled *Wonder and Horror of the Human Head* at the Institute of Contemporary Arts in London which Penrose had recently helped to set up. Miller was responsible for the section devoted to the representation of the head in popular art, contributing among other things, a scrapbook which she had compiled. She simultaneously published a long article in *Vogue* on the subject of the head, which is a blend of neurology, psychology and art history.

{*above*} **Detail of Bernini's 'Ecstasy of St. Teresa', Rome, reproduced in Roland Penrose, 'Wonder and Horror of the Human Head',** London, 1953

{*right*} **Nazi Suicide,** Leipzig, April 1945 (Lee Miller)

The exhibition consisted of over 230 photographs and art objects divided into various categories – Gods, Saints and Heroes; The Head as a Creative Force; Monsters and Grotesques; Distortion; Metamorphosis; Caricature and so on. Works by Magritte, Miró, de Chirico, Man Ray, Picasso, Ernst, Klee, Moore, Sutherland, Bacon and other modern artists, many of them lent by Penrose and Miller, were part of an eclectic display that included reproductions of paintings by Arcimboldo, Bosch and Bruegel, classical antiquities, tribal sculpture, folk art and drawings by the insane. The book published by Penrose to accompany the show is dedicated 'To my Wife, without whose help this essay could not have been written'. It illustrates paintings of Christ's Passion by Bosch and Grünewald whose brutal, grotesque realism echoes particular concentration camp photographs by Miller; while a reproduction of Bernini's sculpture of the *Ecstasy*

of St. Teresa in Rome resembles Miller's almost erotic portrait of the dead daughter of a senior Nazi official in Leipzig. Her photograph of the SS guard who had hanged himself from a radiator recalls, even more shockingly, the head of Grünewald's crucified Christ, lending weight to the view that she perceived things in visual or cultural terms before thinking of their moral implications (of which she was nevertheless acutely aware).

The ability to elicit feelings of disgust and sympathy at the same time is arguably what makes Miller and other war photographers, such as her friend Robert Capa, great artists. The shaven-headed women collaborators or pathetic former camp guards, their faces beaten to pulp, are human beings, however despicable or repulsive their crimes. Even Hitler, she noted

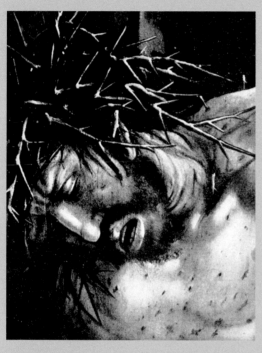

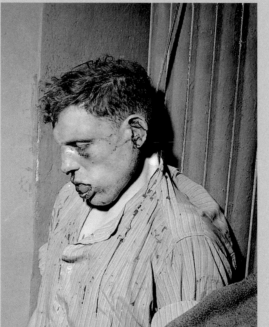

ironically, having lived for a few days in his apartment, had 'almost human habits'. Her frontal, often close-up images of individuals convey a dramatic sense of actuality: the viewer cannot help being drawn in and empathizing with the subject.

After the war Miller concentrated on showing the creative, as opposed to the inhuman, side of humanity. Portraits of artists surrounded by their work, such as Picasso, Cocteau,

{*above*} **Detail of Grünewald's 'Isenheim Altarpiece' showing the crucified Christ, reproduced in Roland Penrose, 'Wonder and Horror of the Human Head',** London, 1953

{*right*} **Suicide of SS Guard,** Buchenwald, April 1945 (Lee Miller)

Bérard and Delvaux, had already become a notable feature of her output in Paris and Brussels following the Liberation. Her message was clearly one of hope: not only have these people survived the rigours of Occupation but their creative spirit remains uncrushed. Miller was also overjoyed to find most of her old friends, a number of whom were Jewish, alive and safe.

Ever since the studio portraits she took of the American Surrealist Joseph Cornell in New York in 1933, Miller liked to depict artists with their work. After the war, there are striking portraits of Noguchi, Arp, Kokoschka, Moore, Morandi, Picasso and others in their studios, in their homes or at exhibitions of their work. Those of her old friend Picasso are particularly strong, a sustained body of work produced over a period of almost twenty years, when Miller accompanied Roland Penrose on his

frequent visits to the artist in France. The most revealing portraits of Picasso that she made during this period show him off-guard or absorbed in some activity, unselfconscious rather than posing. Informality is also a hallmark of the series 'Working Guests', the title of her last, and wittiest, piece of photoreportage, published in the July 1953 issue of *Vogue*. Perhaps inspired by her earlier preoccupation with women learning and performing unfamiliar (e.g. traditionally male) skills to help the war effort, she photographed the weekend guests at Farley Farm grappling with a variety of jobs around the house, in the garden or on the farm. As the majority of the guests were well-known writers, artists, museum directors and architects, Miller's images have a humorous, if not absurdist quality: the dapper figure sporting a trilby feeding the pigs, for example, turns out to be Alfred Barr, the former Director of the Museum of Modern Art in New York.

Miller's critics detect a loss of intensity in her photographs of the 1950s and 1960s. This is unjust. Although the sense of moral outrage is gone, her work retains its penetrating qualities. Miller's postwar portraits tell us the minimum we need to know about the profession or social status of her subjects in order to disclose deeper, psychological truths, as revealed in facial expression, gesture and body language. In this respect her portraits of Picasso rank among her finest achievements. And yet it is fair to say that she was burnt out by the war, disillusioned with *Vogue*, and the change of direction she needed eluded her. It would have been uncharacteristic of her, however, to have retreated completely into a life of rural domesticity. The whole point of 'Working Guests', after all, was to liberate the hostess to do what she liked. One of the photographs illustrating her *Vogue* article shows its author fast asleep on the drawing-room sofa, oblivious to the 'weekend of slavery' she has organised for her friends. After so many years of creating unforgettable images of human beings at their best and at their worst, we may conclude that she deserved her rest.

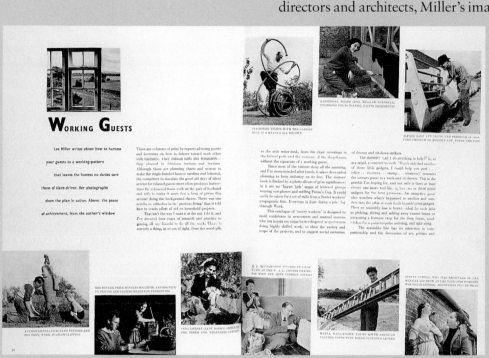

Double page from Miller's article 'Working Guests', British *Vogue*, July 1953

The Surrealist Decade

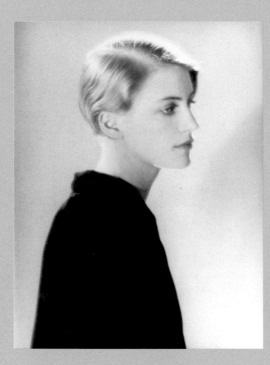

In 1929 Lee Miller, aged 22, gave up her modelling career in New York and
travelled to Europe. Having experienced what it felt like to be photographed,
she was determined to try her hand at the medium. In Paris she contacted
the dada-surrealist artist and photographer Man Ray. She persuaded
him to take her on as his pupil but soon became his assistant, model,
collaborator and lover. The relationship lasted until the autumn of 1932
when Miller returned to New York, but not before she had set up her
own studio in Paris. Back in New York, she opened a photographic studio
specialising in portraiture and advertising work, with her brother Erik
Miller as darkroom assistant. On her marriage to the Egyptian Aziz Eloui
Bey in the summer of 1934 she closed the studio and went to live in Cairo.

Miller's portraits of the early 1930s – the only time in her career that
she had her own studio and darkroom – reflect the influence of Man Ray.
With Man Ray she refined the technique of solarization, an admission of
light into the developing process which heightens contours and creates
an aura around objects. Although she learnt much from Man Ray –
manipulating the photograph to make a self-contained, semi-abstract or
dreamlike image, for example – she did not follow him down the path of
formal experimentation but concentrated on revealing the world around
her in a more intense way. While in Paris she also worked as an assistant to
George Hoyningen-Huene, director of *Vogue*'s Paris studio, who practised
a more theatrical type of portraiture and fashion photography and from
whom she picked up useful hints on lighting.

When she resumed photography in Egypt in the mid-1930s Miller
exchanged the cultivated stylishness of her studio work for a more relaxed
and spontaneous approach to her subjects, many of whom where shot out
of doors. These qualities can be seen in the portraits she made of artist
friends in England and the south of France in the summer of 1937, after
she had met her future second husband Roland Penrose.

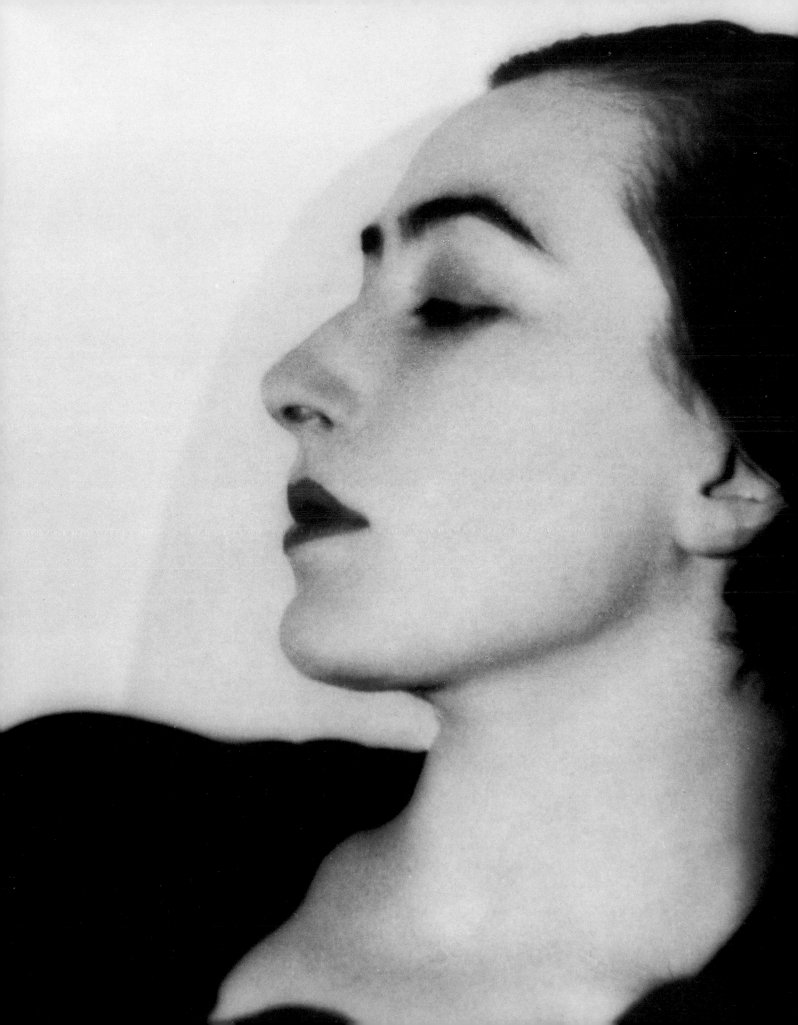

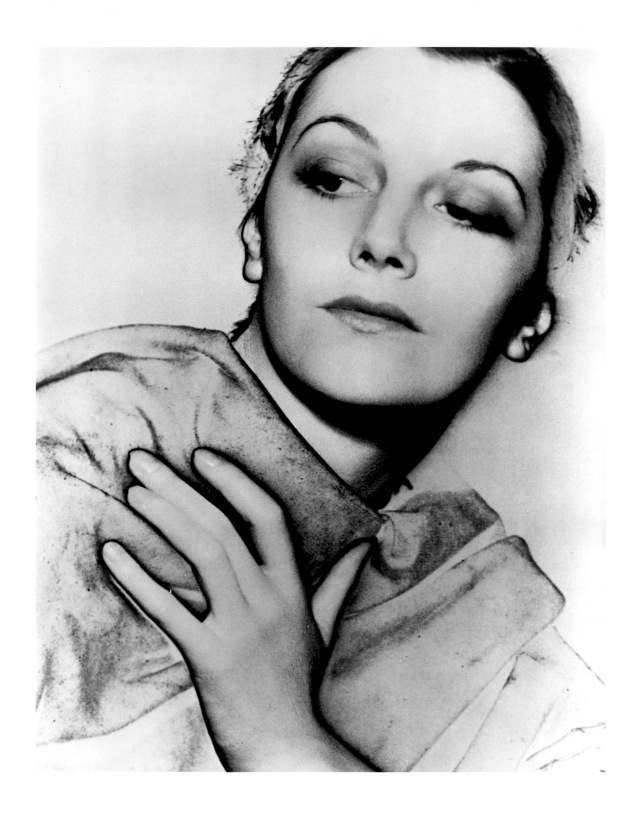

{above} **Solarized Portrait**
(unknown subject), Paris, 1930
This is the earliest known example of Miller's use of
solarization, which involves exposing the negative to light
during development. She accidentally discovered the
technique and refined it in collaboration with Man Ray.

{opposite} **Man Ray,** Paris, 1931
Man Ray, one of the founders of the Dada movement
and an important figure in Surrealism, was a formative
influence on Miller's photography. From him she learned
various technical skills and a range of aesthetic devices,
including unusual and dramatic camera angles,

the close-up, and how to separate a head or figure
from its context and make it appear to float in space.

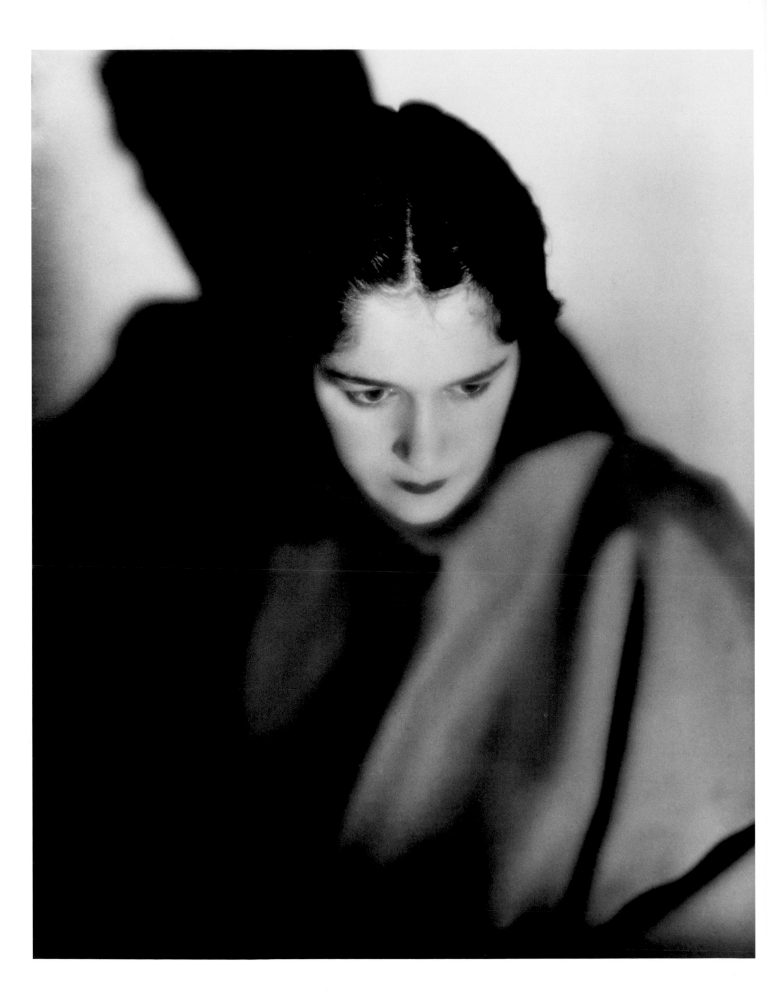

{*opposite*} **Tanja Ramm,** Paris, 1931
Tanja Ramm was one of Miller's closest friends. They
met at the Art Students' League in New York and travelled
to Europe together in 1929. It was Ramm who introduced
Miller to Eloui Bey.

{*above*} **Charlie Chaplin,** Paris, 1930
The comic film actor and director, at the climax
of his career (*City Lights* appeared the year after this
photograph was taken), was a friend of Eloui Bey.
Chaplin and Miller developed a strong rapport.

{*above*} **Woman with Hand on Head,** Paris, 1931
{*opposite*} **Nude Wearing Sabre Guard,** Paris, *c.* 1930
Both photographs exhibit typically surrealist
preoccupations. The wire-mesh sabre guard is intended
to protect swordsmen but as worn here it exposes the
woman's defenceless torso and adds an erotic frisson.

Back views were used by Magritte and Ernst as a
disorientating way of concealing the face of a subject;
in Ernst's work in particular, hair has fetishistic overtones.
The hand in Miller's photograph assumes a life of its own.

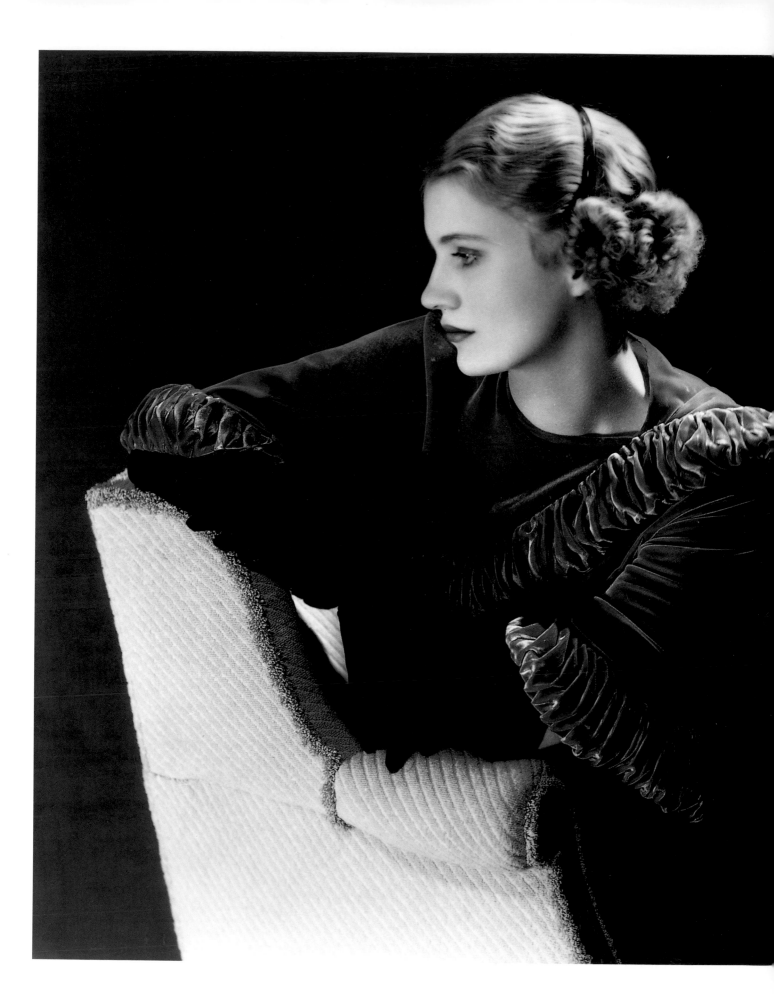

Self-portrait, New York, 1932
The pretext for this classically beautiful image, in which
Miller mimics the dress and conventions of Renaissance
court portraiture, was a fashion article on plastic
hairbands which had just been introduced. This picture
was taken in the studio that Miller had recently opened
on East 48th Street.

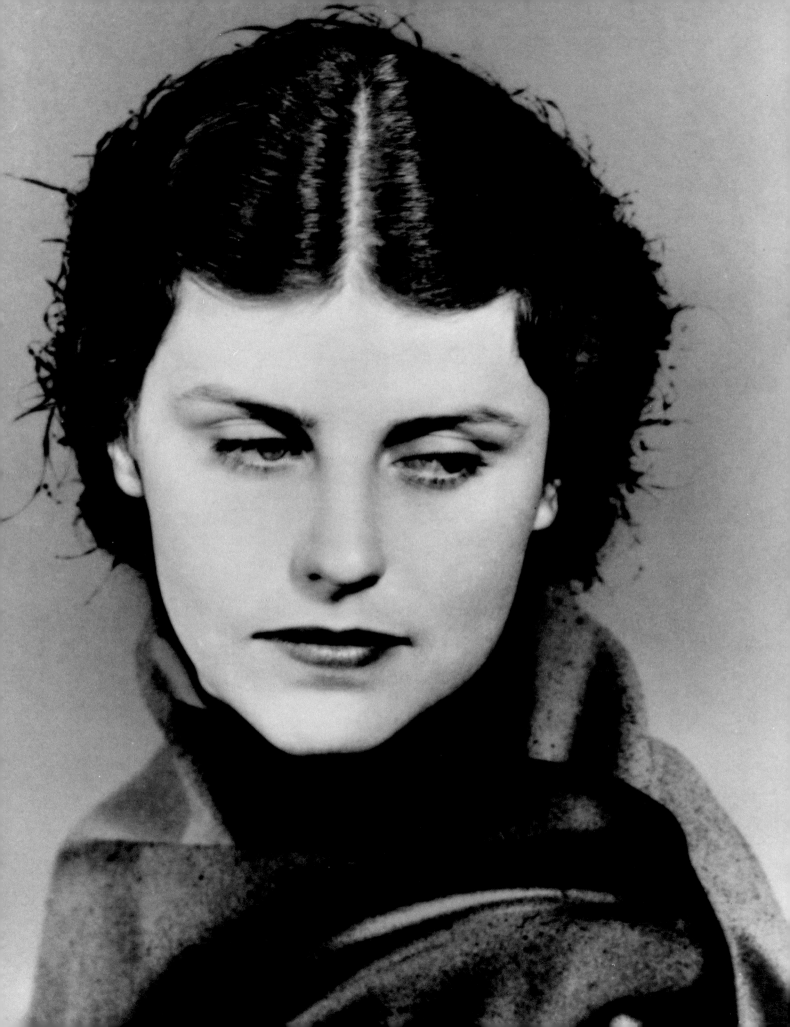

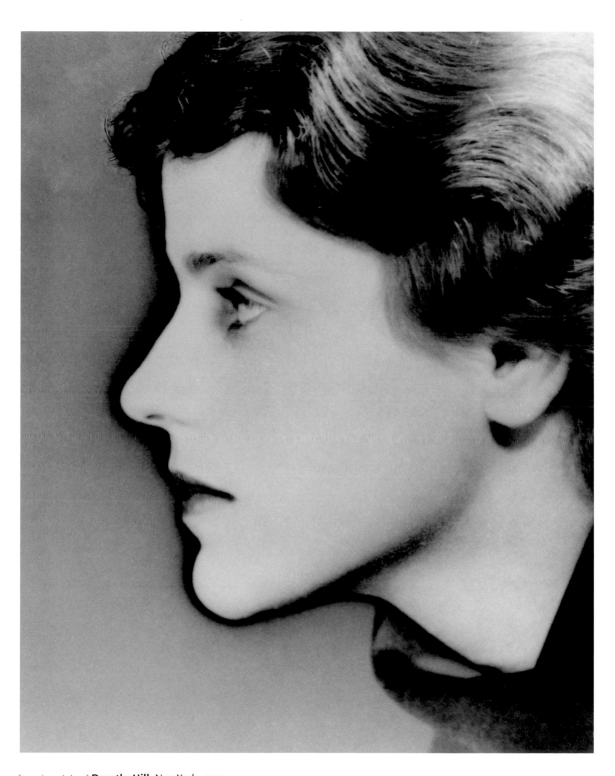

{*opposite and above*} **Dorothy Hill,** New York, 1933
Two solarized portraits of one of Miller's New York
friends. In early 1933 Miller had a one-woman show
of her photographs at the Julien Levy Gallery in New York.
The exhibition was a critical success and *Vanity Fair* listed
her among 'the most distinguished living photographers'.

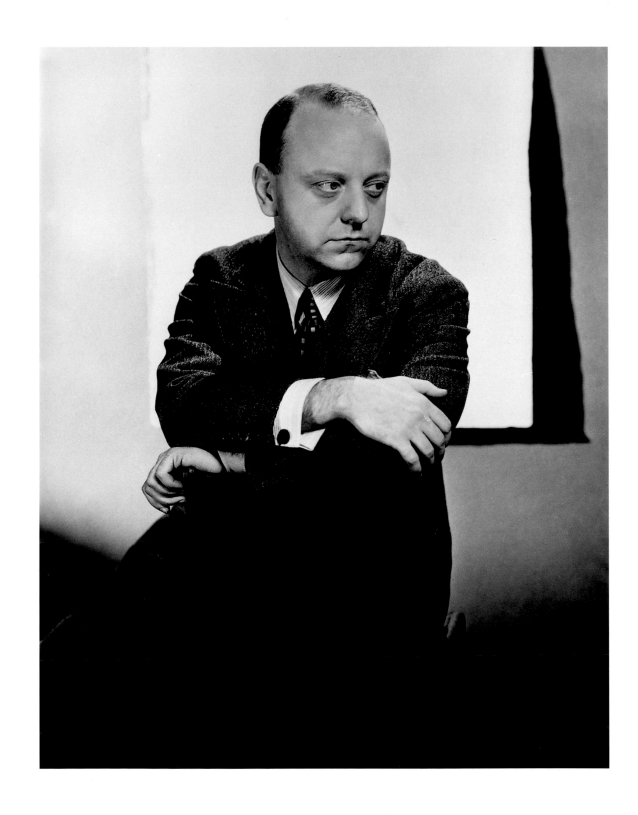

{*above*} **Virgil Thomson,** New York, 1933
Thomson composed the music for the surrealist opera
Four Saints in Three Acts, produced and directed by John
Houseman; the libretto was by Gertrude Stein. Miller, a
friend of Houseman, was commissioned to photograph
the cast for the programme and publicity.

{*opposite*} **Gertrude Lawrence,** New York, 1933
The famous star of revues and stage musicals in Britain
was also a hit on Broadway. In 1934 Lawrence appeared
alongside Laurence Olivier in the film *No Funny Business*.
The flowers in the vase are made of metal.

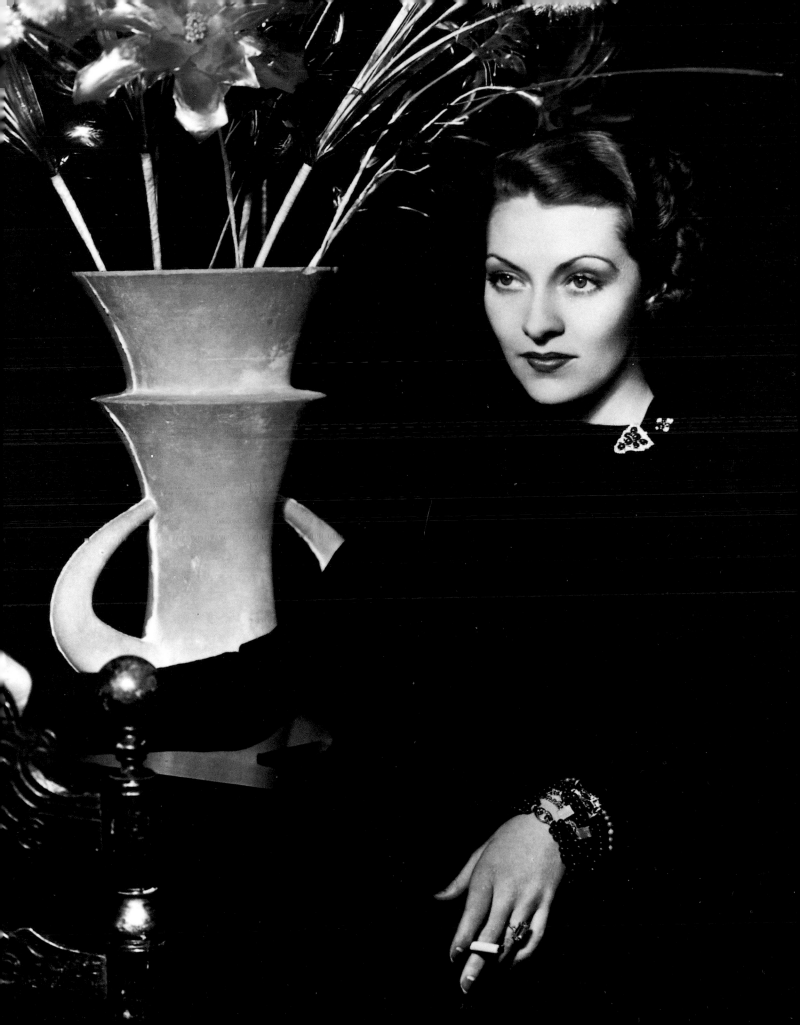

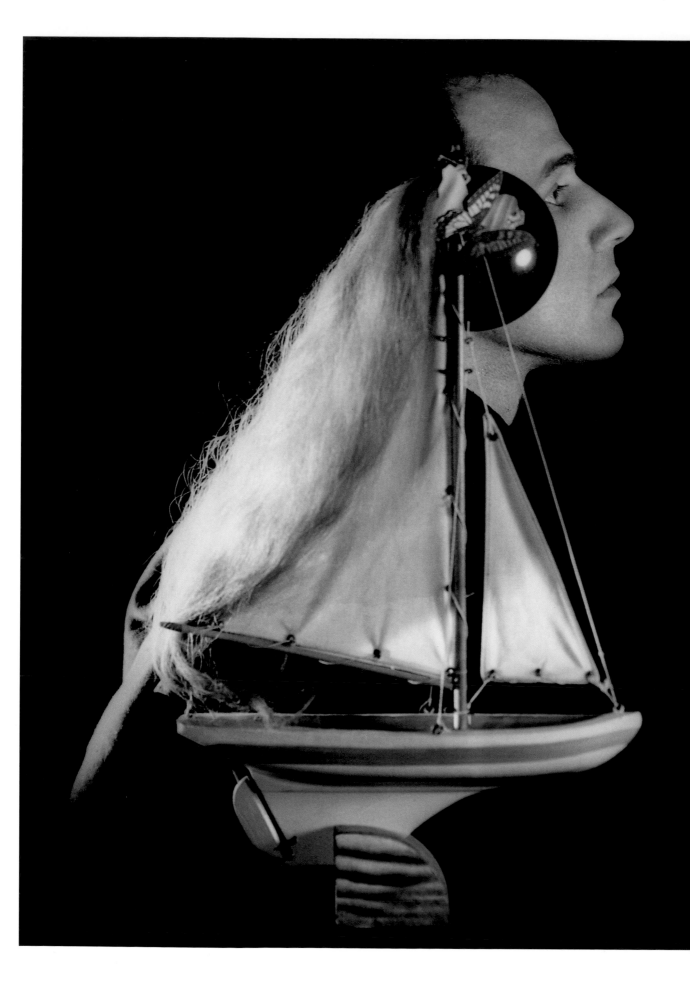

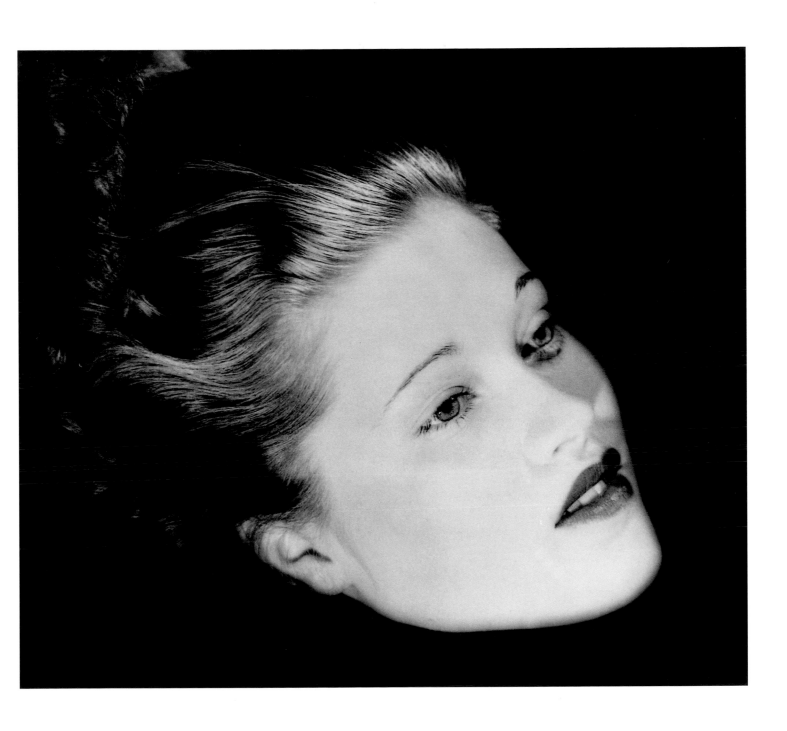

{opposite} **Joseph Cornell,** New York, 1933
The eccentric artist Joseph Cornell was first shown
in an exhibition of Surrealism at the Julien Levy Gallery,
New York, in 1932. His work was later included in the
exhibition *Fantastic Art Dada Surrealism* at the Museum
of Modern Art, New York, in 1936. In this portrait, Miller
merges Cornell's profile with one of his 'objects'. Her
photographs of his work from this period constitute
an important record.

{above} **Floating Head (Mary Taylor),** New York, 1933
Mary Taylor, an aspiring young actress working on
Broadway, was photographed by Miller to provide pictures
for Taylor's agent to send to Hollywood.

31

Lilian Harvey, New York, 1933
Although British, Harvey spent most of her childhood
and youth in Germany, where she became a star of
screen musicals including the internationally successful
Der Kongress tanzt (*The Congress Dances*). In 1933 she went
to Hollywood and acted in a number of films.

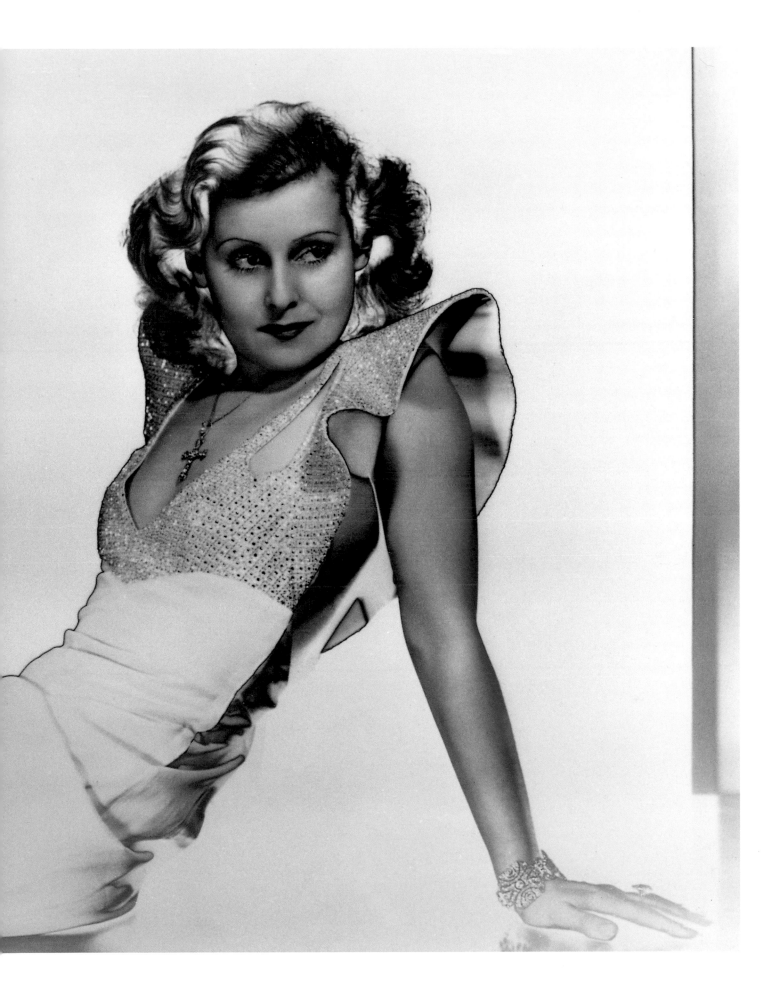

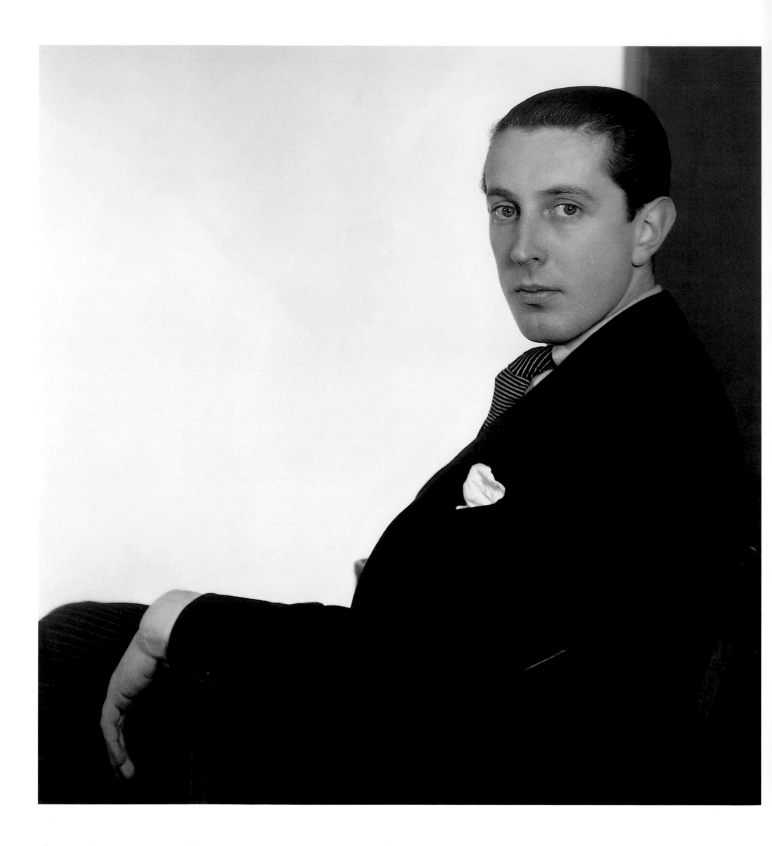

{above} **Frederick Ashton,** New York, 1933
The twenty-nine-year-old choreographer spent a year in the USA before returning to Britain to work for the Ballet Club (later Ballet Rambert). While in America he choreographed the dances for Virgil Thomson's opera *Four Saints in Three Acts*.

{opposite} **Chick Austin,** New York, 1933
A. Everett ('Chick') Austin, Jr. was the dynamic young director of the Wadsworth Atheneum at Hartford, Connecticut, where in 1931 he organised the first exhibition of Surrealism in the USA. Over the next decade the Atheneum became a centre for Surrealism, acquiring paintings by Dalí, Miró, Ernst, de Chirico, Picasso and others. In 1934 Austin invited Dalí to lecture at the museum and put on a display of his work. The premiere of the Virgil Thomson-Gertrude Stein opera *Four Saints in Three Acts* inaugurated a new wing at the museum in 1934.

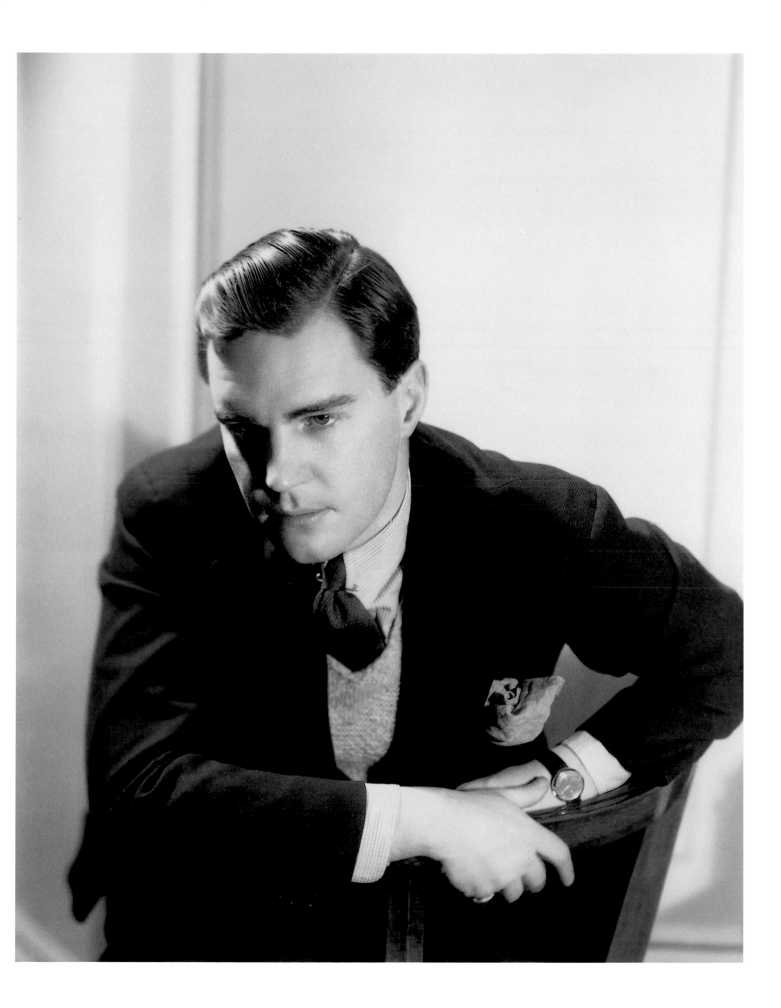

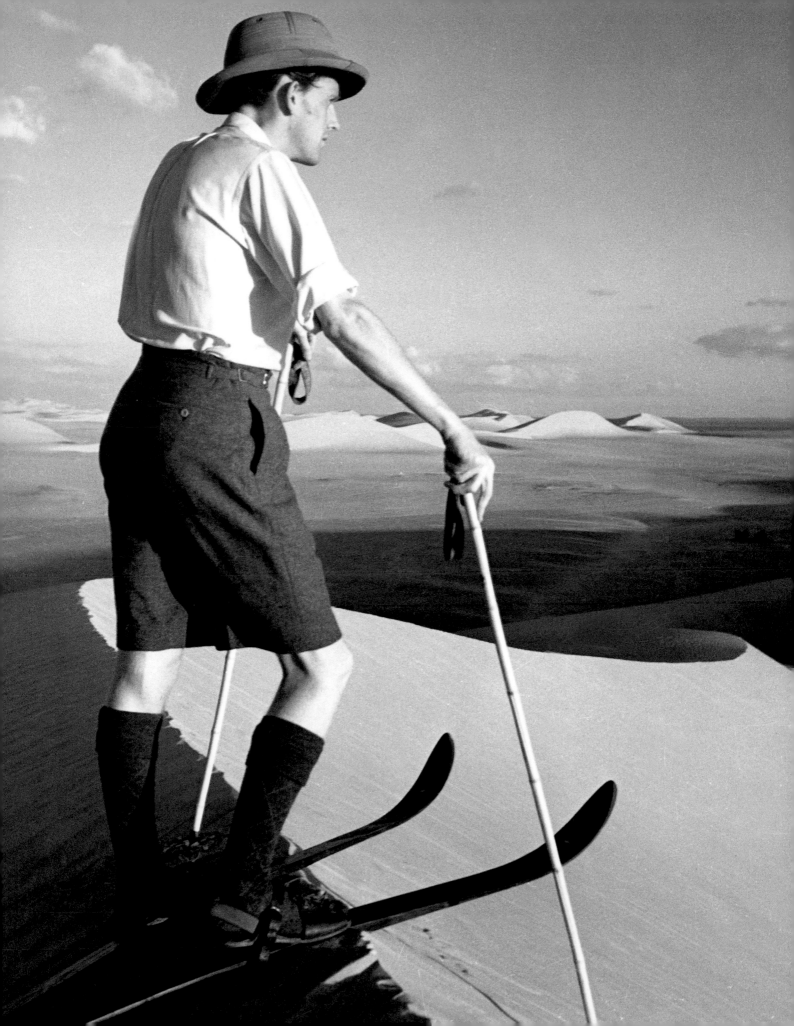

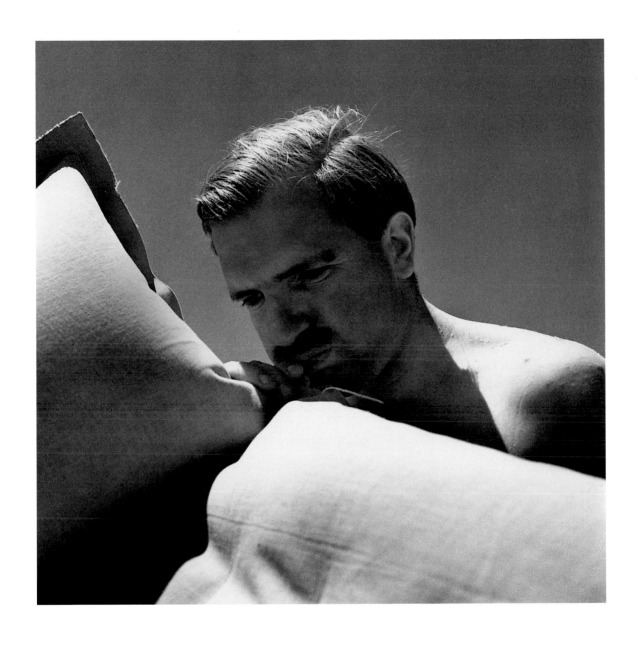

{opposite} **Robin Fedden,** Egypt, 1937
Robin Fedden was a writer and poet who lectured in the
English department at Cairo University. During the war he
co-founded, with Lawrence Durrell and Bernard Spencer,
the literary magazine *Personal Landscape.* Miller shows
Fedden sand-skiing on one of their trips into the desert.

{above} **Bernard Burrows,** Red Sea, 1938
Bernard (later Sir Bernard) Burrows was the Second
Secretary at the British Embassy in Cairo when Miller
met him; he later became a distinguished Ambassador
to Turkey. A classical education and a fascination with
archaeology made him an ideal travelling companion;

he and Miller made several trips to the Red Sea, and
in 1938 they explored Syria and the Lebanon. Burrows
is shown inflating an airbed on one of their journeys.

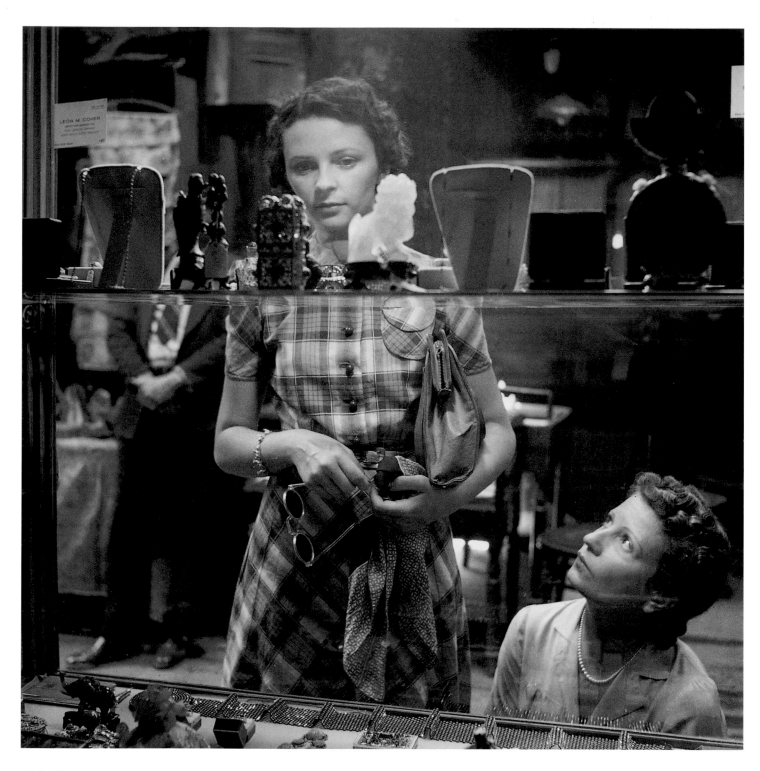

Mafy Miller, Cairo, c. 1937
Miller's brother Erik and his wife Mafy followed Miller to
Egypt in 1937, where Erik worked for an air-conditioning
company owned by Eloui Bey. Miller catches Mafy's
serene expression as she gazes at the window display;
she is watched by their mutual friend Diane Pereira.

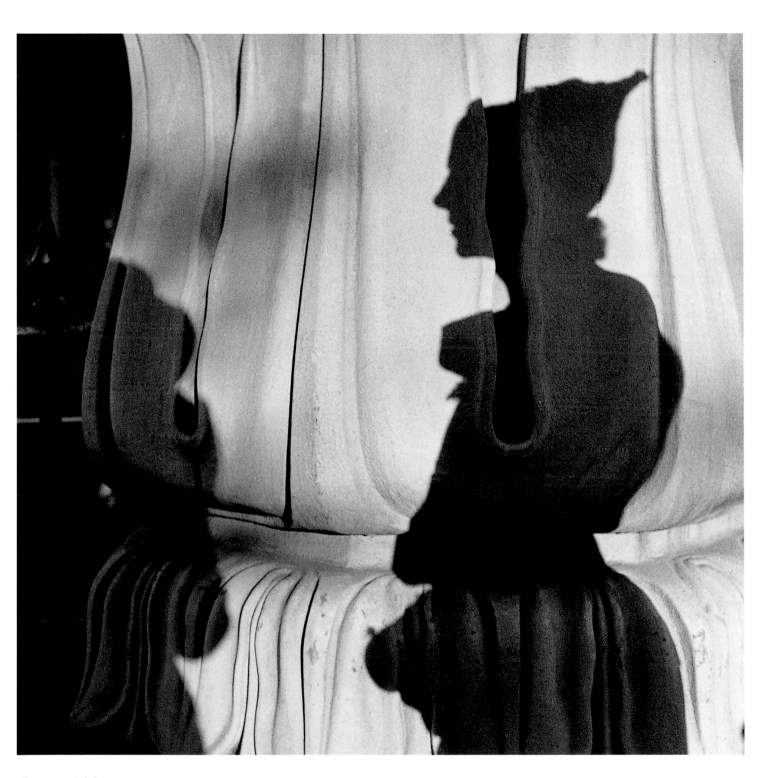

Eileen Agar, Brighton, 1937

The British surrealist artist Eileen Agar was a close friend of Roland Penrose, who included her work in the *International Surrealist Exhibition* in London in 1936. The following summer, during a brief visit to England to see Penrose, Miller photographed Agar's shadow on one of the exotic columns of the Brighton Pavilion. The bulge in the lower part of the silhouette is Agar's Rolleiflex camera.

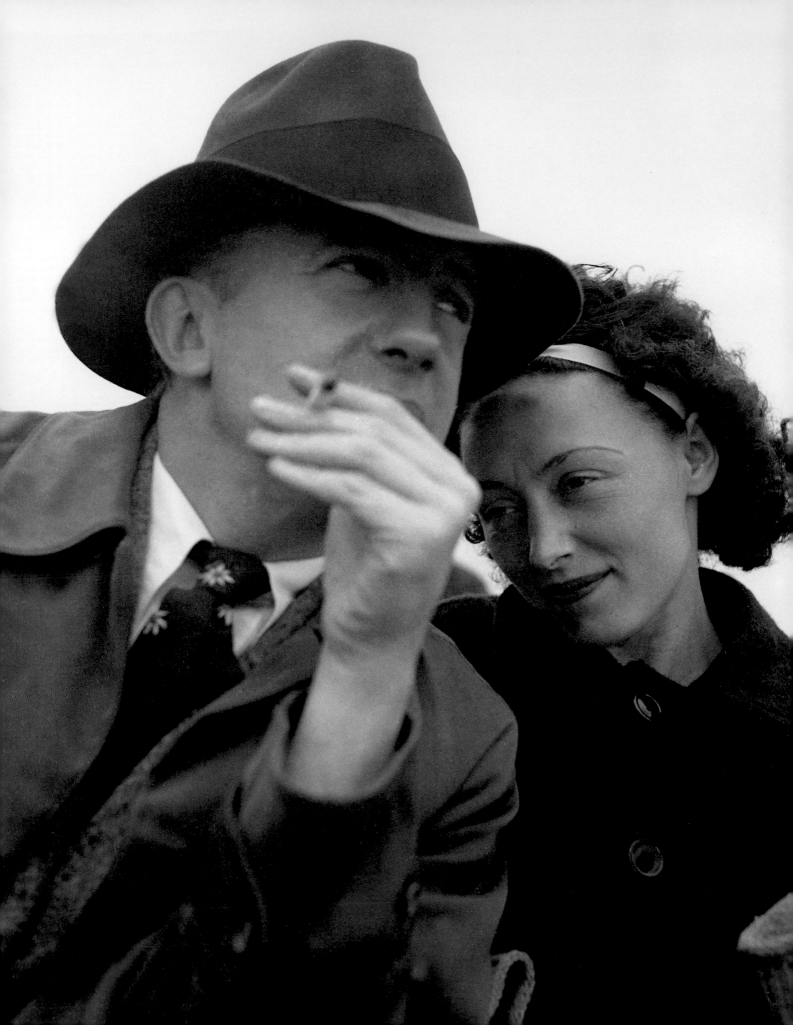

Paul and Nusch Eluard, Cornwall, 1937

The French surrealist poet Paul Eluard and his wife Nusch were part of a month-long house party in July 1937 at Lamb Creek, the house belonging to Penrose's brother. In addition to Penrose and Miller, the party included Man Ray and his girlfriend Ady Fidelin, Max Ernst and Leonora Carrington, and Eileen Agar and her husband, the writer Joseph Bard. Eluard had recently married Nusch, a former circus performer whose beauty was celebrated by Picasso and the Surrealists.

Paul Eluard, Cornwall, 1937
Eluard was Roland Penrose's closest friend in the
surrealist movement. In 1938 Penrose bought his
outstanding collection of modern art, including forty
works by Max Ernst. Eluard is seen here in holiday mood,
dressed as a woman from a 17th-century Dutch portrait.

Leonor Fini, St Martin d'Ardèche, France, 1939
The surrealist painter and writer Leonor Fini was staying
with her close friends Max Ernst and Leonora Carrington
when Miller and Penrose visited them in the south of
France shortly before the outbreak of war.

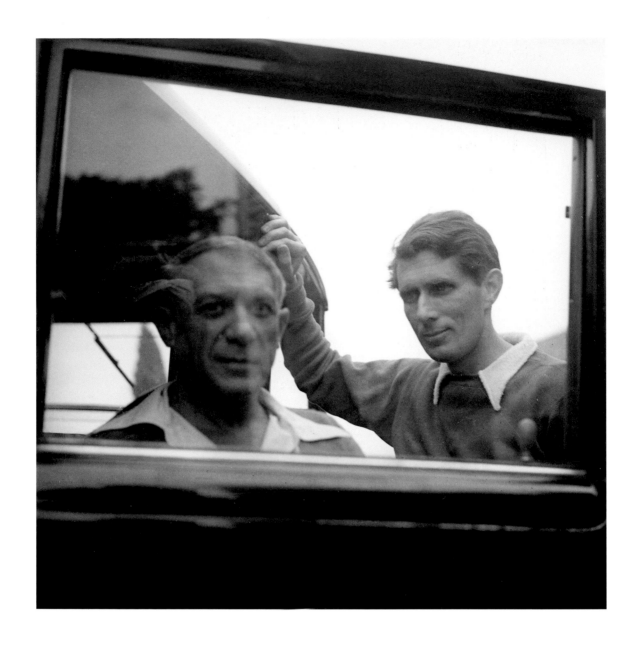

Picasso and Roland Penrose, Mougins, France, 1937
Following their holiday in Cornwall, Miller and Penrose stayed for the month of August at the Hôtel Vaste Horizon at Mougins in the south of France, where Picasso and Dora Maar were already installed. Penrose had been introduced to Picasso by Eluard the previous year, when he bought the first of many works by Picasso. In the 1950s Penrose would write the first full-length biography of the artist. The two friends are shown framed in the window of Picasso's Hispano Suiza.

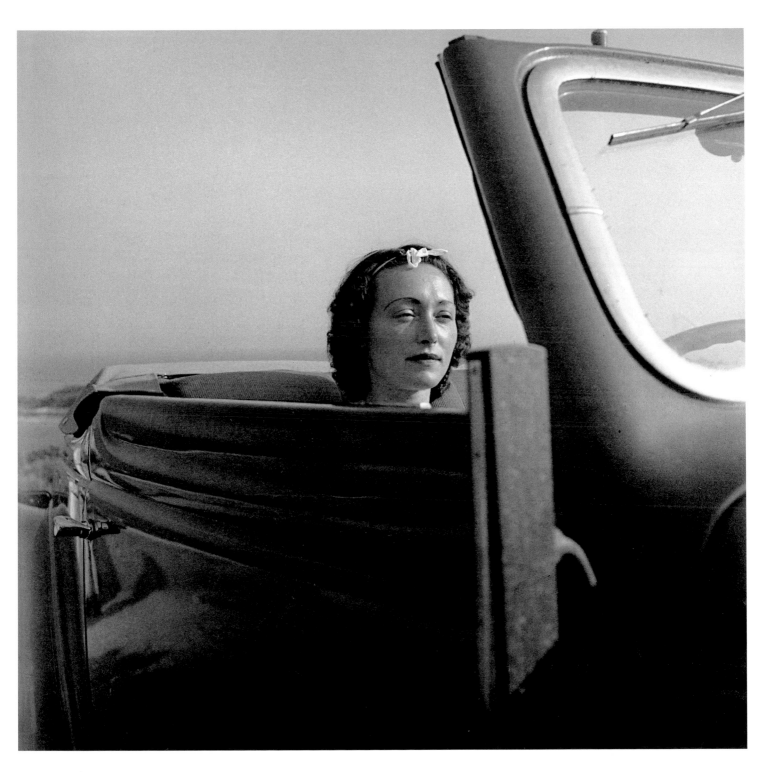

Nusch Eluard, Mougins, France, 1937
The Eluards were also staying at Mougins, where Miller
photographed an inscrutable-looking Nusch sitting
in Penrose's Ford V8.

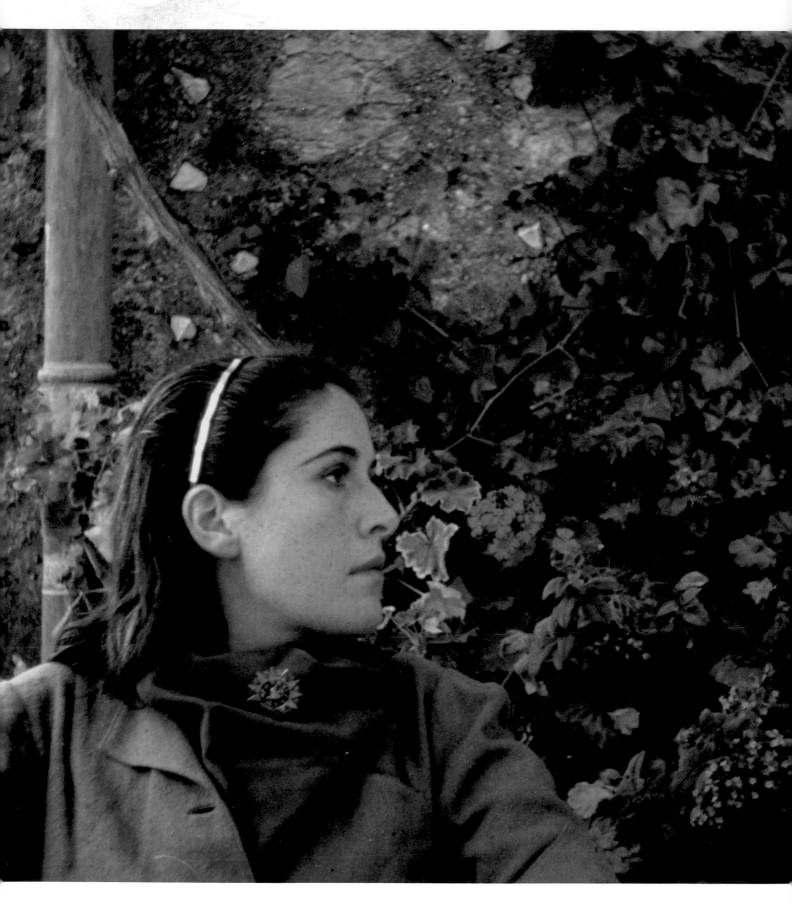

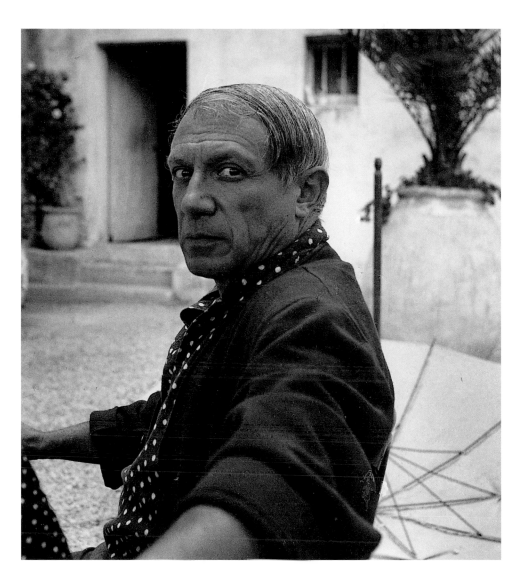

Picasso, Mougins, France, 1937
Photographed soon after finishing *Guernica*, Picasso was
midway through his series of 'weeping women', one of
which was acquired by Penrose. On holiday in the south
of France, he relaxed by painting portraits of his friends,
including at least four of Miller.

Dora Maar, Mougins, France, 1937
Dora Maar was Picasso's mistress from 1936 to 1945
and the inspiration for such masterpieces as *Weeping
Woman* 1937 (Tate), painted a couple of months after
this photograph was taken. The image of the crying
or screaming woman had first appeared in *Guernica*,
the mural-length canvas Picasso painted in response
to the bombing of the Basque town of the same name
in the Spanish Civil War in late April 1937. Dora Maar,
who was a talented photographer, took a series of
photographs recording *Guernica* in its various stages.
Miller and Penrose remained friendly with her long
after she split up with Picasso.

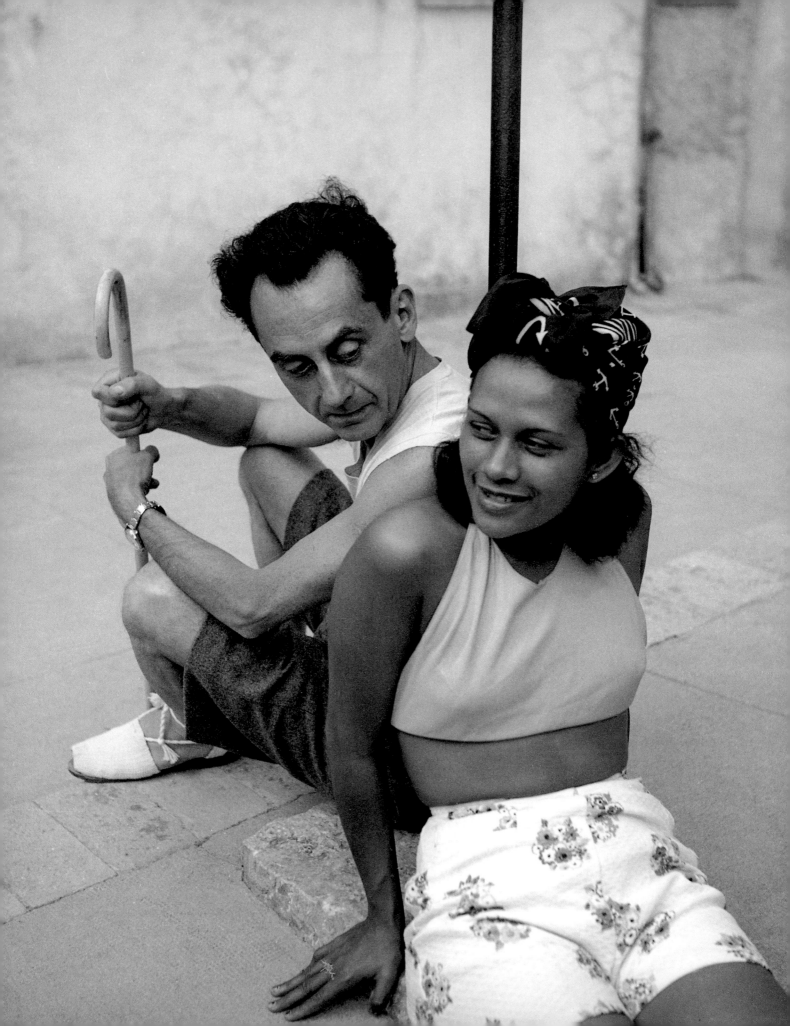

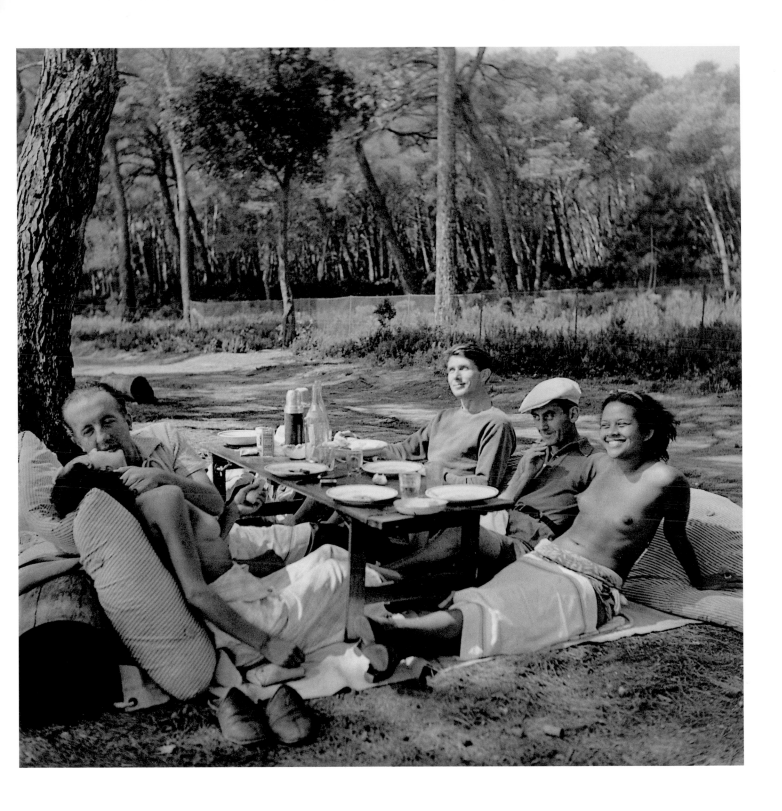

{opposite} **Man Ray and Ady Fidelin,**
Mougins, France, 1937
Adrienne ('Ady') Fidelin came from the Caribbean island
of Martinique and was Man Ray's first serious girlfriend
after Miller had left him in the summer of 1932.

{above} **Picnic,** Mougins, France, 1937
Miller recorded the artistic and erotic relationships
of the group of surrealist friends at Mougins in several
photographs, of which this is the most famous. Left
to right: Nusch and Paul Eluard, Roland Penrose,
Man Ray and Ady Fidelin.

Leonora Carrington, St Martin d'Ardèche, France, 1939
Shortly before the outbreak of war, Miller and Penrose drove
to the south of France to see the surrealist artists Max Ernst
and Leonora Carrington. Within a few weeks Ernst and
Carrington had been separated by the war: Ernst, a German,
was interned as an 'enemy alien', while Carrington
managed to cross to Spain where she suffered a
breakdown and was incarcerated in a mental institution.

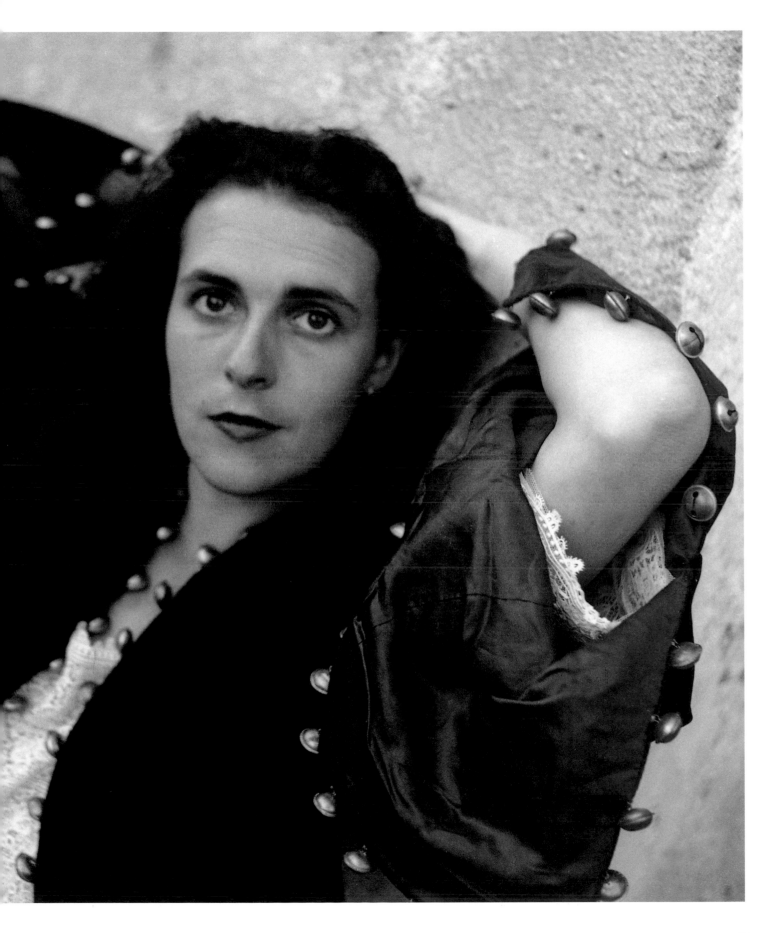

The War at Home

Lee Miller Photographing Scrap Metal Collectors,
England, 1943 (David E. Scherman)

{opposite} **Fire Masks,** Hampstead, London, 1941
Miller posed this shot, which was commissioned by *Vogue*, at
the entrance to the air-raid shelter in the garden of Penrose's
house in Downshire Hill. The masks were designed to afford
protection from incendiary bombs but here they have a
surrealist quality, recalling Magritte's paintings of figures
with concealed faces or Henry Moore's lead *Helmet* which
Penrose had acquired in 1940.

After she separated from Eloui in 1939, Miller joined Penrose in Europe
and travelled with him to London as war was declared. She chose to
remain with Penrose rather than return to the USA. In 1940 she joined
Vogue as a freelance. From early 1941 her photographs of anonymous
models in functional outfits began to appear in the magazine, illustrating
features with titles such as 'Fashions for Factories' and 'Smart Fashions
for Limited Incomes', reflecting the increasingly austere times. The
government had levied a Purchase Tax in 1940 (though this did not apply
to utility clothes) and in June 1941 clothes rationing was introduced.
Miller also photographed well-known sportswomen, actresses and
ballerinas modelling relatively restrained fashion items.

In spite of paper restrictions and bomb damage to its offices, *Vogue*
continued to be published and was read by tens of thousands of women.
Miller, meanwhile, was involved in a project with Ernestine Carter, wife
of the London director of Scribners, the American publisher, to produce a
book of photographs for the American market showing the impact of the
Blitz on London and its citizens. *Grim Glory: Pictures of Britain under
Fire* came out in May 1941 with a preface by Ed Murrow, the American
broadcaster based in London. Twenty-two of Miller's photographs were
reproduced (one-fifth of the total), some with her own captions.

Impressed by Miller's first venture into photoreportage, Withers
commissioned her to cover the diverse and vital contribution of women
to the war effort. For the next few years Miller's photographs of uniformed
women at work and off duty began to change the look of *Vogue*. Having
become accredited to the US Army as a war correspondent, she was
allowed access to restricted areas. A permanent result of this engagement
with women at war was Miller's book *Wrens in Camera* which appeared
in 1945. At the same time she continued to take portraits for *Vogue* of stage
and screen stars, artists, and fellow war correspondents; a particular
interest was Americans in Britain.

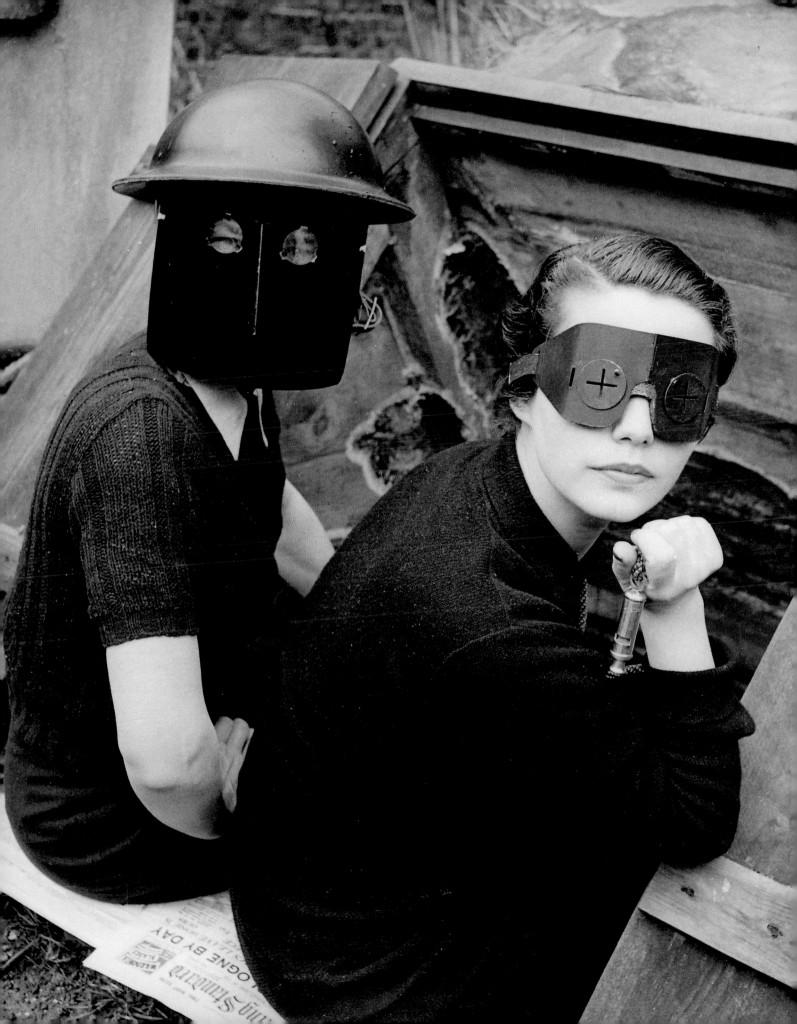

{*opposite*} **Charles Hawtrey,** London, 1940
Photographed by Miller in May 1940 for the regular 'Spotlight' column in *Vogue*, the actor Charles Hawtrey was known for his female impersonations as well as for parts in Will Hay comedies. Hawtrey came from a theatrical family and studied for the stage at the Italia Conti School. Between 1958 and 1973 he appeared in over 21 films in the popular 'Carry On' series, usually playing a weedy, bespectacled character.

{*above*} **Flora Robson,** London, 1944
Flora Robson was one of the great character actresses of the London stage in the 1930s; she also appeared in numerous films in a career lasting six decades. Miller photographed her for *Vogue* in April 1944, when Robson was playing Thérèse Raquin in *Guilty* at the Lyric Theatre, Hammersmith.

{above} **Ann Todd**, London, 1944
The British actress Ann Todd is best known for her portrayal of a pianist in the film *The Seventh Veil* (1945), in which she starred with James Mason. She later married the film director David Lean who directed her in several films including *The Passionate Friends* (1949) and *The Sound*

Barrier (1952). Miller photographed her modelling this pillbox hat by Marcelle for the September 1944 issue of *Vogue*. At the time Todd was filming in the Alexander Korda production of *Perfect Strangers*.

{opposite} **Margot Fonteyn**, London, 1944
Miller photographed the twenty-five-year-old prima ballerina modelling black felt Chinese hats by Aage Thaarup for the September 1944 issue of *Vogue*. During the war, Fonteyn's performances for the Sadler's Wells Company did much to popularize ballet in Britain.

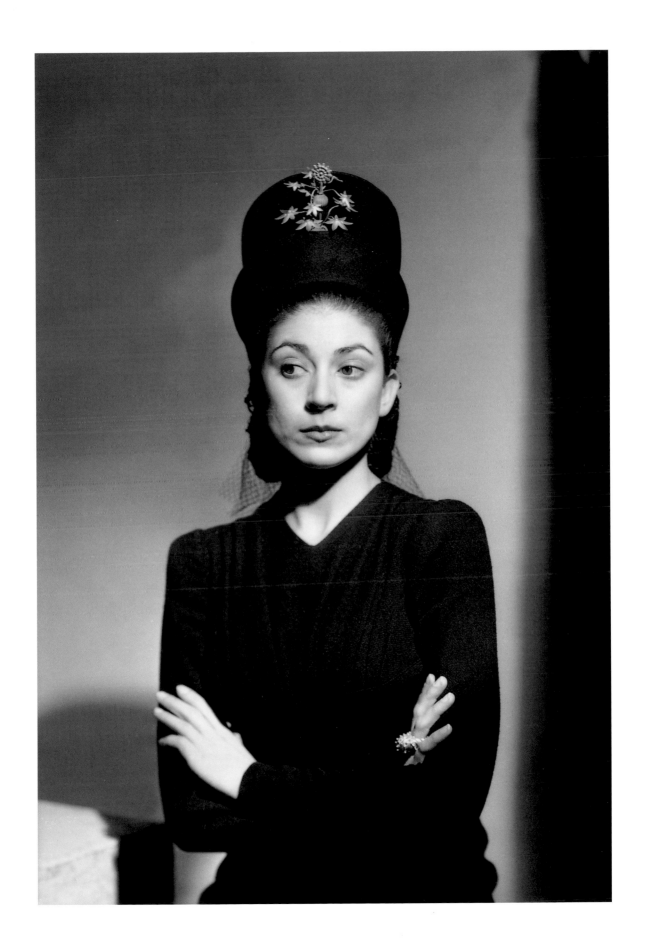

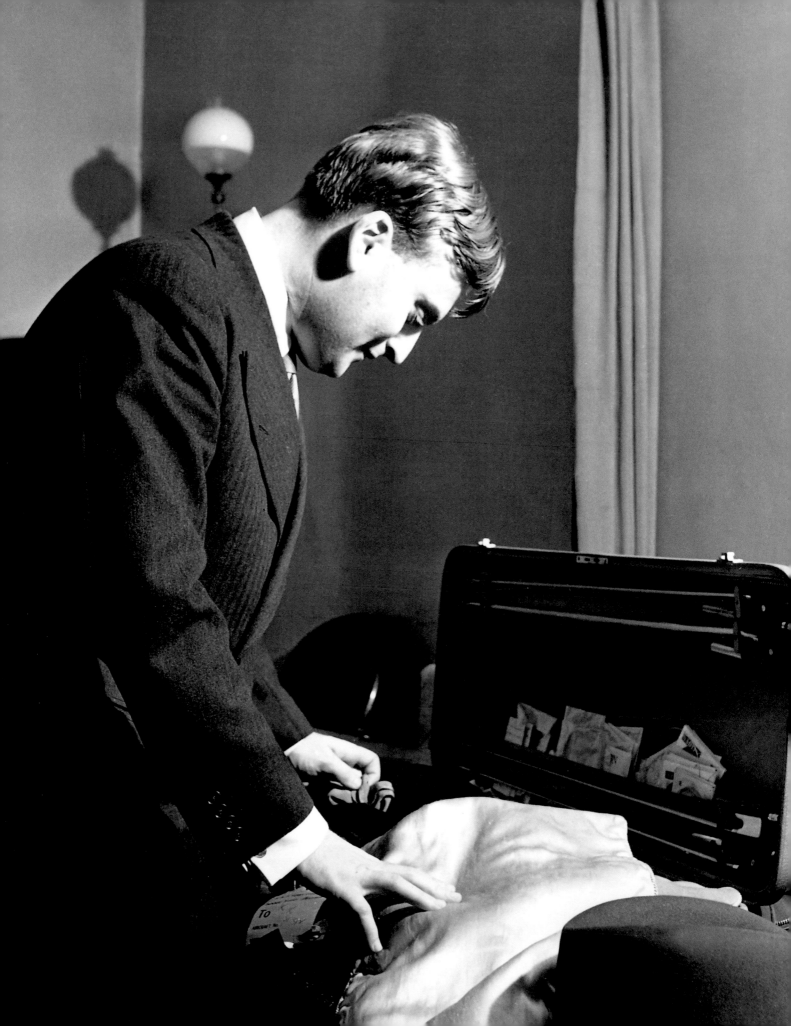

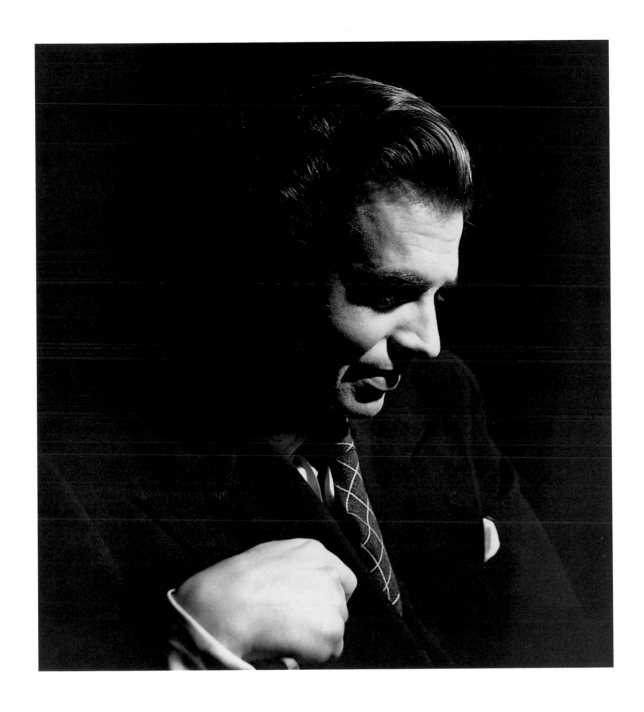

{opposite} **Yehudi Menuhin,** London, 1943
A child prodigy, the New York-born British violinist made his London debut at the age of thirteen. Three years later he recorded Elgar's *Violin Concerto* conducted by the composer. Here Menuhin is seen unpacking his violin before a concert at the Albert Hall.

{above} **James Mason,** London, 1943
Mason became captivated by the stage while studying architecture at Cambridge University. His career was spent mainly in films; as a conscientious objector he was able to act throughout the war, since the film industry was judged to be of national importance. In 1943, the year Miller photographed him at *Vogue's* studios, Mason scored his first success in the costume drama *The Man in Grey*. In 1945 he played opposite Ann Todd in *The Seventh Veil*, and after the war starred in a succession of hits including *The Prisoner of Zenda* and *A Star is Born*.

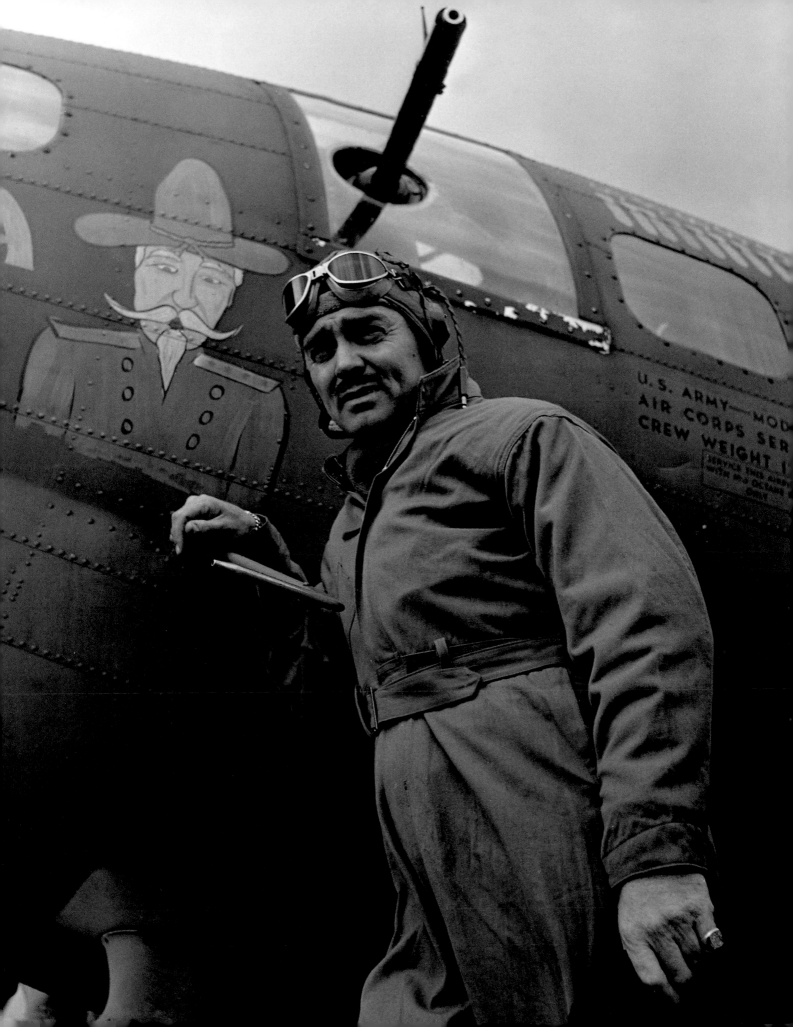

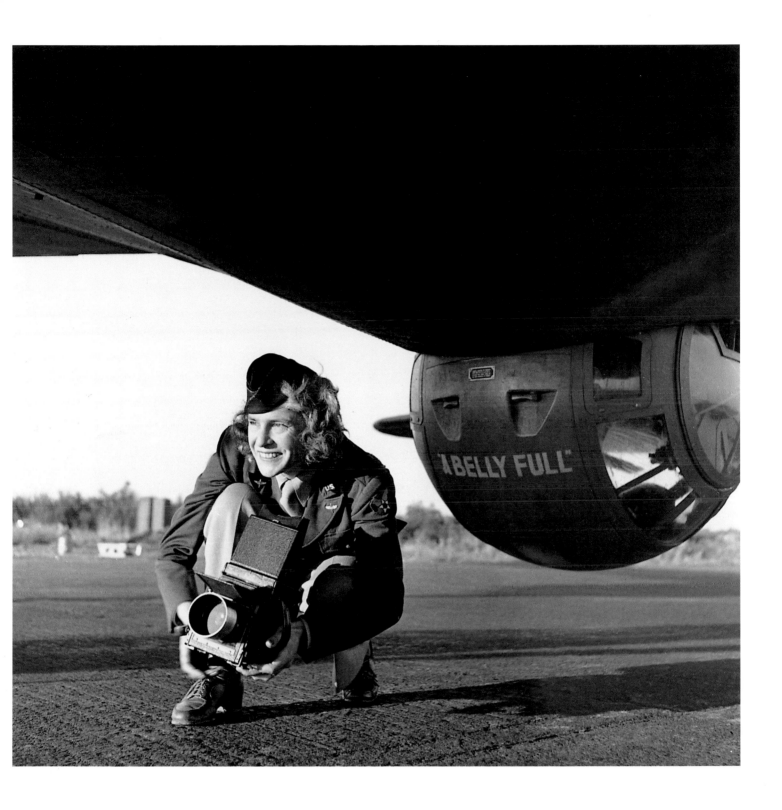

{opposite} **Clark Gable,** US Airforce base, England, 1943
The epitome of tough, handsome American masculinity, Clark Gable's most famous film role was as Rhett Butler in *Gone With the Wind* (1939). Following the death of his third wife, the actress Carole Lombard, in a plane crash, Gable joined the US Airforce in 1942, attaining the rank of Major.

{above} **Margaret Bourke-White,** England, 1942
The American Margaret Bourke-White was one of the first photographers to join *Life* magazine. In 1941 she was the only foreign photographer in the Soviet Union allowed access to the German front; she also took Stalin's portrait in the Kremlin. In 1942 she came to Britain and was accredited to the US Airforce. Miller photographed Bourke-White at an American airbase where she was covering the assembly of B-17 squadrons, for a profile published in *Vogue* in January 1943. Bourke-White was married to the writer Erskine Caldwell.

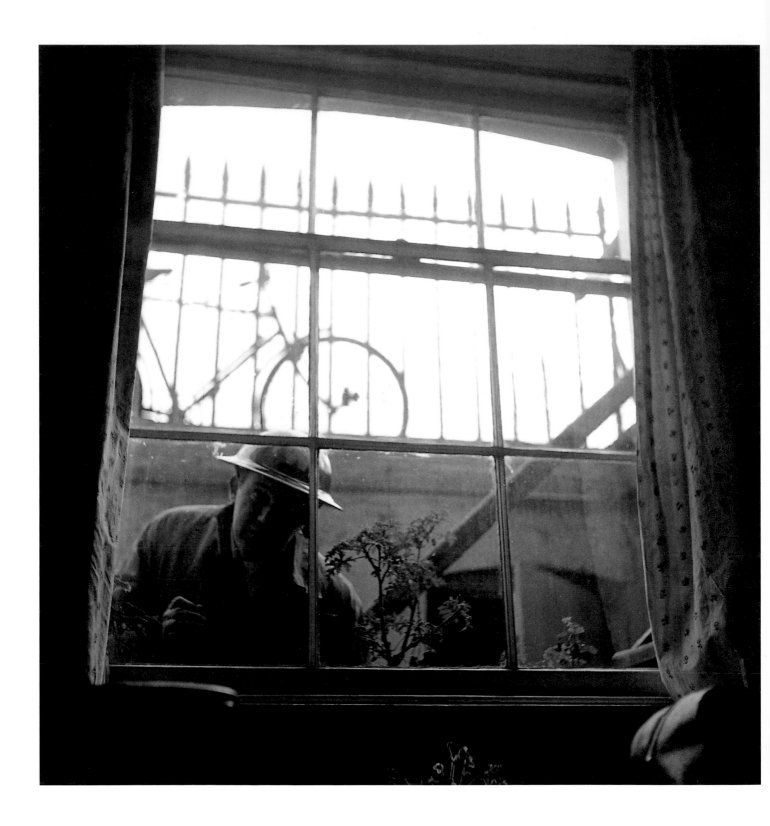

Freddie Mayor, Hampstead, London, 1940

This was one of twenty-two photographs by Miller published in the book *Grim Glory: Pictures of Britain Under Fire* (1941), edited by Ernestine Carter and with a preface by the veteran broadcaster Ed Murrow. Miller's images of London in the Blitz combine the best of documentary reporting with a wry surrealist streak. Freddie Mayor, the founder of the Mayor Gallery in London which specialized in contemporary art, was a friend of Penrose and lived in the latter's house in Hampstead at the beginning of the war. Both men were air-raid wardens during the Blitz.

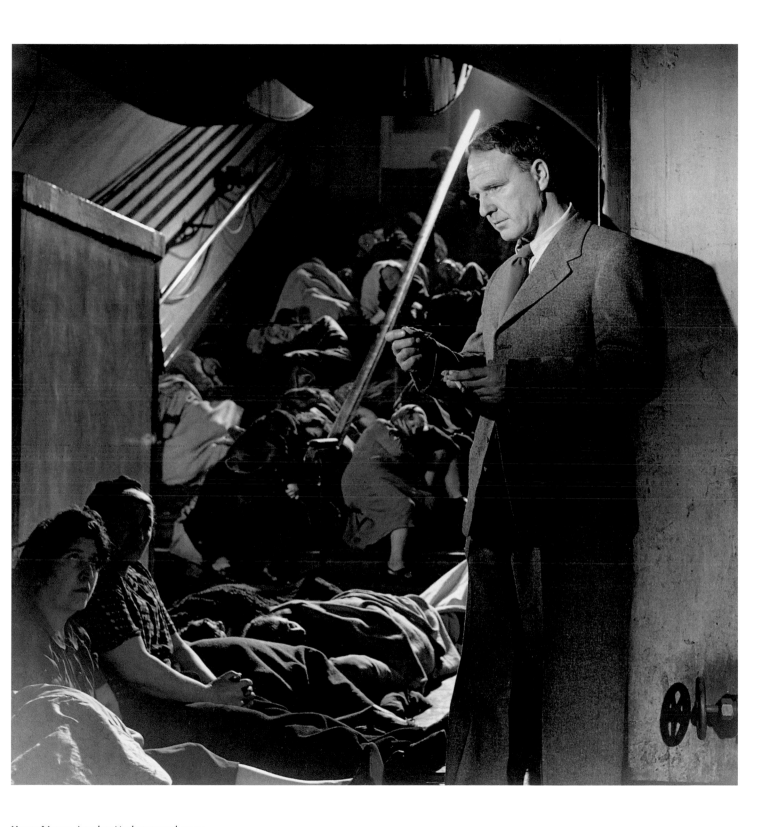

Henry Moore, London Underground, 1943
In 1940–41 the sculptor Henry Moore made numerous
drawings of civilians sheltering from German air-raids in
the London Underground at night. This scene at Holborn
Station is a reconstruction, made two years after the Blitz
had ended, for the documentary *Out of Chaos*, directed

and scripted by Jill Craigie, about Official War Artists.
Miller also photographed other artists, including Graham
Sutherland, being filmed by Craigie for an article which
appeared in *Vogue* in February 1944.

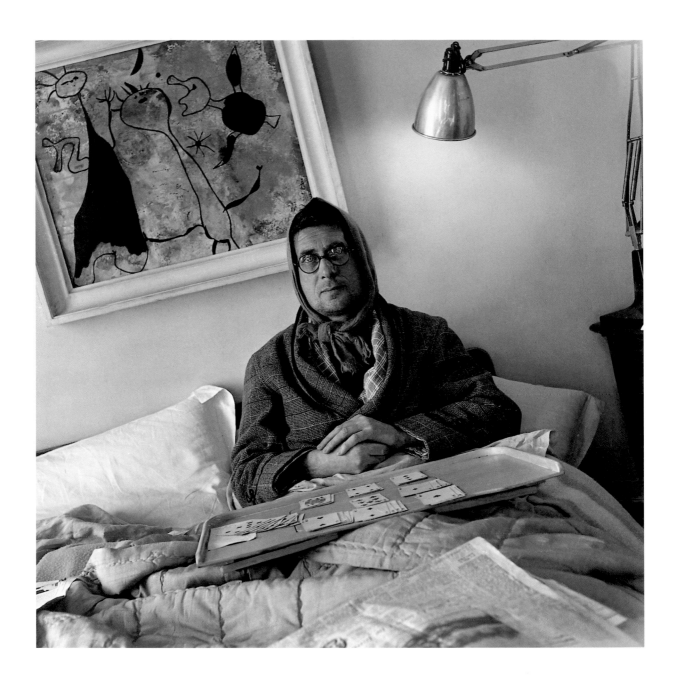

{above} **Roland Penrose,** Hampstead, London, 1942
Penrose, who had contracted mumps, is seen here in
bed at his house in Downshire Hill, a 1930s Miró from
his collection on the wall behind. Penrose had been
appointed a lecturer in camouflage to the Home Guard
in 1940; the following year his *Home Guard Manual*
of Camouflage was published. In 1943 he was commissioned
in the army as a Captain and posted to the Eastern
Command Camouflage School at Norwich.

{opposite} **Bob Hope,** London, 1943
Miller took this photograph of the American comedian
at 'The Met' theatre in London's Edgware Road, where
he was appearing with the French actor Adolphe Menjou.
Another of Miller's photographs of Hope was used
in the September 1944 issue of *Vogue.*

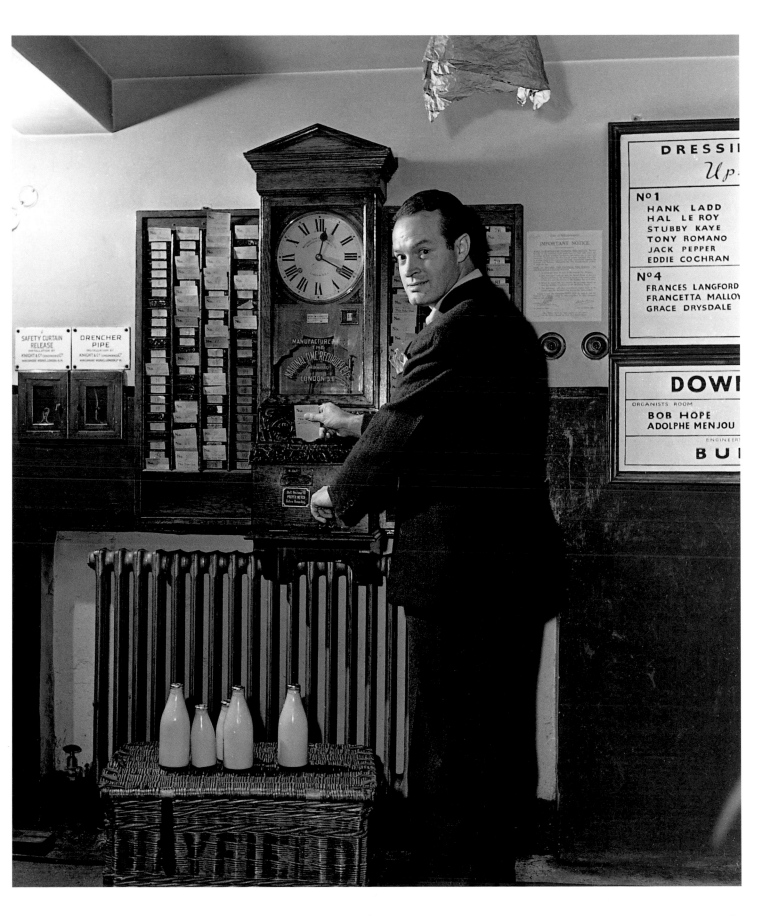

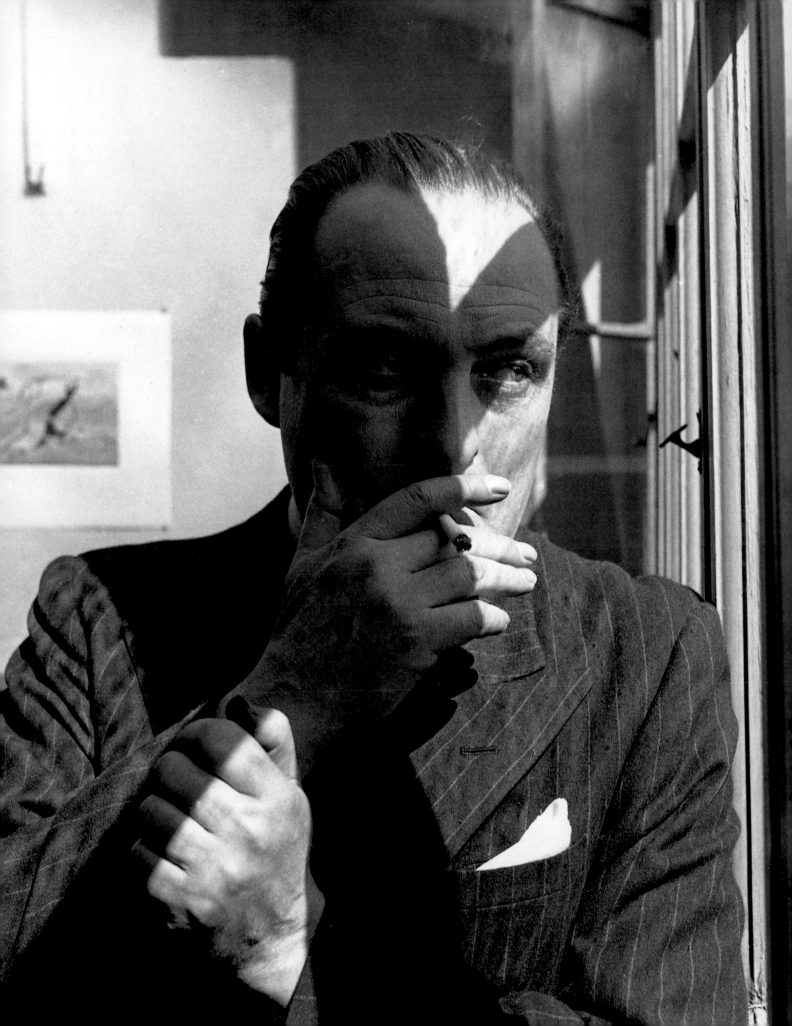

{opposite} **Hein Heckroth,** Cambridge, 1942
The set and costume designer Hein Heckroth emigrated to Britain from Germany in 1935. Heckroth's name is inextricably linked with the Ballets Jooss which transferred from Germany to Dartington Hall, Devon. Heckroth was interned as an 'enemy alien' in 1940. After his release,

he resumed working for Kurt Jooss. Miller photographed Heckroth at the Arts Theatre, Cambridge in April 1942, on his set for the ballet In Wonderland. After the war, Heckroth won an Oscar for his designs for the Powell-Pressburger film The Red Shoes (1948), starring Moira Shearer.

{above} **Humphrey Jennings,** London, 1944
Jennings, an outstanding documentary filmmaker, took part in the International Surrealist Exhibition organised by Penrose in 1936. When Miller photographed him for the April 1944 issue of Vogue, Jennings was directing The True Story of Lili Marlene on location in Wapping.

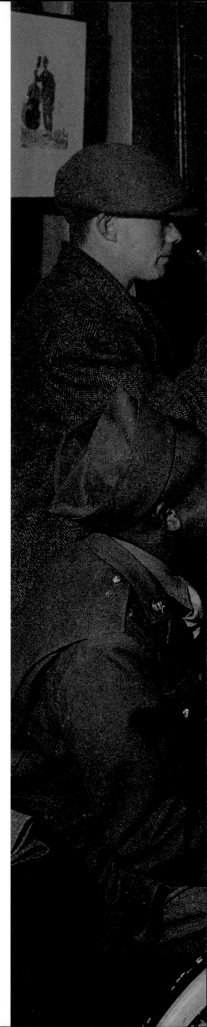

{above} **Ed Murrow,** London, 1944

The American Edward R. ('Ed') Murrow was head of CBS in Europe and a tireless broadcaster from London throughout the war. He was the subject of Miller's second article for British *Vogue* (August 1944). 'Ed Murrow is literally tall, dark and handsome,' she wrote, '...he doesn't laugh very much and he doesn't interrupt people with wisecracks, but I've watched him smile. It starts at the back of his neck and creeps up over his scalp until first his eyes smile and then his mouth, and there's nothing sluggish or gloomy about that.' The embroidered waistcoat hanging over the back of the chair was picked up in Bulgaria on Murrow's pre-war travels in Europe.

{opposite} **Giles,** Suffolk, 1944

Carl Giles – the cartoonist Giles – creator of Ernie, Grandma and other inimitable characters, was the subject of a profile in the August 1944 issue of *Vogue*. At the time Giles was making animated cartoon films for the Ministry of Information at his studio near Ipswich in Suffolk. Miller photographed him playing the piano in a jam session with black American GIs in his local pub.

{above} **S. W. Hayter,** London, 1940
Stanley William Hayter, an influential printmaker and
member of the English Surrealists, set up the Industrial
Camouflage Research Unit with Penrose and other artists
to advise on the camouflage of buildings. Hayter is seen
here working on a camouflage model in his London studio.

{right} **Kenneth Clark,** London, 1942
Miller photographed Sir Kenneth Clark in his office at the
National Gallery, where he was Director from 1934 to 1945.
Clark was chairman of the War Artists' Advisory Committee
which commissioned Paul Nash, Stanley Spencer, Henry
Moore and others to record aspects of the war in Britain.

70

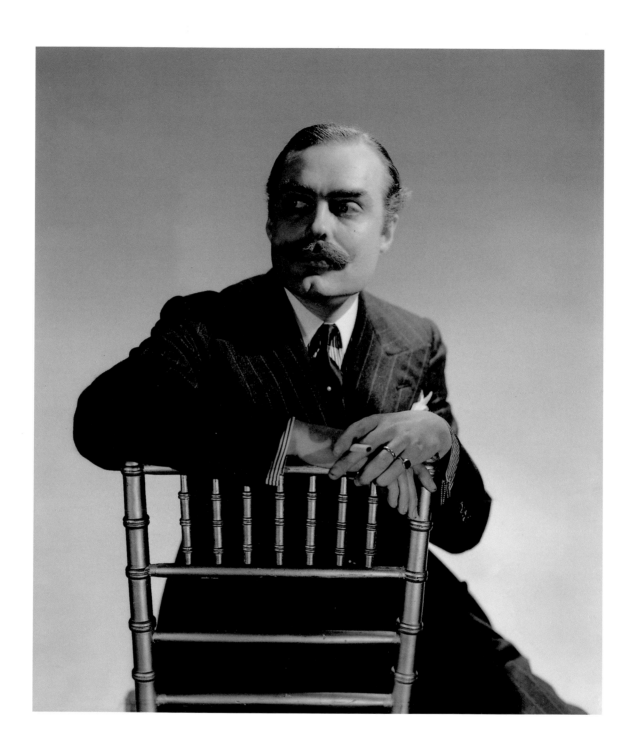

{*above*} **Osbert Lancaster,** London, 1940
Lancaster was known for his witty pocket cartoons in the *Daily Express* featuring the English upper classes and their resistance to social change, epitomized by characters such as Maudie Littlehampton. He also produced a series of satirical books on architectural and decorative taste.

{*opposite*} **Ivy Compton-Burnett,** London, 1943
'She has become a cult,' noted *Vogue*'s 'Spotlight' column, for which Miller took this photograph of the fifty-nine-year-old novelist. 'The viper of her wit lurks in the foliage of her style. Amid the rich mahogany and mutton of an English domestic interior (which she infers but never describes) large disagreeable families exchange formalities with the nicety and malicious calculation of diplomats. Behind the facade, violent and impolite occurrences animate the scene.... She is small, pin-neat, vital...works on her embroidery, and offers an appearance of domestic placidity.'

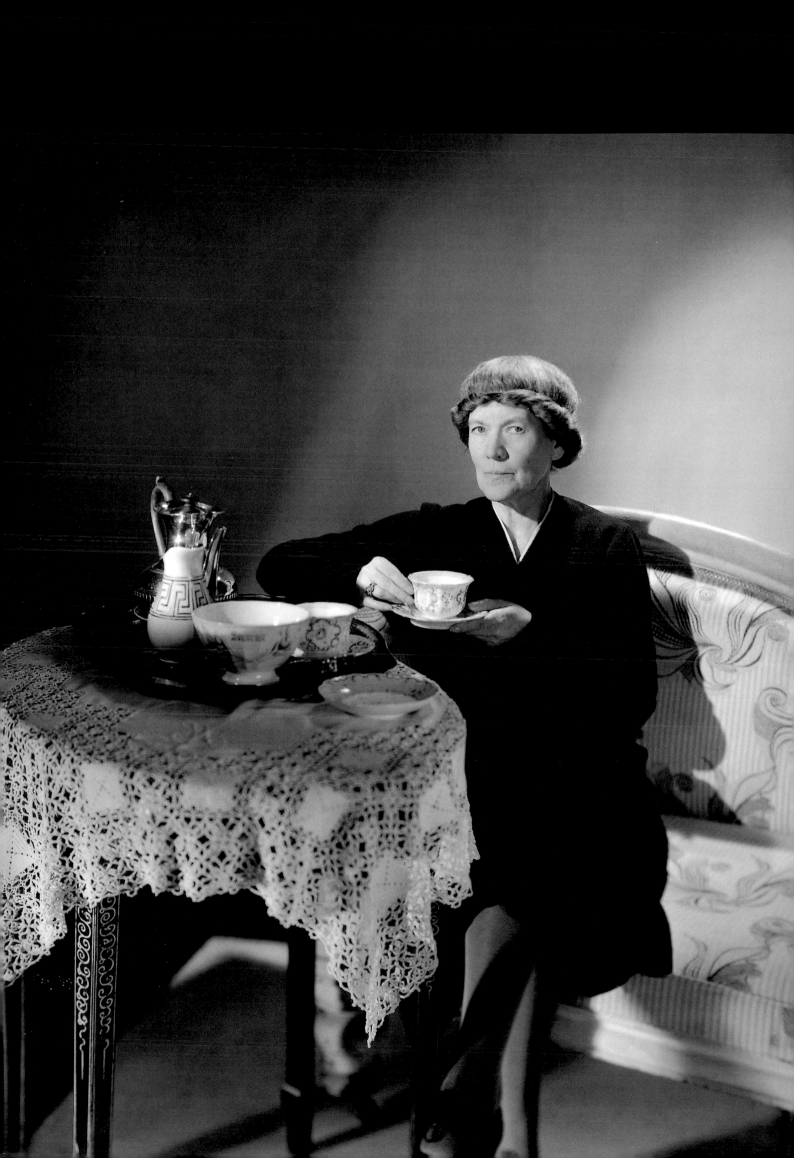

Valentine Penrose, Hampstead, London, 1940
Penrose's first wife, the French surrealist poet Valentine
Boué, was stranded in London at the outbreak of war.
When her hotel was bombed she moved in with Penrose
and Miller at 21 Downshire Hill, and remained there until
the end of the Blitz.

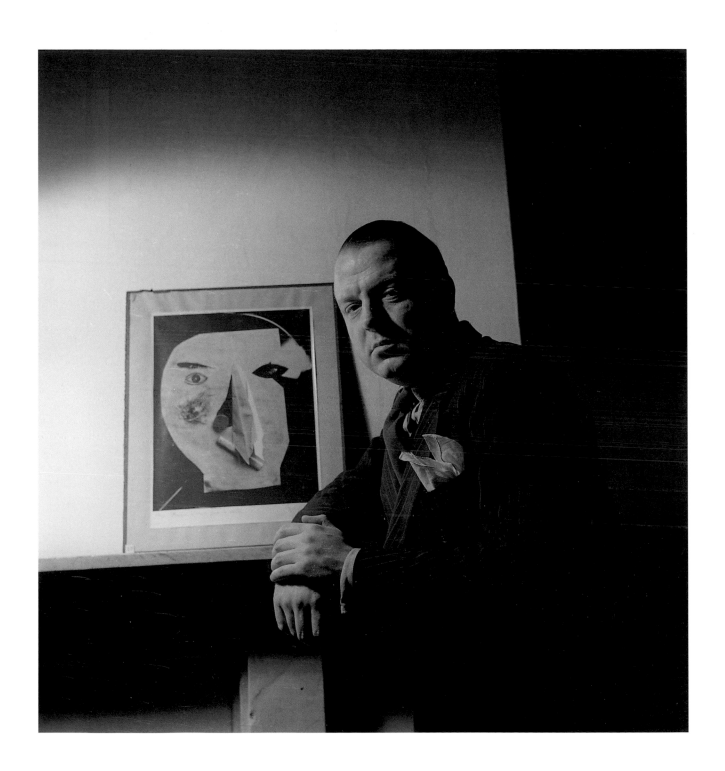

E. L. T. Mesens, Hampstead, London, 1944
Mesens, a Belgian artist, ran the London Gallery which
Penrose had bought in 1938. During the war Mesens and
his wife Sybil lived in Penrose's house in Downshire Hill
where Miller took this photograph. On the mantelpiece
is a framed photograph of one of Mesens's own collages.

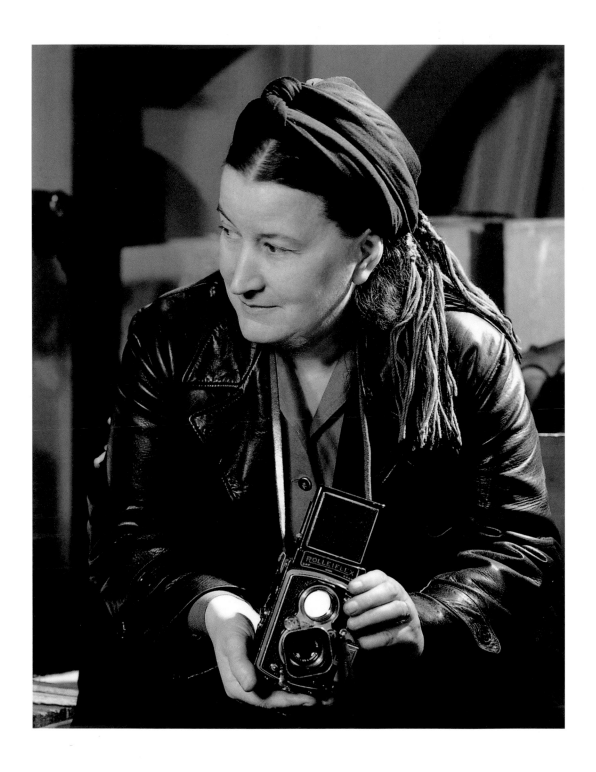

{above} **Thérèse Bonney,** London, 1942
Thérèse Bonney was an American war photographer who
had run a picture-news service in Paris before the war.
Miller photographed her at the Savoy Hotel in London,
Bonney's wartime base. In the April 1942 issue of *Vogue*,
Lesley Blanch described Bonney's appearance as follows:

'...a red flannel shirt, blue serge bloomer-culottes, long
laced-up boots, several big silver and turquoise rings...
and a knotted and tasselled monkey-cap clapped in a
downright manner on to her fine Roman head.'

{opposite} **Martha Gellhorn,** London, 1943
The leading American war correspondent Martha
Gellhorn was included in a feature on women in the news
in the March 1944 issue of *Vogue*. Gellhorn had recently
married the novelist Ernest Hemingway, snapshots of
whom are pinned to the mirror behind her.

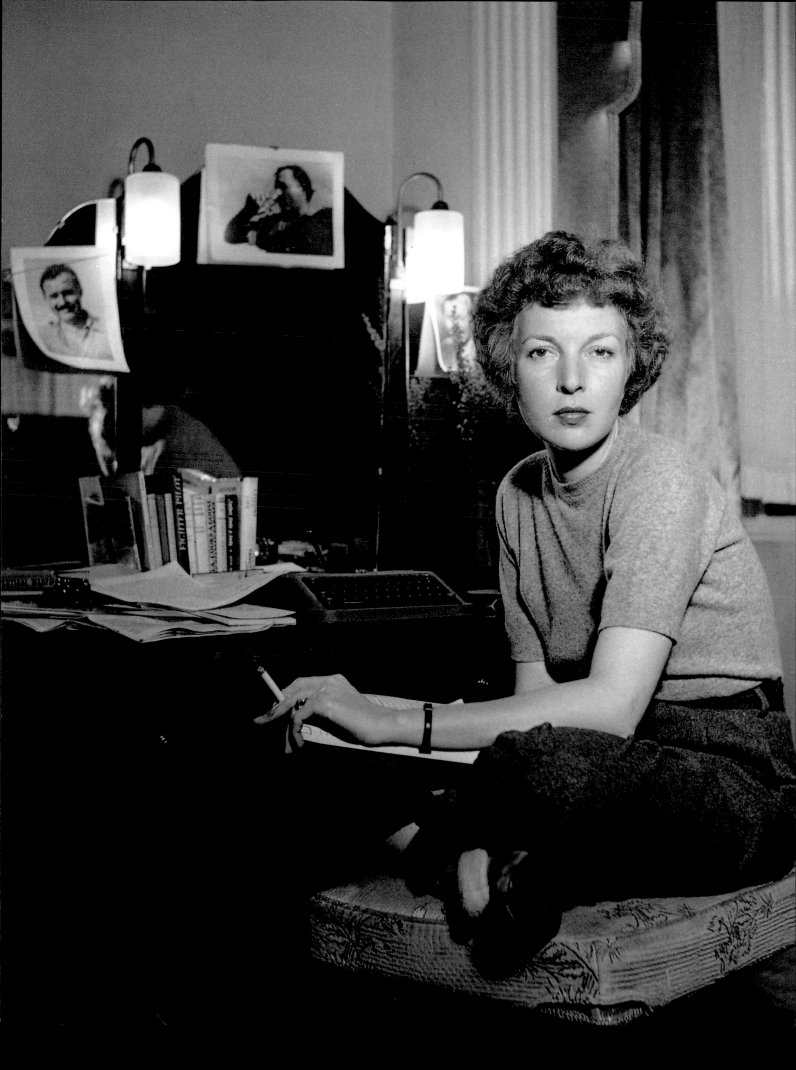

David Scherman, Hampstead, London, 1942
David E. Scherman, a young photojournalist on *Life*
magazine, met Miller in London in 1941 and soon moved
in with her and Penrose. He encouraged Miller to apply
to the US Army for accreditation as a war correspondent.
From 1942 to 1945 they often worked as team.

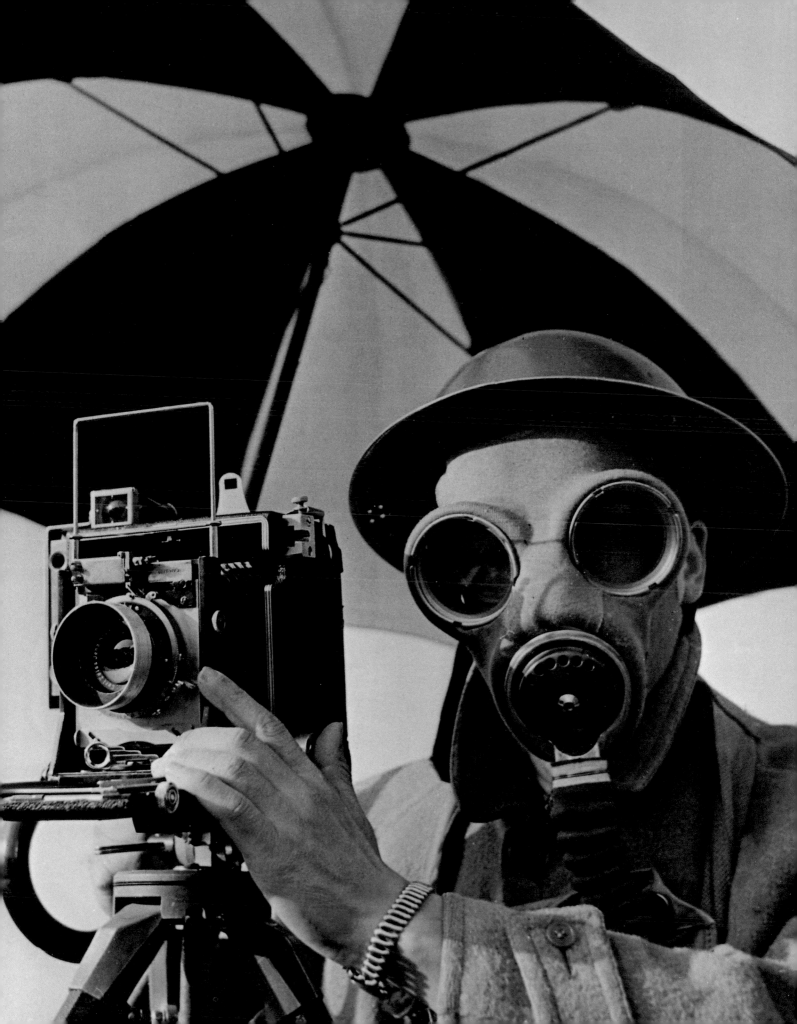

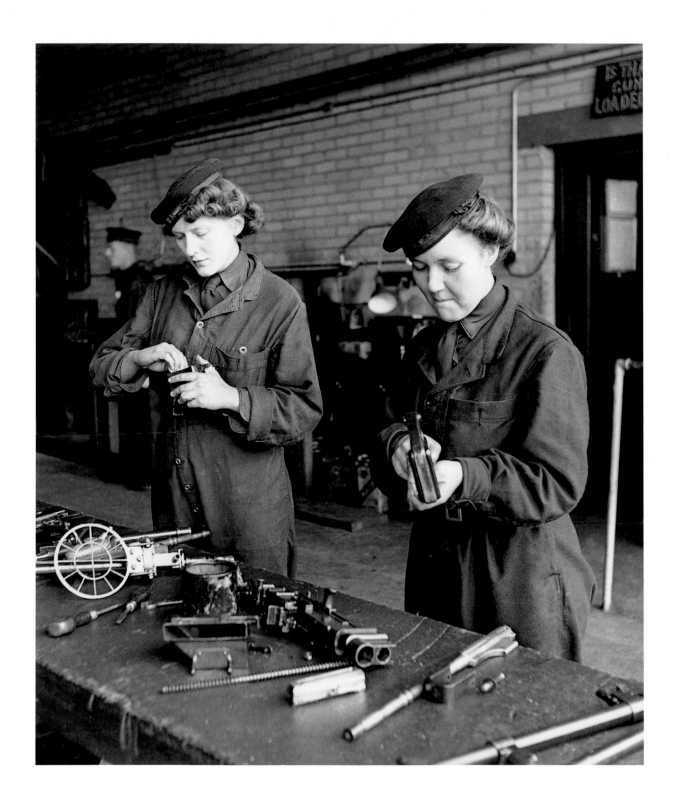

Ordnance Wrens, England, 1944
Miller's accreditation to the US Army as an official war correspondent allowed her access to restricted areas. Here she portrays Ordnance Wrens absorbed in the intricate task of servicing small arms. A similar shot was later published in Miller's book, *Wrens in Camera*.

{*opposite*} **Radio Mechanic,** England, 1944
The caption in *Wrens in Camera* reads: 'One of the most skilled jobs in the WRNS is done by the radio mechanic. Testing radio equipment in flight she needs, apart from her trained knowledge, powers of concentration and a steady nerve.'

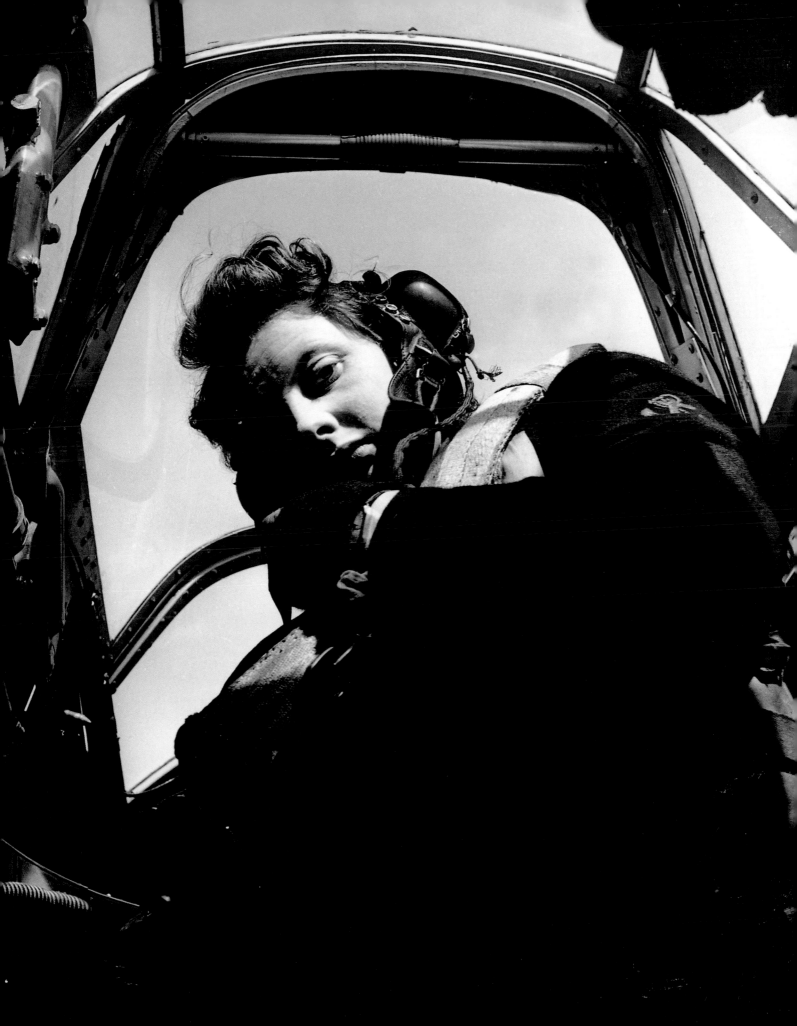

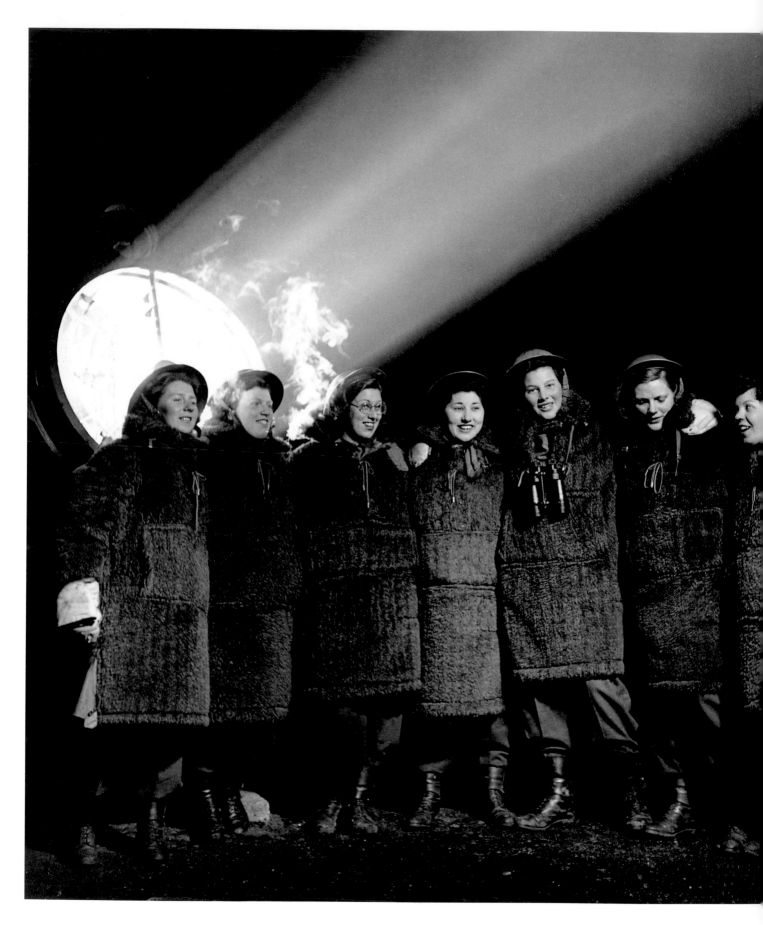

{*above*} **ATS Searchlight Operators,** North London, 1943
Miller, assisted by Scherman, photographed this ATS searchlight
crew at Hendon for a *Vogue* feature, 'Night Life Now', which also
portrayed Wrens and WAAFs working at night.

{*opposite*} **ATS Searchlight Battery,** North London, 1943
Shortly after Miller took this photograph of the searchlight
crew dressed in their 'big bear-coats', for the same *Vogue*
feature, German aircraft machine-gunned the searchlight.

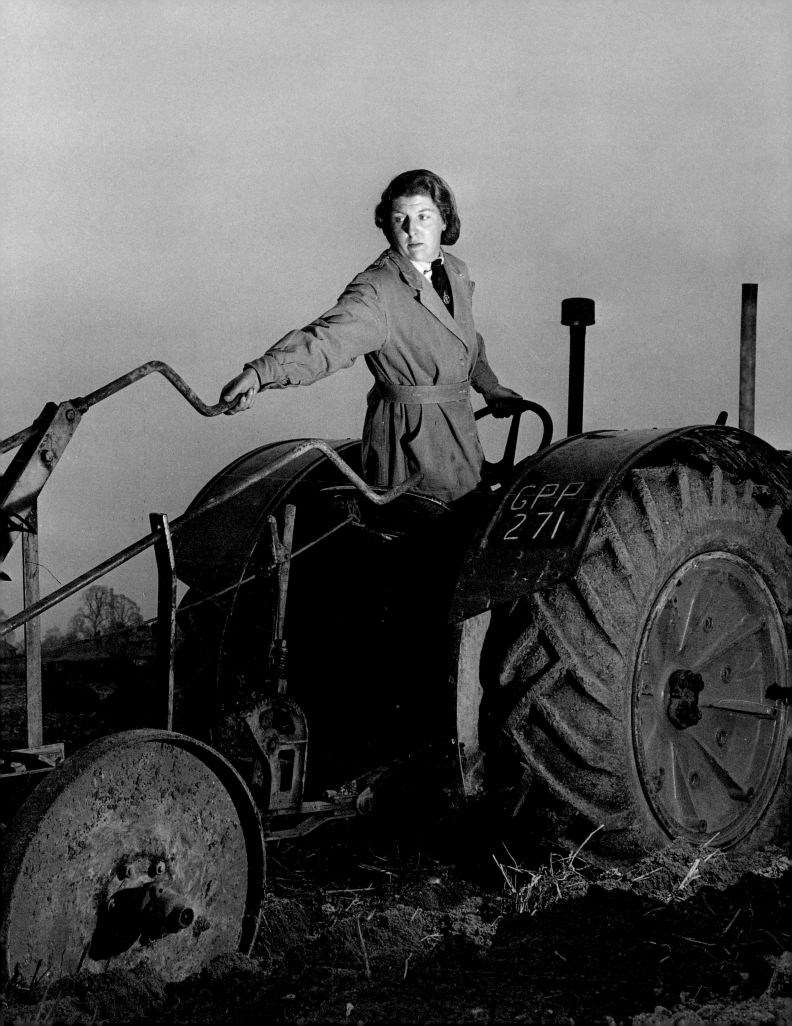

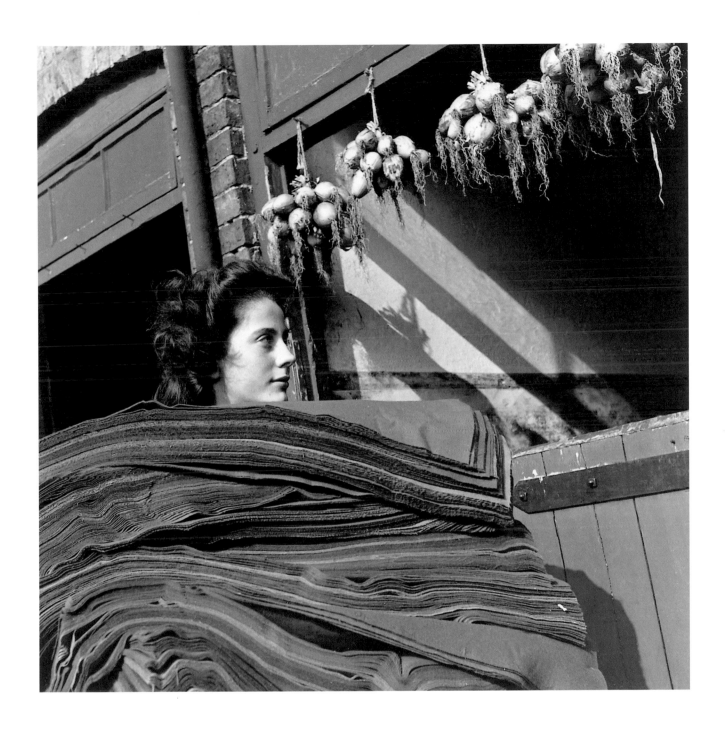

{opposite} **Land Girl Ploughing,** England, 1943
This photograph and others by Miller were reproduced in an article on land girls in *Vogue* (April 1943). 'As the seasons advance,' commented *Vogue*, 'they do a vast variety of jobs – some heavy, some light. They drive the tractor and level land behind the gyro tiller, to fill in gun pits on park land which is being broken up for the first time. They buckhead and split hedges, spread manure, transplant mangold seeds, learn and revive old trades like hand-thatching and mending harness...' Miller's subject is driving a Fordson tractor.

{above} **Textile Factory Worker,** England, 1943
The presence of a stable door and bunches of hanging onions suggest that the factory had been set up in farm buildings. The head emerging from the pile of cloth (resembling geological strata) is a typical Miller conceit.

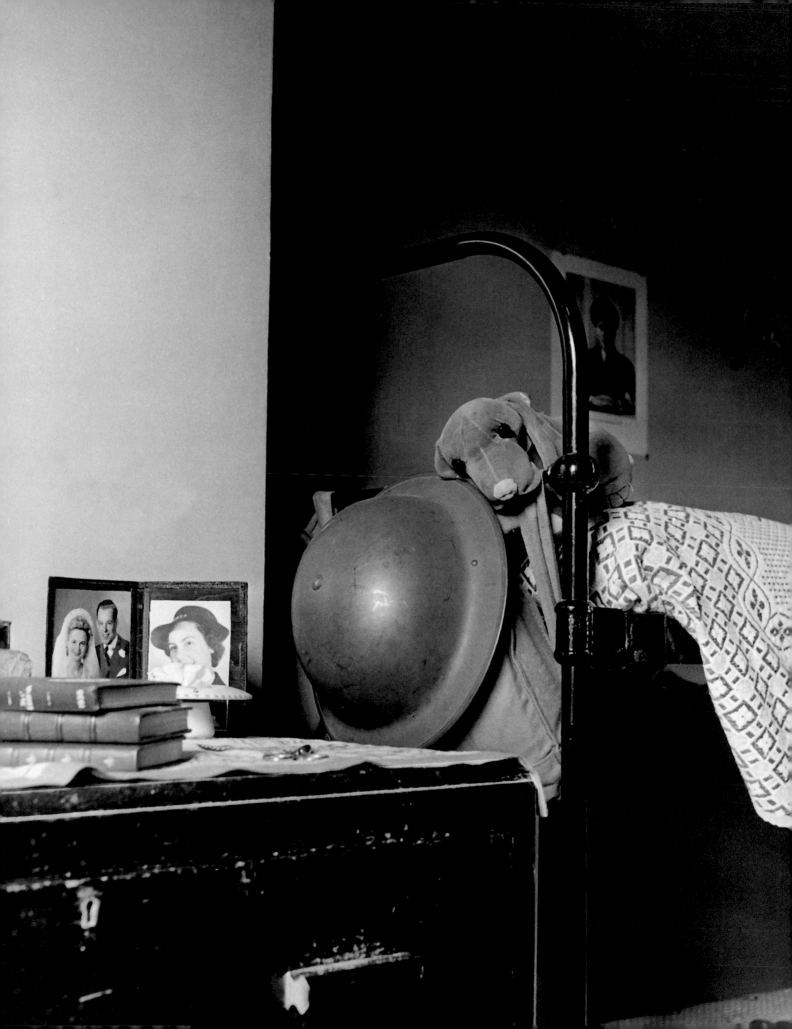

{*opposite*} **A Canadian Wren's Cabin,** London, May 1944
In focussing on personal possessions such as family
photographs, books and a soft toy animal, Miller creates
a tender portrait of an absent Wren. This photograph
was reproduced in Miller's book, *Wrens in Camera*.

{*above*} **US Army Nurses' Billet,** Oxford, 1943
Miller's first piece of published writing was a short article
on 'American Army Nurses' which appeared in *Vogue* in
May 1943, accompanied by her own photographs. The
nurses in question worked for the Presbyterian Hospital

of New York which had taken over the Churchill Hospital
in Oxford. Miller admired her compatriots for the
professional way they 'went quietly about their business
of healing and caring for the American Armed Forces'.

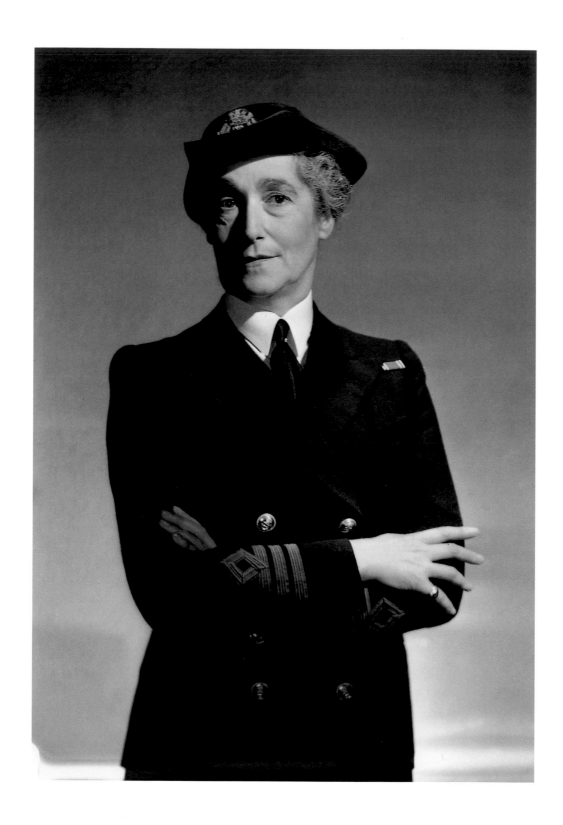

The Marchioness of Cholmondeley,
Staff Officer, WRNS, London, 1944
Sybil, Marchioness of Cholmondeley, was the sister of the
wealthy political and society host Sir Philip Sassoon, and
the wife of the Fifth Marquess of Cholmondeley. She was
Deputy Director of the Wrens.

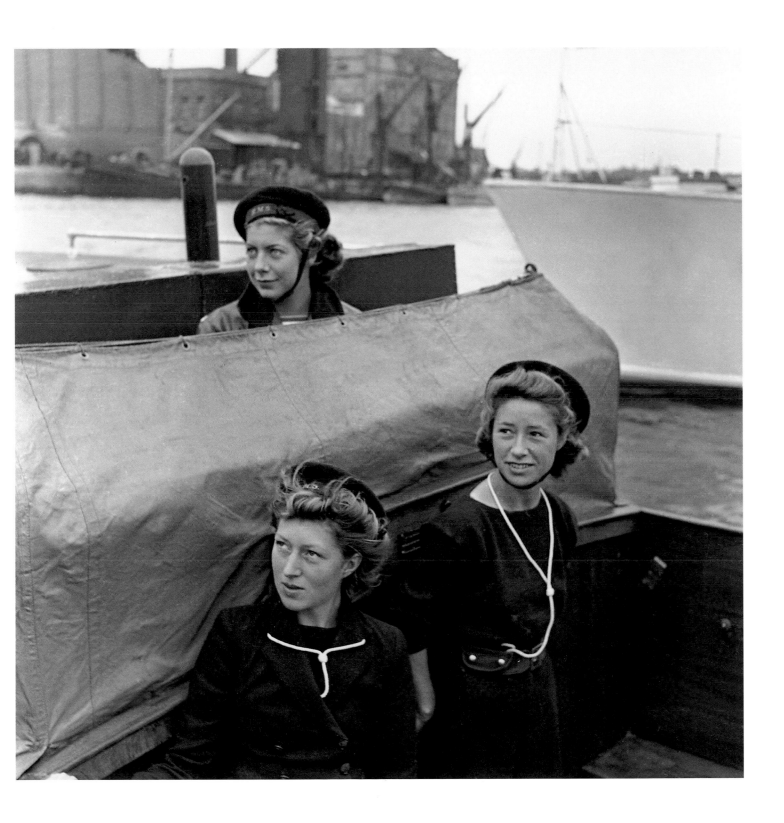

Wrens Aboard a Tender, Harwich, 1943
The Admiralty gave Miller permission to visit naval bases
in England and Scotland in order to photograph Wrens.
Miller's empathy with her young subjects creates an
unselfconscious directness that draws the viewer in.

The War in Europe

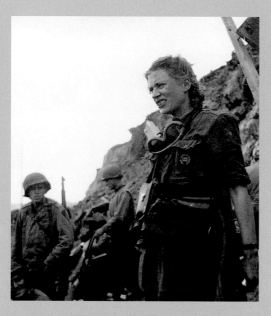

Lee Miller at the Siege of St Malo, France, August 1944
(David E. Scherman)

{*opposite*} **Female Collaborators,** Rennes, August 1944
In a letter to Audrey Withers, her editor at *Vogue*, Miller
wrote: 'In Rennes today I went to a chastisement of French
collaborators – the girls had had their hair shaved…. Later
I saw four girls being paraded down the street and raced
ahead of them to get a picture…the victims were spat on
and slapped.'

From the summer of 1944 Miller wrote nearly all the texts that accompanied her photographs in *Vogue*. One of her first, tentative attempts at writing was a profile of Ed Murrow. In July 1944, a few weeks after D-Day, she flew to Normandy to cover the heroic work of an American Evacuation Hospital. The assignment turned Miller into a serious war reporter and astonished *Vogue's* editor Audrey Withers, who called it 'the most exciting journalistic experience of my war'. Miller was largely responsible for adding a different dimension to *Vogue*'s image as a high-class fashion magazine.

For the next year Miller sent back photographs and written reports from the front as she witnessed the siege of St Malo, the Allied advance through France, the liberation of Paris, the Alsace campaign, the American-Russian meeting on the Elbe, the liberation of Buchenwald and Dachau, the battles for Cologne, Leipzig and Munich and the destruction of Hitler's mountain retreat at Berchtesgaden. With the war over she stayed on to document its difficult and often tragic after-effects in eastern Europe. Her stories were published in British and American *Vogue* from October 1944 to May 1946, sometimes two or even three in the same issue.

Miller's base for much of this period was a room in the Hôtel Scribe (the Allied press headquarters) in Paris, its chaotic appearance captured in a celebrated photograph by the *Life* magazine photographer David Scherman, who accompanied her on many of her trips. In Paris she covered the reopening of the couture houses, helped get French *Vogue* back on its feet, and went in search of her creative friends from prewar days. Miller's life-enhancing portraits of Cocteau, Picasso, Bérard, the Eluards and Aragon (and of Magritte and Delvaux in Brussels) are in stark contrast to the images that followed soon afterwards: the displaced persons, emaciated Jewish prisoners, dead Nazis and beaten-up SS guards.

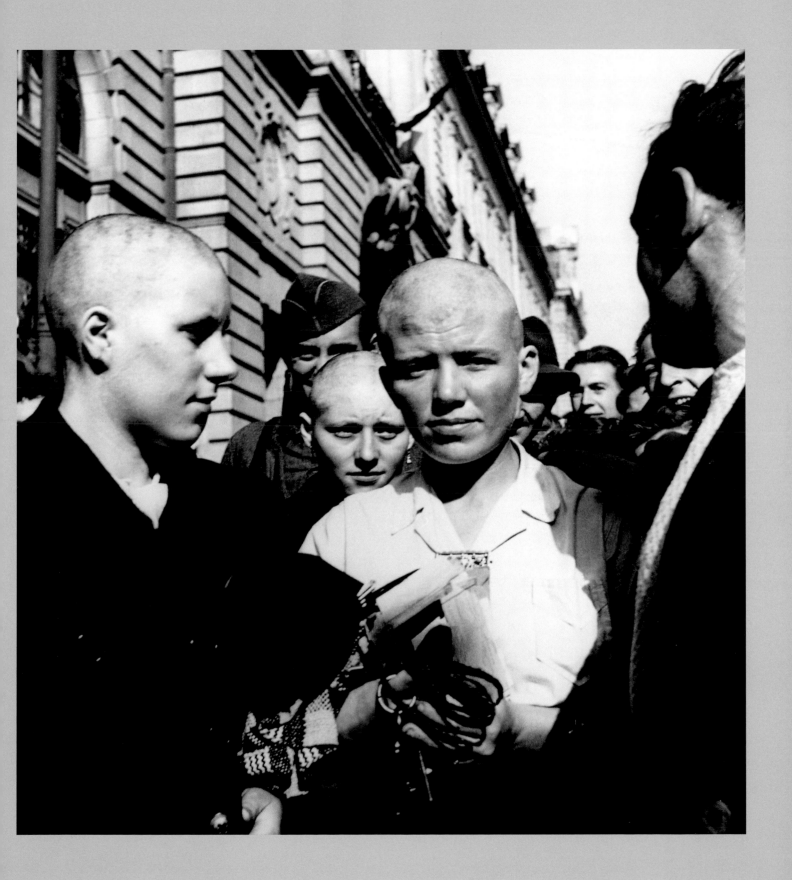

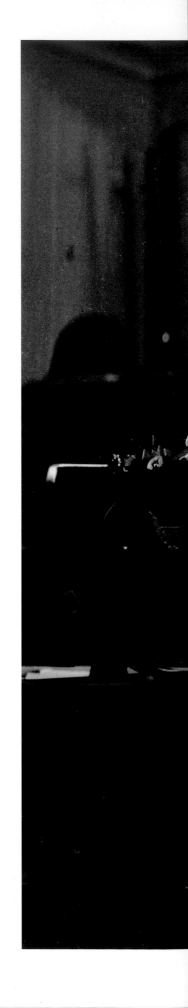

Major Speedie, St Malo, August 1944
Speedie was a battalion commander in the 329th Infantry Regiment, 83rd Division, US Army. Miller photographed him planning the final assault on the citadel at St Malo, which was heavily defended by the Germans. The siege lasted two weeks and Miller was the only journalist to witness its final days, when the Americans used napalm for the first time. Her illustrated account was published in the October 1944 issue of *Vogue*.

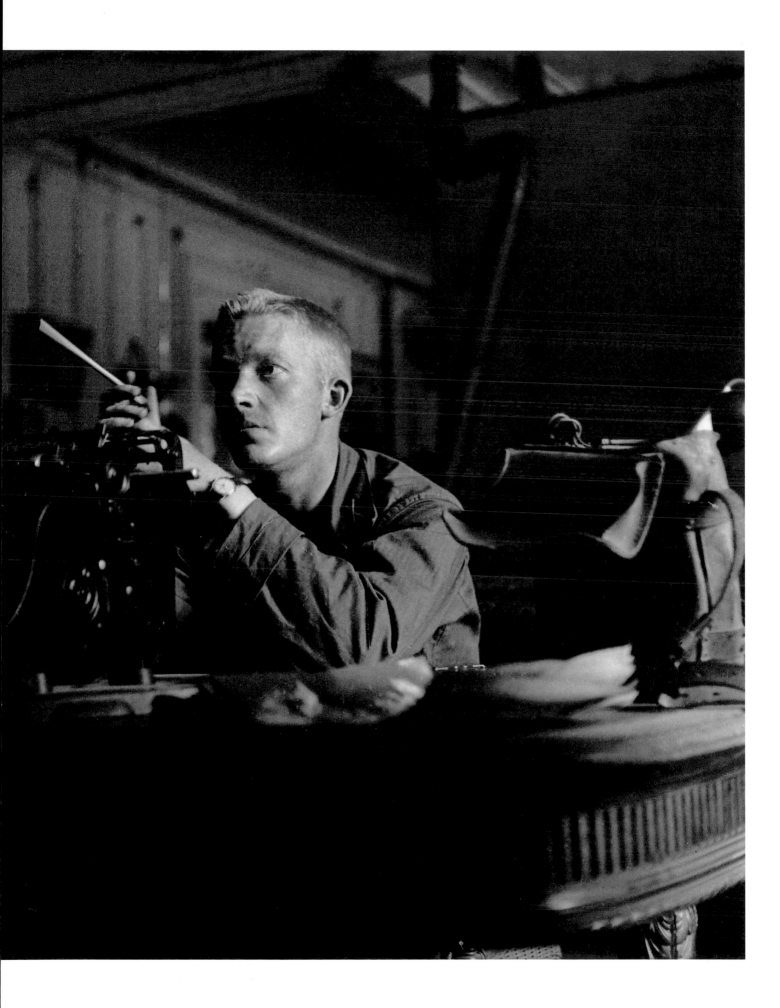

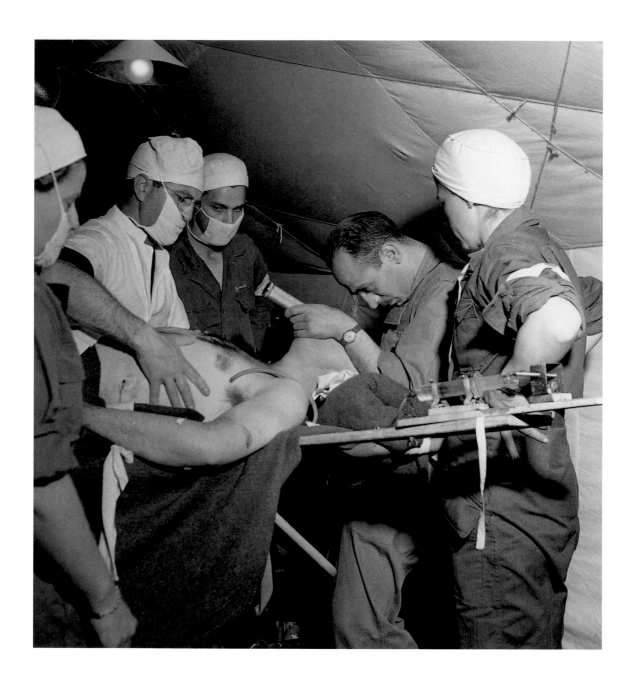

Doctor using Bronchoscope, Normandy, July 1944
Miller's first assignment in Europe as a photoreporter,
a few weeks after D-Day, was to cover the American 44th
Evacuation Hospital near Omaha Beach in Normandy.
This was one of twelve photographs that accompanied
her article, 'Unarmed Warriors', in *Vogue* (September 1944).

{*opposite*} **Nurse Exhausted after Long Shift,**
Normandy, July 1944
Miller was especially impressed by the nurses of the 44th.
'A group came single file between the tent stakes loosening
their surgical whites. They washed away the sweat from all
night duty and fell on their cots, dead beat.'

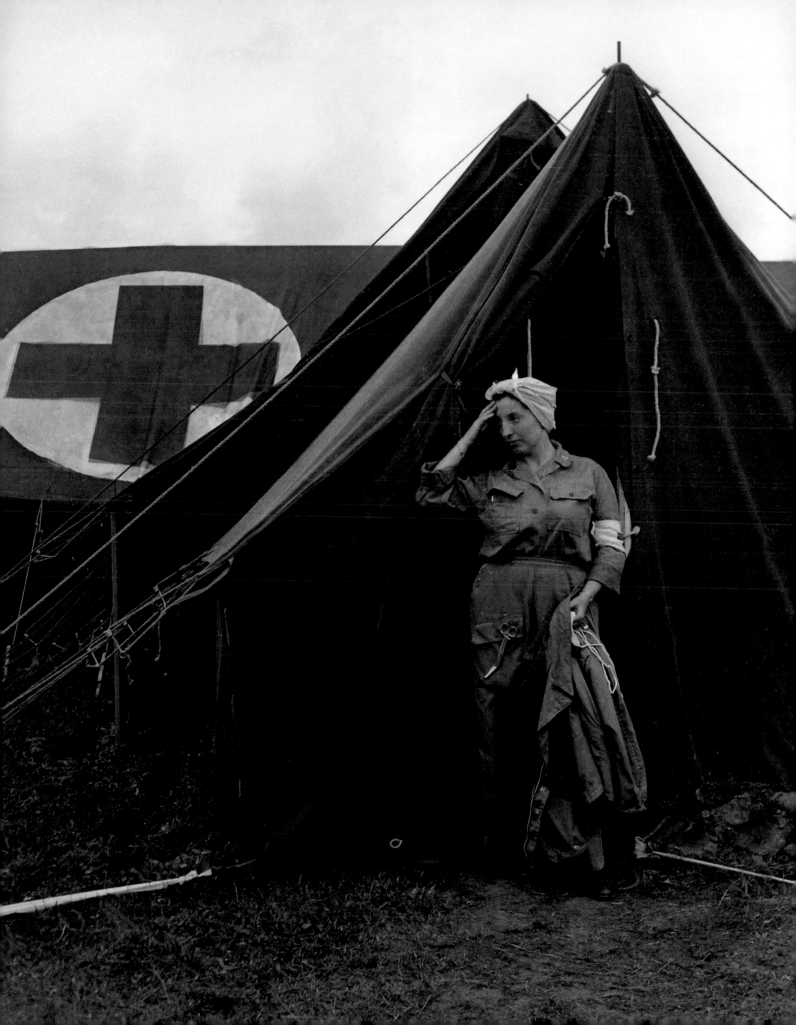

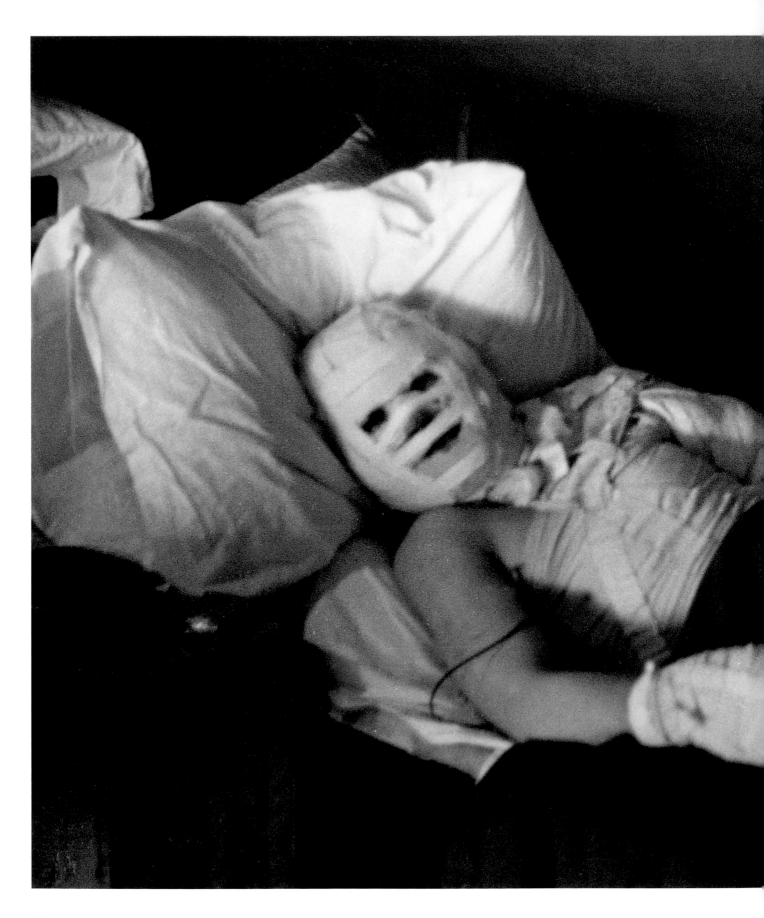

Bad Burns Case, Normandy, July 1944
'A bad burns case asked me to take his picture as he
wanted to see how funny he looked. It was pretty grim
and I didn't focus good.' The man later died.

Jean Cocteau, Paris, September 1944

Miller was probably the first woman war photographer to enter Paris, arriving with the American troops on Liberation Day, 25 August 1944. Over the next few weeks she went in search of her artist friends from before the war. She photographed Cocteau in the colonnade of the Palais Royal. 'We fell into each other's arms,' she wrote. 'He's looking incredibly well, and younger than I thought possible....'

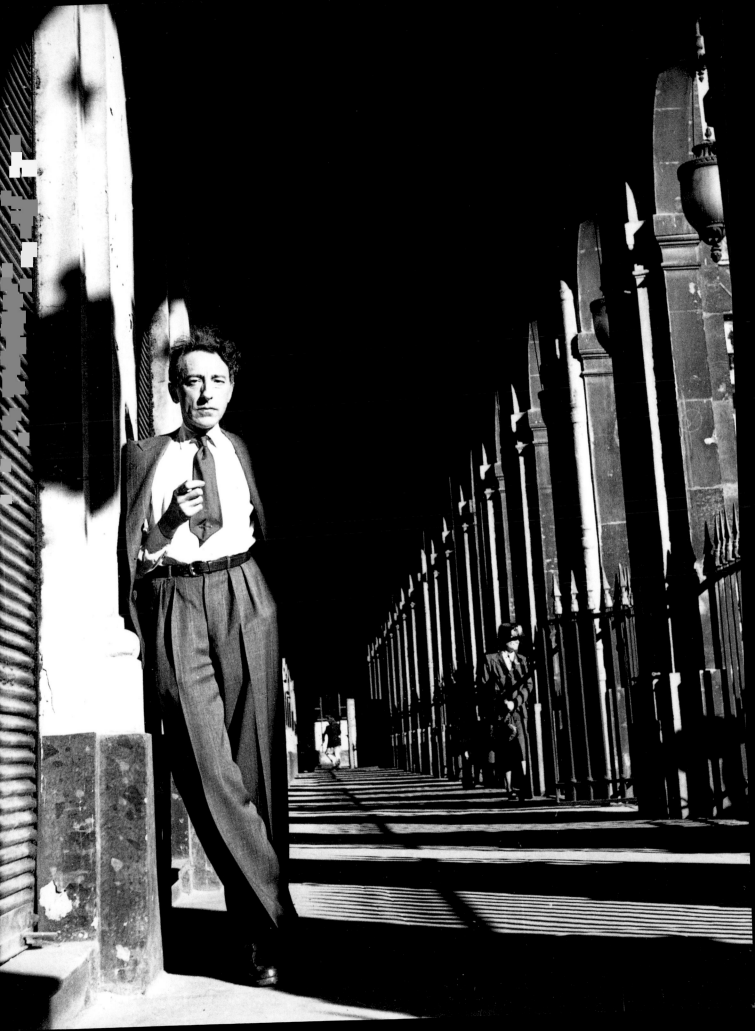

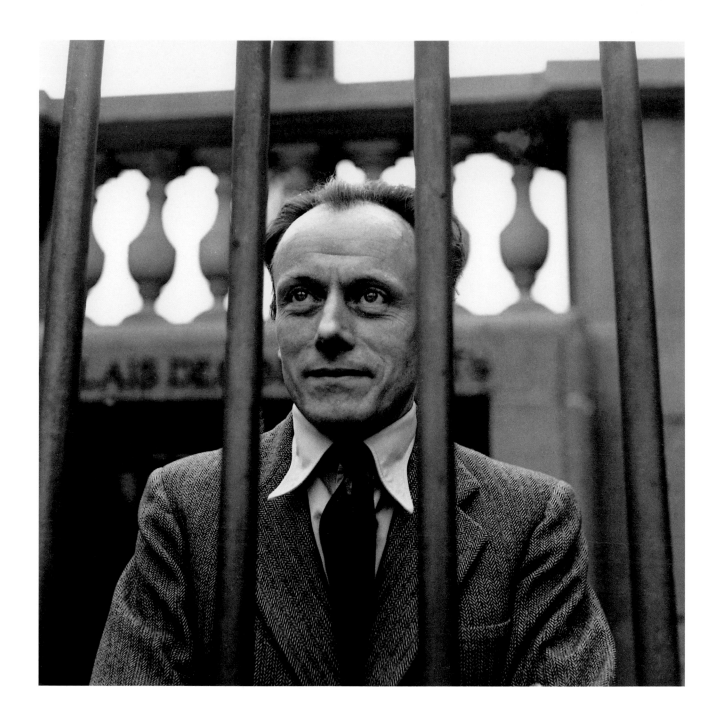

{*above*} **Paul Delvaux,** Brussels, November 1944
In November 1944 Miller spent a few days in liberated
Brussels, where, she wrote later in *Vogue*, she found her
'favourite Modern Belgian painters', including Delvaux,
in good health. 'These last months of occupation and
invasion urged him to paint prisoners and skeletons.'

{*opposite*} **Fred Astaire,** Paris, September 1944
Astaire danced at the first show for the American troops
in Paris after the Liberation, at the Théâtre Olympia.
'All Paris had been talking of nothing else for a week...
and wanting to see him...[he] showed the minimum
of irritability that his theatre call was hours too early.'

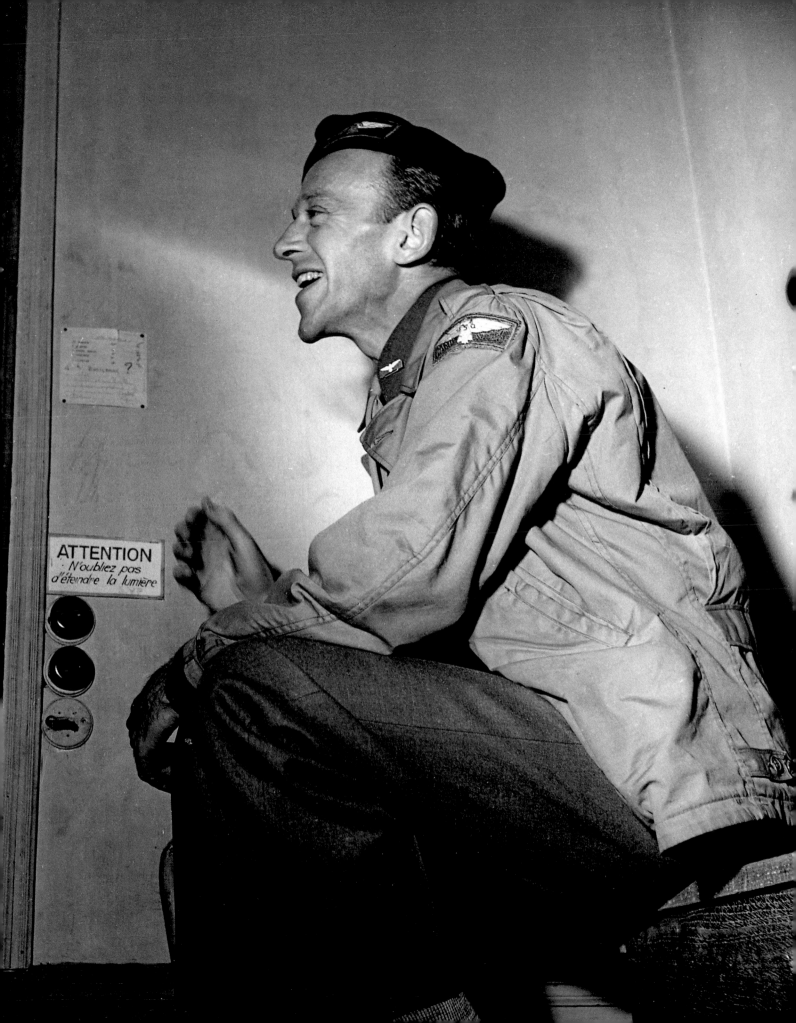

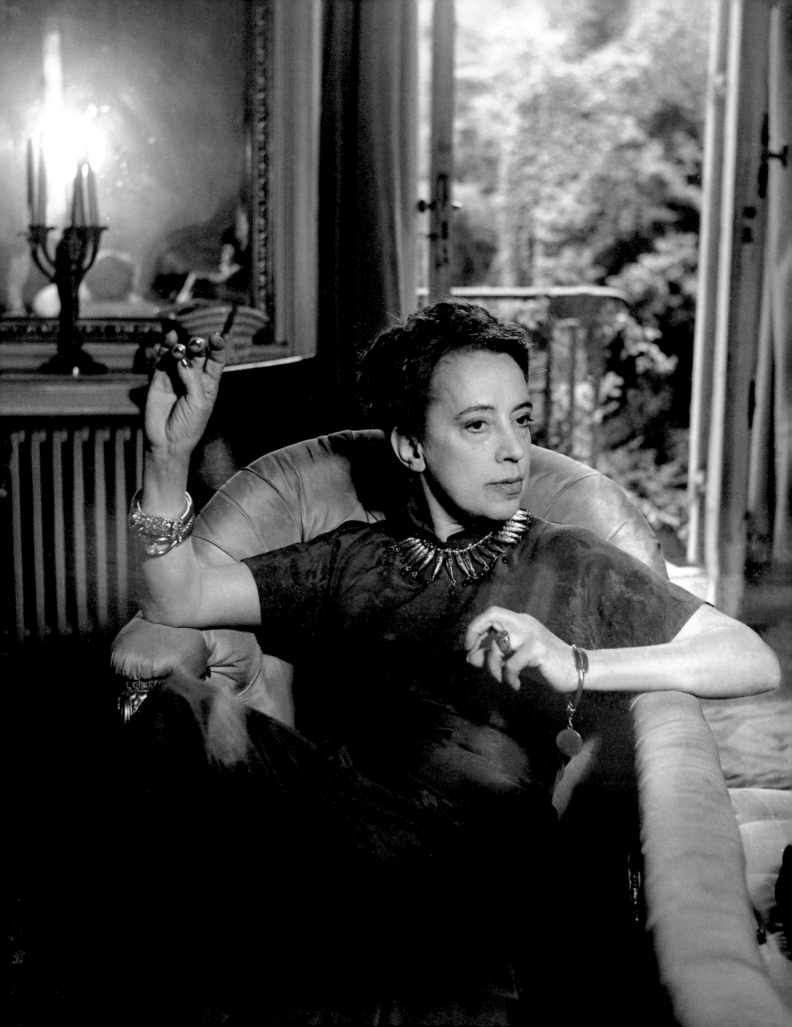

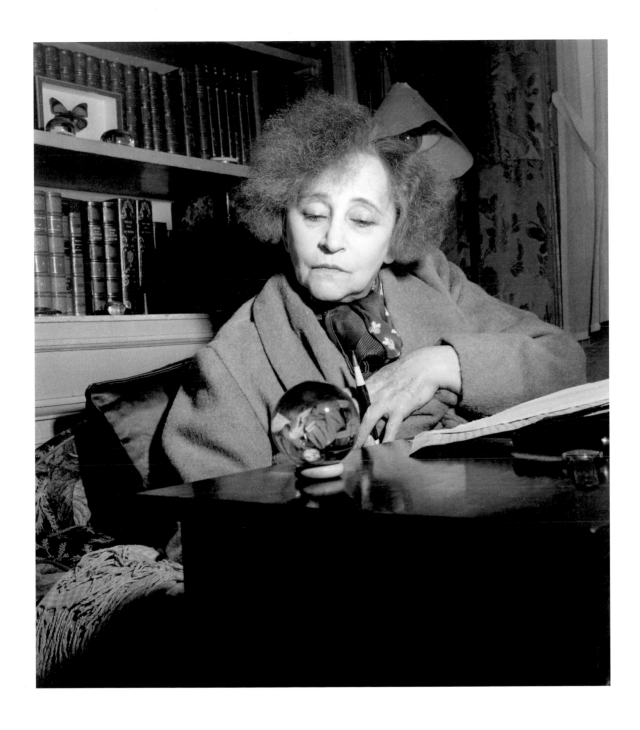

{*opposite*} **Elsa Schiaparelli,** Paris, August 1945
One of Miller's assignments for *Vogue* was to document the recovery of the Paris fashion industry. Before the war the Italian-born Schiaparelli, a designer strongly influenced by Surrealism, had given work to Miller, whose studio was in Montparnasse, Paris.

{*above*} **Colette,** Paris, November 1944
Miller called on Colette at her apartment in the Palais Royal in the winter of 1944; her profile of the seventy-one-year-old novelist was published in *Vogue* the following March. 'Against the cold light from the tall windows Colette's fuzzy hair is a halo. The room is hot, the fur coverings of her bed, tawny rich.... Her voice was gruff but her hand had been warm and her kohl-rimmed eyes matched in sparkle and clarity the myriad of crystal balls and glass bibelots which strewed the room.'

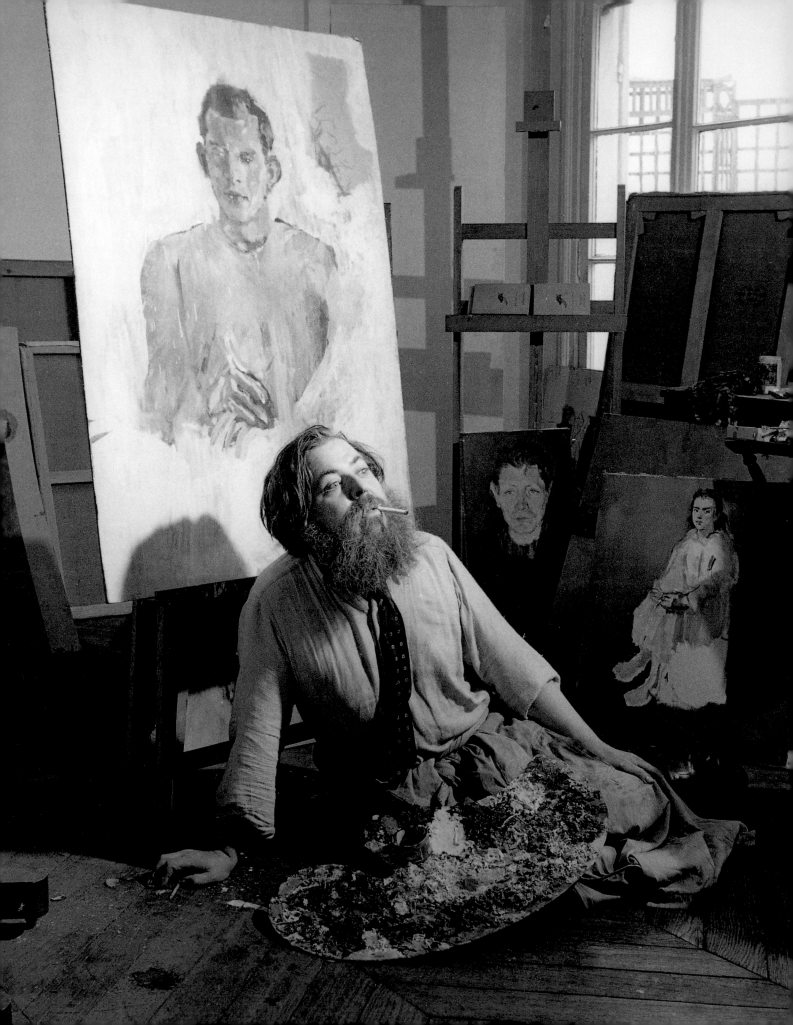

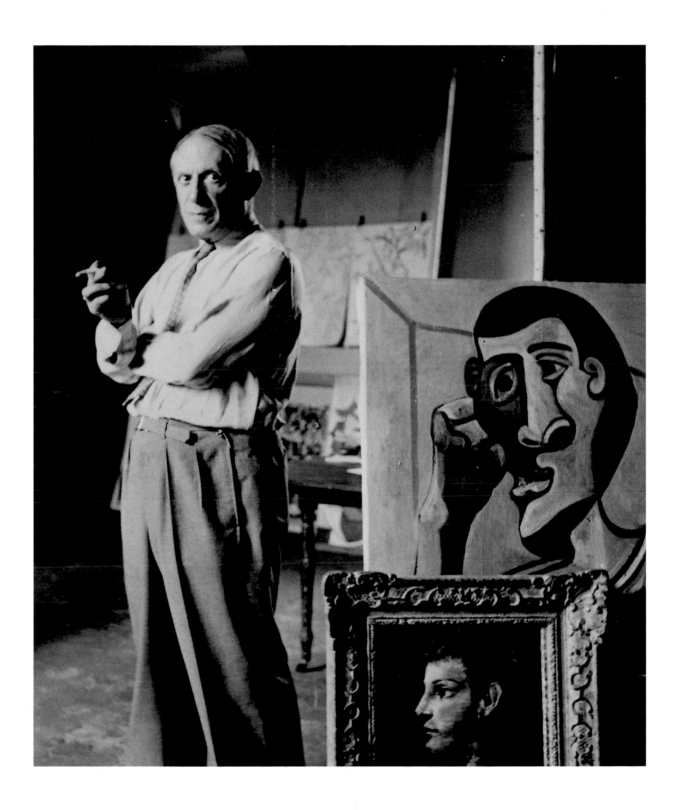

{*opposite*} **Christian Bérard,** Paris, August 1944
Christian ('Bébé') Bérard, a close friend of Cocteau
and an opium addict, was a painter known for his stage
designs as well as for his fashion illustrations in French
Vogue. He lived with the choreographer Boris Kochno
in an exotic flat near the Place de l'Odéon.

{*above*} **Picasso,** Paris, August 1944
Miller found Picasso at his studio in the rue des Grands
Augustins: 'Picasso and I fell into each other's arms
and between laughter and tears and having my bottom
pinched…we looked at new pictures which were dated
on all the Battle of Paris days.'

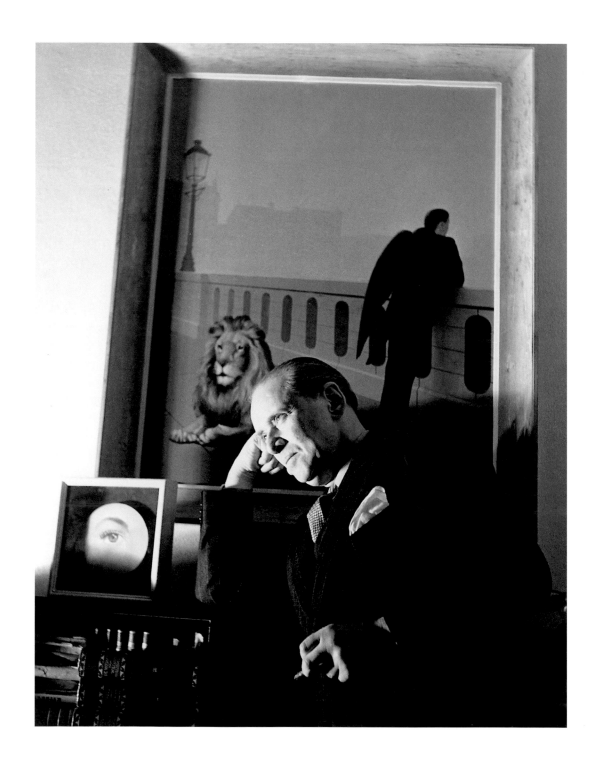

{*above*} **Paul-Gustav van Hecke,**
Brussels, November 1944
The publisher and gallery-owner van Hecke was a
collector of the Surrealists: two of Magritte's works
feature here. In the 1920s Magritte had worked for the
Brussels couture house Norine, run by van Hecke's wife.

{*opposite*} **René Magritte,** Brussels, November 1944
Miller was one of the first to document Magritte's
dramatic change of style. 'He has abandoned the dry,
stilted manner like village posters,' she wrote in *Vogue*,
'and paints now like a streaky Renoir and has a passion
for varicoloured naked ladies and mystic bouquets.'

{above} **Maurice Chevalier and Louis Aragon,**
Paris, September 1944
Chevalier, the popular singer and actor, was holding
a press conference in the flat of Louis Aragon, the
communist poet, to answer questions about his alleged
collaboration with the Nazis. Chevalier's 'crime' was

to have entertained French prisoners-of-war in Germany,
but from 1942 he had worked in the Resistance with
Aragon, who defended him. 'Chevalier looked just like
Chevalier. Blue serge suit, bow tie with irregular spots,
pale blue linen shirt and broken left index finger.'

{opposite} **Marlene Dietrich,** Paris, September 1944
During the war Dietrich made anti-Nazi broadcasts
and entertained US troops. Miller photographed her
wearing a new evening coat by Schiaparelli. 'The design
is so subtle that one hardly notices that it represents
the British lion capering among faint bluish flowers.'

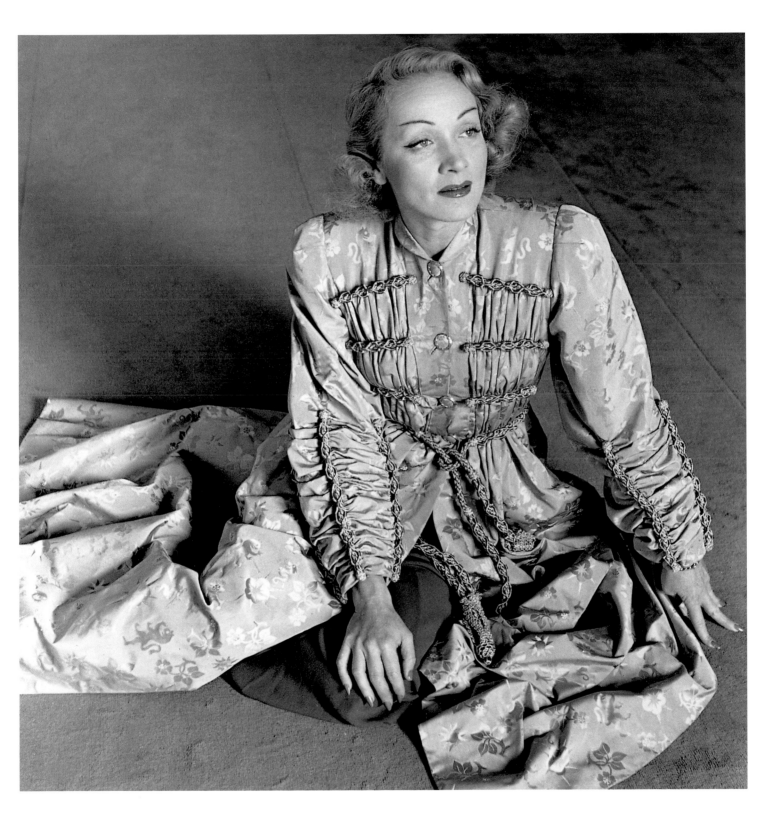

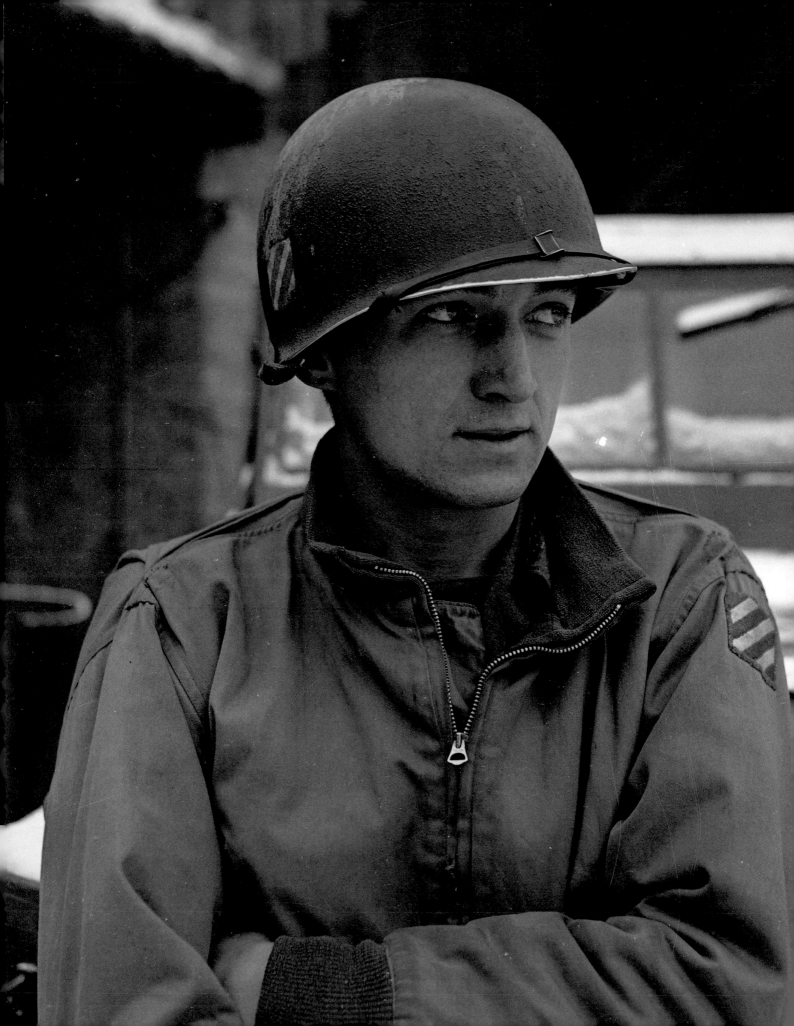

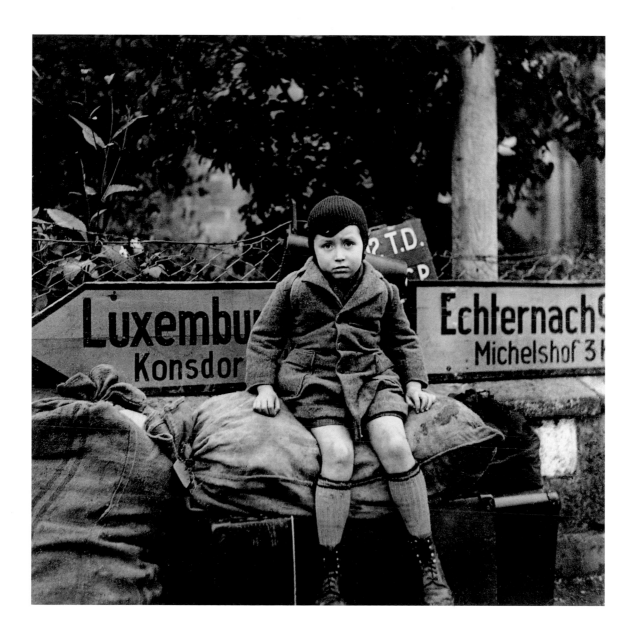

{*opposite*} **First Lieutenant Tominac,** Alsace, 1945
In early 1945 Miller spent several weeks at the bitterly cold Alsatian front, where General 'Iron Mike' O'Daniel's forces were engaged in fierce fighting with the Germans around Colmar. Tominac was an officer in the 15th Infantry Regiment of the 3rd Division, US Army.

{*above*} **Young Evacuee,**
Luxembourg-Germany Border, late 1944
Miller's first-hand experience of the liberation of Luxembourg, where she met up again with her friends from the 329th Regiment, left her with few illusions. 'The pattern of liberation is not decorative,' she wrote, '.... There is the beautiful overall colour of freedom but there is ruin and destruction.' She witnessed a stream of evacuees fleeing the fighting on the German border. 'Kids sat patiently, like bundles on the top of bundles.'

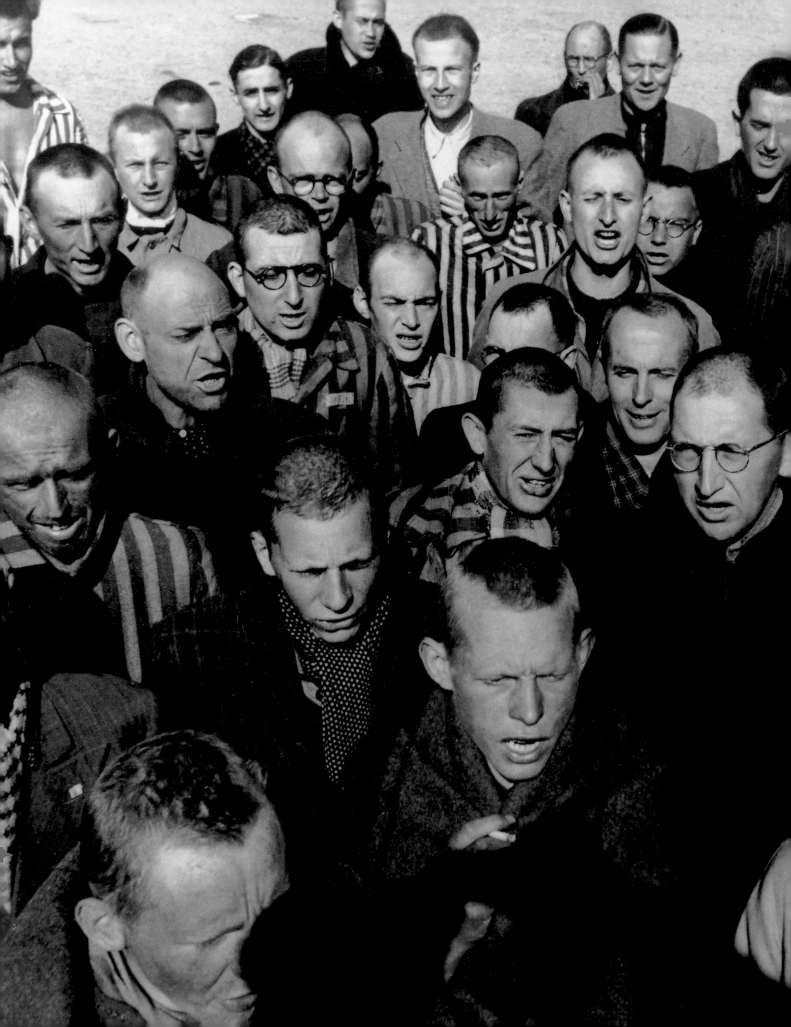

Freed Prisoners, Dachau, April 1945
Prisoners strong enough to stand await the distribution of bread, while singing hymns and national anthems. Miller and Scherman entered the concentration camp on 30 April, the day after its liberation by the 42nd and 45th Infantry Regiments of the US Army. There she took some of the most harrowing and moving photographs of her career, a number of which were published in *Vogue* under the headline 'Believe It'.

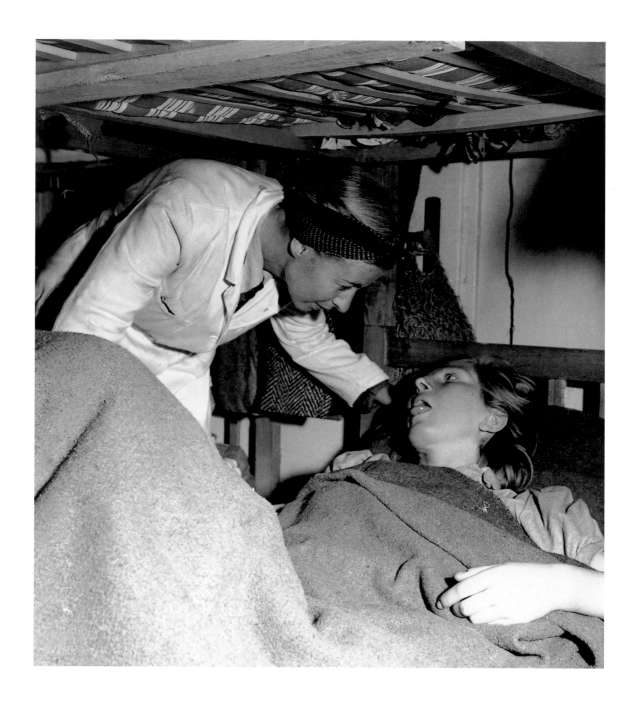

{*above*} **Dr Ella Lingens,** Dachau, April 1945
Ella Lingens, a Viennese doctor who also had a law degree
from the London School of Economics, was imprisoned in
Dachau for sheltering Jewish women. Immediately after
the camp's liberation she treated sick women, many of
them slave labourers, in the former camp brothel.

{*opposite*} **SS Prison Guard,** Buchenwald, April 1945
A fortnight before entering Dachau, Miller photographed
inmates and their former persecutors at the recently
liberated Buchenwald concentration camp near Weimar.
This SS guard in civilian disguise had been recognised by
ex-prisoners, beaten up, and brought back to the camp jail.

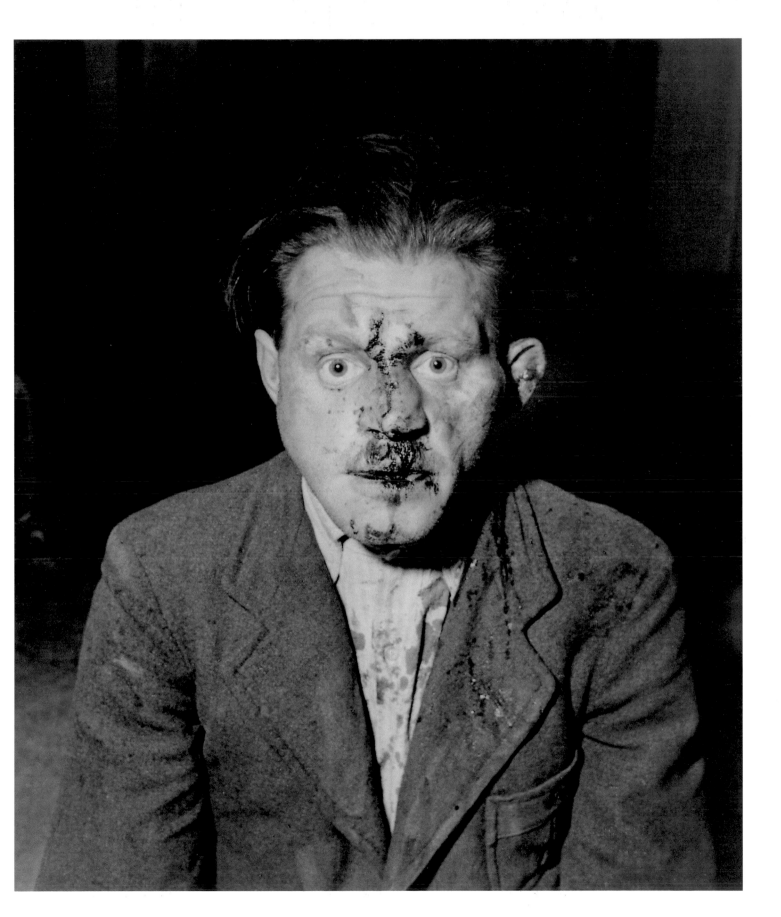

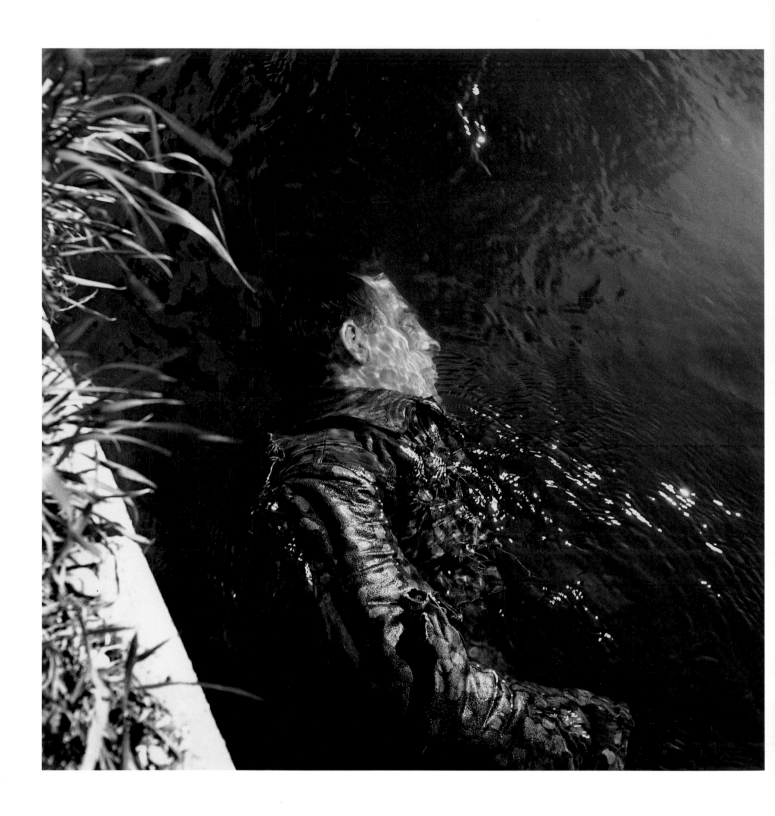

{*above*} **Murdered Prison Guard,** Dachau, April 1945
'The small canal bounding the camp was a floating mess
of SS, in their spotted camouflage suits and nail-studded
boots. They slithered along in the current, along with a
dead dog or two and smashed rifles.' The image recalls
Magritte's paintings of drowned or sleeping figures.

{*opposite*} **Nazi Suicide,** Leipzig, April 1945
Several high-ranking Nazis committed suicide as
American tanks rolled into Leipzig. In an office in the
Town Hall Miller came across the bodies of a man, woman
and girl – thought to be those of Alfred Freyburg, the
Bürgermeister, and his wife and daughter. 'Leaning back

on the sofa is a girl with extraordinarily pretty teeth,
waxen and dusty. Her nurse's uniform is sprinkled with
plaster from the battle for the city hall....'

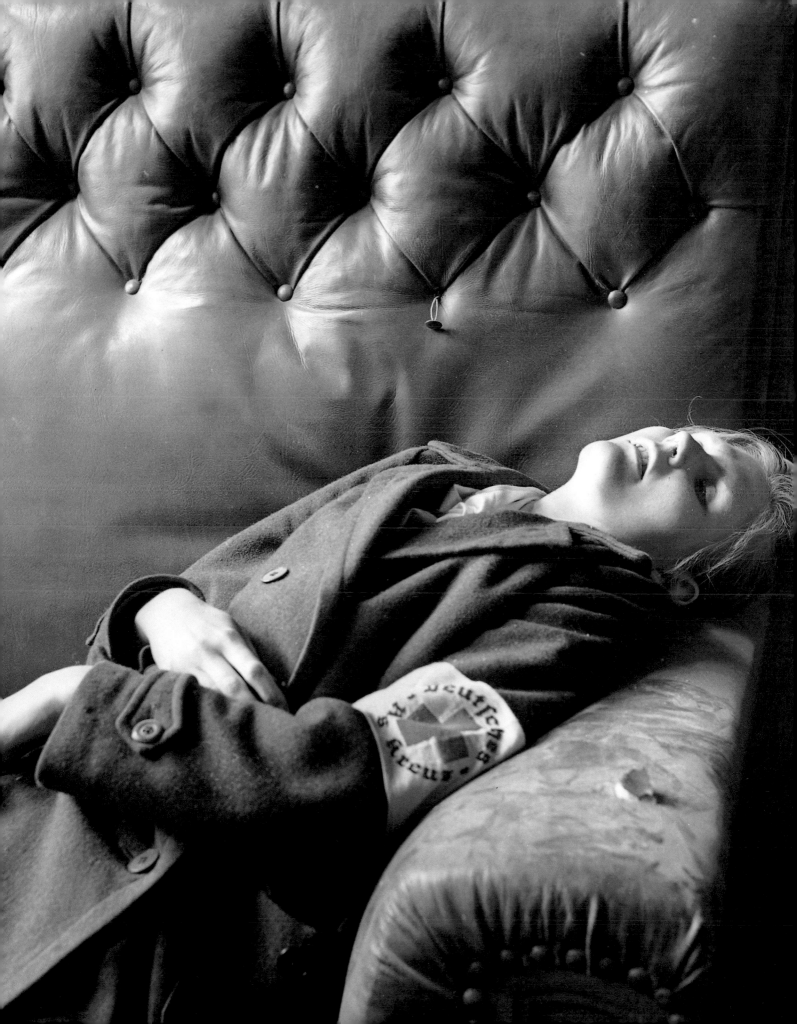

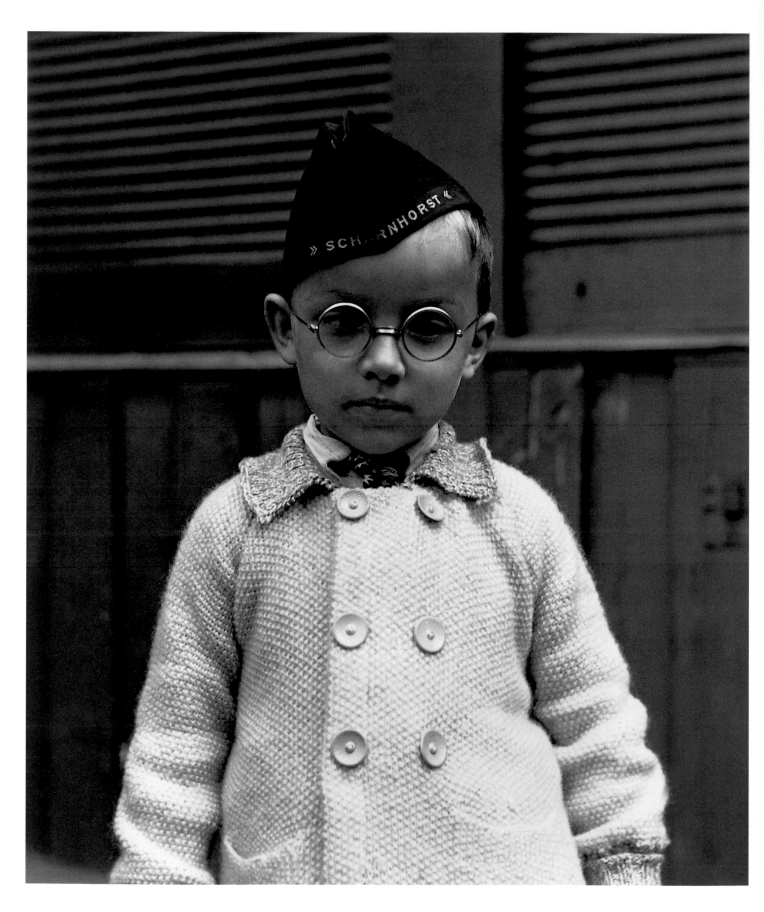

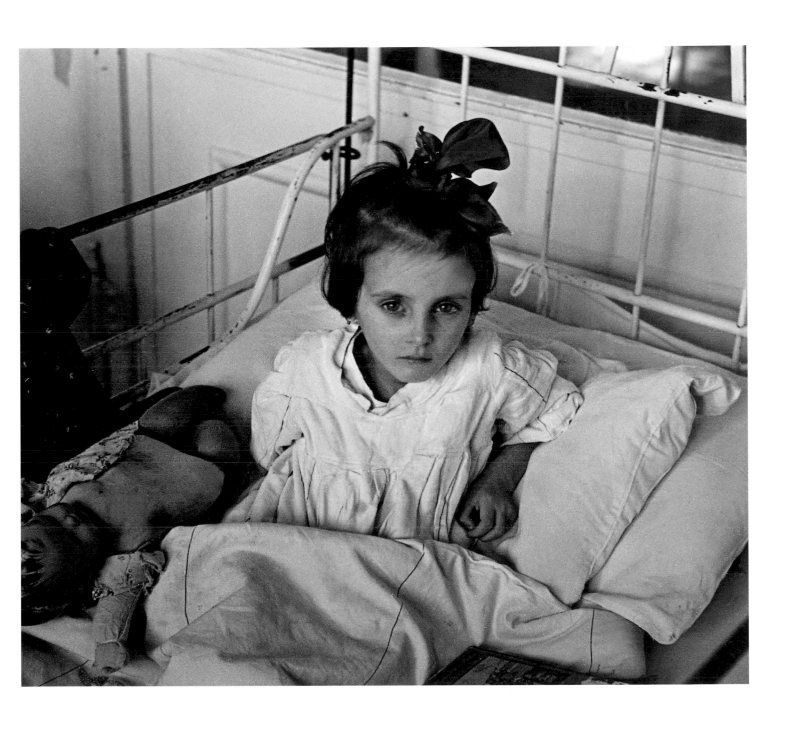

{*opposite*} **Boy Wearing Scharnhorst Cap,**
Vienna, September 1945
The *Scharnhorst*, a German battleship responsible for
inflicting huge losses on Allied shipping, was sunk by
the Royal Navy on 26 December 1943 off the North Cape.
Of the 2,000 men on board only 36 survived.

{*above*} **Sick Child,** Vienna, September 1945
Miller visited Vienna University's Children's Hospital
where she watched helplessly as a baby died for lack
of drugs. In the wards for older children, 'the girls were
on one side with a red or pink bow in their immaculately
dressed hair...and the boys wore blue jackets.'

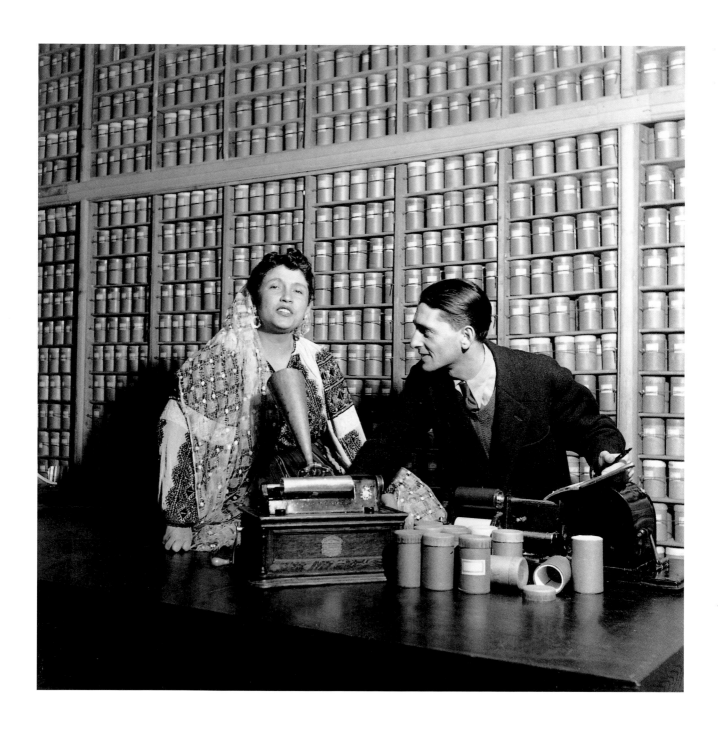

{*above*} **Harry Brauner and Maritza,**
Bucharest, early 1946
Harry Brauner was director of the National Folklore
Research Institute. Before the war Miller had travelled
with him around Romania researching folk culture.
Here Brauner is seen recording Maritza, the gypsy singer.

{*opposite*} **Irmgard Seefried,** Vienna, September 1945
Miller heard the young soprano sing in *Madame Butterfly*;
the next day she photographed her in the ruins of the
Vienna State Opera House. 'Perched on a plank across
a drop…she sang the aria I'd heard the night before…
her dress was safety-pinned to fit her hungry thinness.'

Baroness Schell, Budapest, early 1946
Miller was particularly struck by the women aristocrats
of Budapest, who had 'learned courage and endurance
and a long-term sense of values' and were in the process
of reinventing themselves. Miller photographed Katya
Schell in the famous Café Roszwurm in the Var.

Wilhelm Guillon, Hausmeister, Munich, May 1945
Guillon was the caretaker of the Sterneckerbräu Haus,
the beer-hall in Munich that Hitler had used as a
meeting place in the early years of the Nazi movement.
Miller noted that his 'food supplies on the table were
a few eggs and a very large glass of beer'.

Queen Helen of Romania, Sinaia, early 1946
Miller visited Helen, the Queen Mother, and her son,
King Michael of Romania, in the summer palace at Sinaia,
north of Bucharest. Miller was immediately drawn to
Queen Helen, 'a graceful, beautiful woman with a sense
of humour and a great deal of charm'.

Postwar: Artists and Writers

Exhausted by eighteen months of continuous field reporting, much of it in wartime conditions of discomfort, dirt and danger, and already disillusioned with the peace ('a world of crooks who have no honour, no integrity and no shame'), Miller finally returned to Penrose in London in February 1946. In May of that year they flew to the USA to visit her family at Poughkeepsie whom she had not seen for more than a decade. They also spent some time in New York, where she was warmly welcomed by *Vogue*, and flew to Arizona to see their old friend Max Ernst, soon to be married to the painter Dorothea Tanning. Some of Miller's portraits of Ernst show him as a giant bird of prey in the rocky Arizona desert. She and Penrose travelled on to Los Angeles where her brother Erik was working as a photographer for the Lockheed Aircraft Corporation. In Los Angeles they met up with many old friends, including Man Ray who had recently married Juliet Browner, and visited Stravinsky and others in Hollywood.

Back in Europe, Miller discovered in early 1947, while on a *Vogue* assignment in Switzerland, that she was pregnant. Once divorced from Eloui, she married Penrose and their son Antony was born in September 1947; the experience formed the subject of an article in *Vogue* the following April. Although she still did the occasional fashion shoot for *Vogue*, her heart was no longer in this kind of work. A feature on 'Joyce's Dublin' (February 1950) was more to her taste, and she began to write about art while photographing an increasing number of artists and writers. Her review of the 1948 Venice Biennale for *Vogue* was accompanied by ten of her own portraits. In Switzerland in 1947 she photographed fourteen leading figures in Swiss cultural life, including the artists Jean Arp and Hans Erni: these were published in the May 1947 issue of *Vogue* with her own extended captions. Miller's postwar portraits exhibit the same incisiveness as her earlier work, with her characteristic use of doors, mirrors, windows and other architectural features as devices to frame and isolate the subject.

Miller on a Fashion Assignment in Switzerland,
March 1947 (Unknown)

{*opposite*} **Roland Penrose and Man Ray,**
Los Angeles, 1946
Man Ray left France in 1940, travelling to America via Spain and Portugal. He eventually settled in Hollywood, where he remained until his return to Paris in 1951. Miller's double portrait was made in Man Ray's studio in Vine Street.

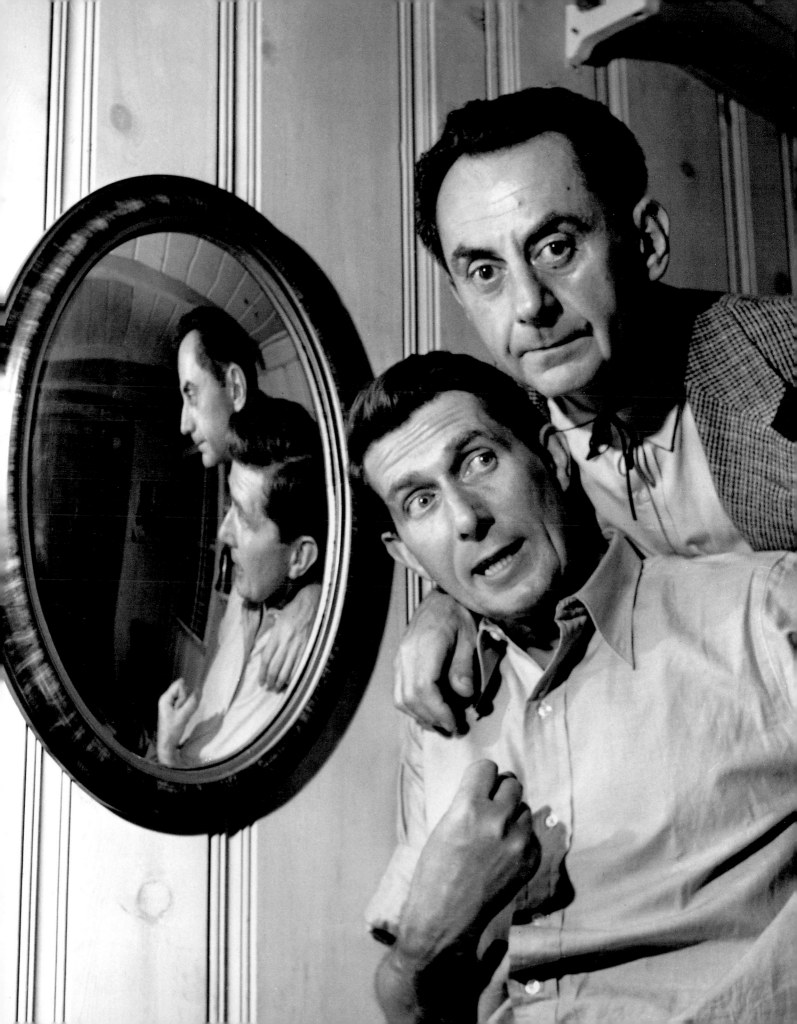

{*above*} **Damon Runyon,** New York, 1946
Runyon was a journalist, sports columnist and writer of humorous short stories about New York lowlife. His first collection *Guys and Dolls* (1932) later inspired the musical comedy of the same name. Runyon died in 1946.

{*opposite*} **Wifredo Lam,** New York, 1946
Born in Cuba, the painter Wifredo Lam moved in surrealist circles in Paris before the war. In 1941 he visited Martinique with André Breton and André Masson. Miller photographed Lam in his New York studio where she bought the painting in the background.

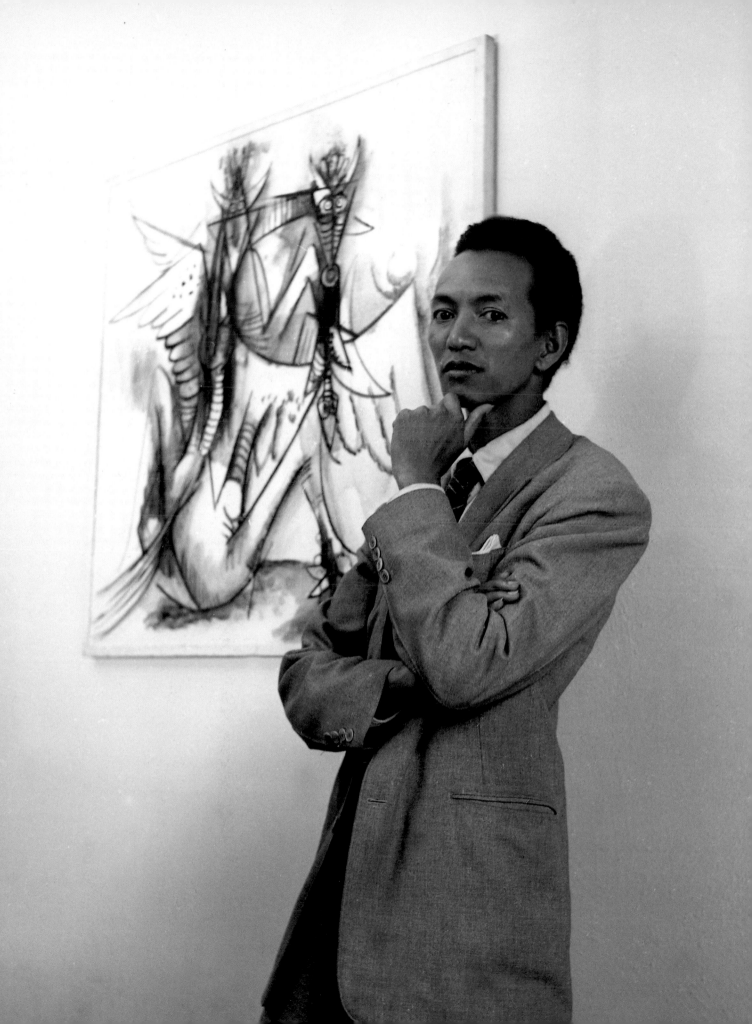

Max Ernst, Arizona, 1946
One of the founders of Cologne Dada in 1919, Ernst moved to Paris in 1922. His first one-man show, the previous year, had made a big impression on Breton, Eluard and the nascent Surrealists. Through his illogical combinations of images, developed first in collage and then in his paintings, Ernst became the quintessential surrealist artist. Penrose had first met him in Paris in the 1920s and remained a lifelong friend. When Miller and Penrose visited him at Oak Creek Canyon, Sedona, Ernst was building a studio.

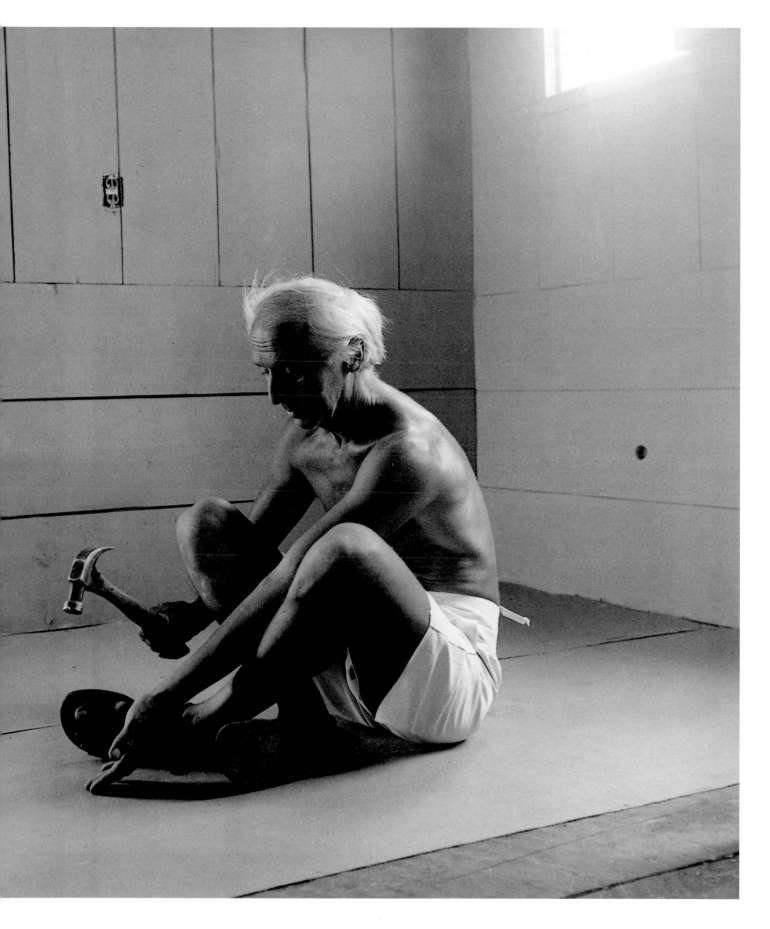

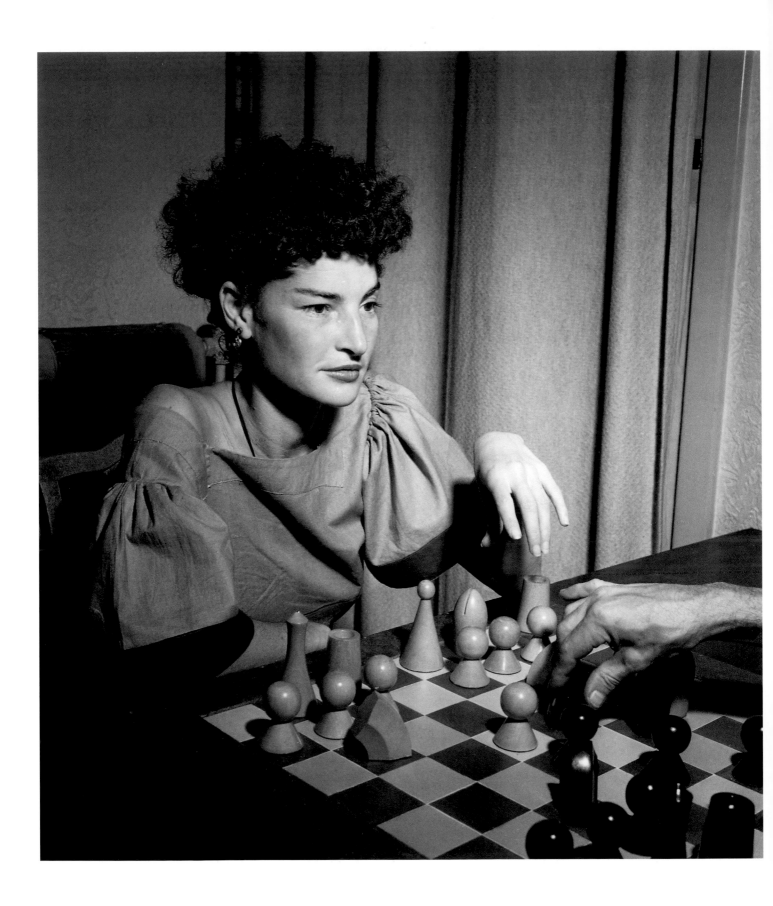

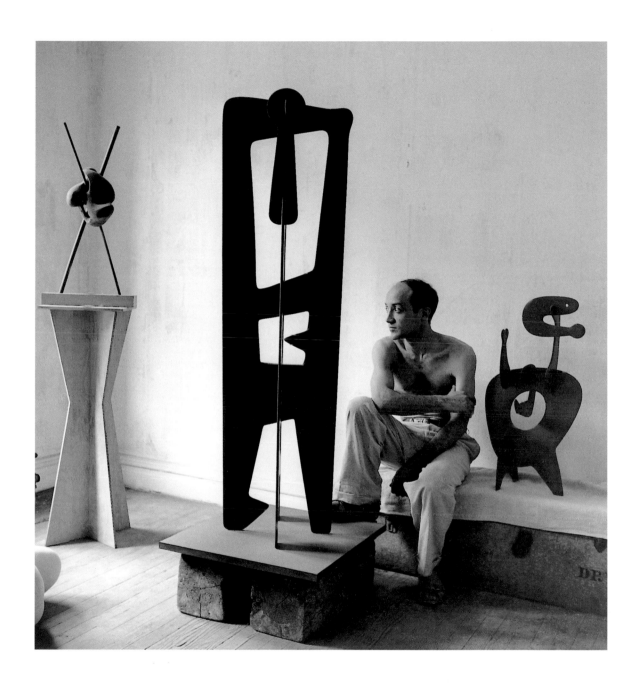

{*opposite*} **Juliet Browner,** Los Angeles, 1946
Juliet Browner, who had studied dance with Martha
Graham, met Man Ray in 1940 and married him in
Hollywood in 1946, in a double ceremony with Max Ernst
and Dorothea Tanning. Browner is shown playing chess
with her husband, using a set designed by him.

{*above*} **Isamu Noguchi,** New York, 1946
Noguchi was born in Los Angeles to an American mother
and a Japanese father. He studied sculpture with Brancusi
in Paris, before returning to New York in 1929. Celebrated
for his large-scale works, Noguchi also designed over
twenty stage sets for Martha Graham.

{*above*} **Jean Arp,** Switzerland, 1947
Miller made portrait studies of leading figures in Swiss
cultural life for a feature in the May 1947 issue of *Vogue*.
'Jean Arp invented Dadaism,' she wrote in her caption,
'and is called Surrealist, but he remains uniquely
himself.' One of Arp's painted reliefs hangs behind him.

{*opposite*} **Albert Skira,** Switzerland, 1947
The renowned art-book publisher Albert Skira had
produced *Minotaure*, one of the chief magazines of the
surrealist movement, in Paris before the war. Now, Miller
reported, he was bringing out a monthly review of art
and literature called *Labyrinthe*.

Igor Stravinsky, Los Angeles, 1946
Stravinsky emigrated from France to America in 1939,
settling in Hollywood where he remained until a few years
before his death in 1971. During the war he composed
Symphony in C (1940) and *Symphony in Three Movements*
(1945), masterpieces of his neo-classical period.

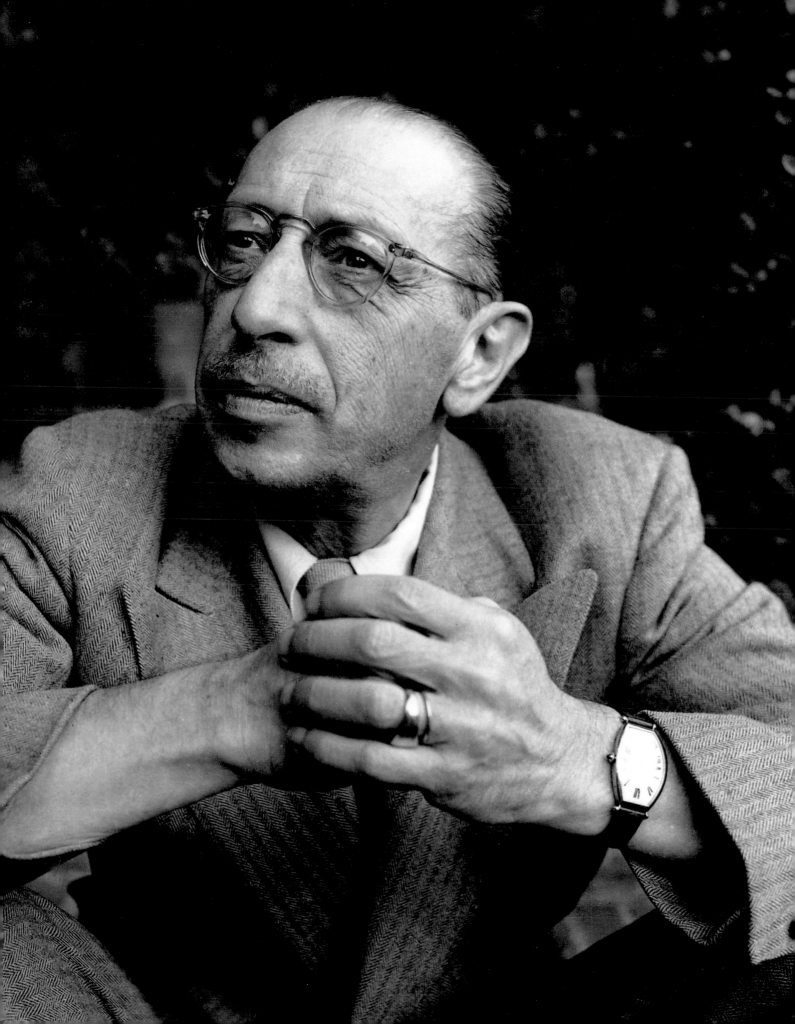

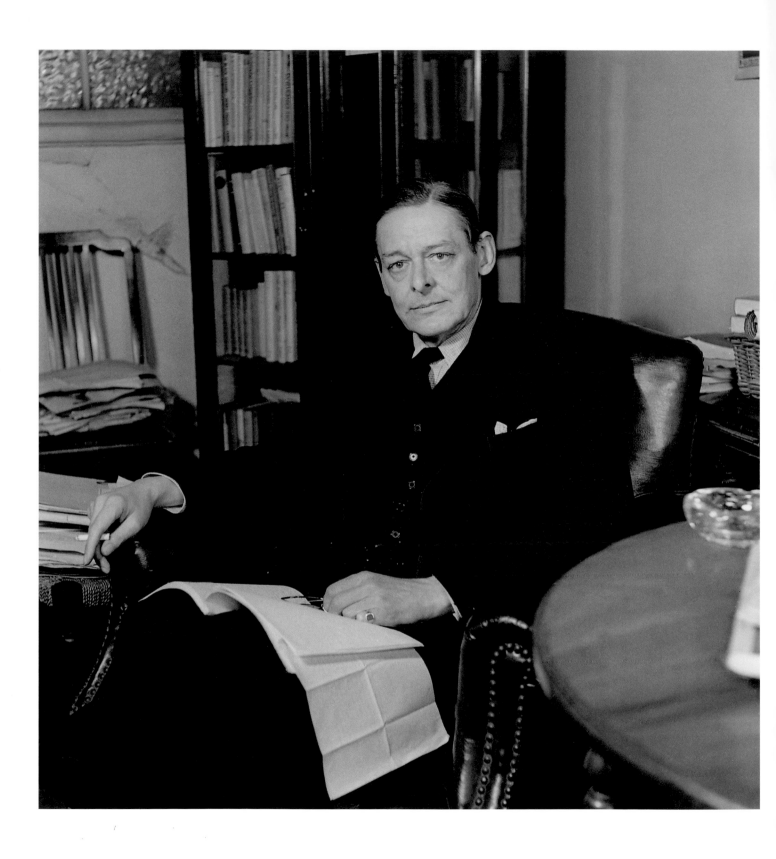

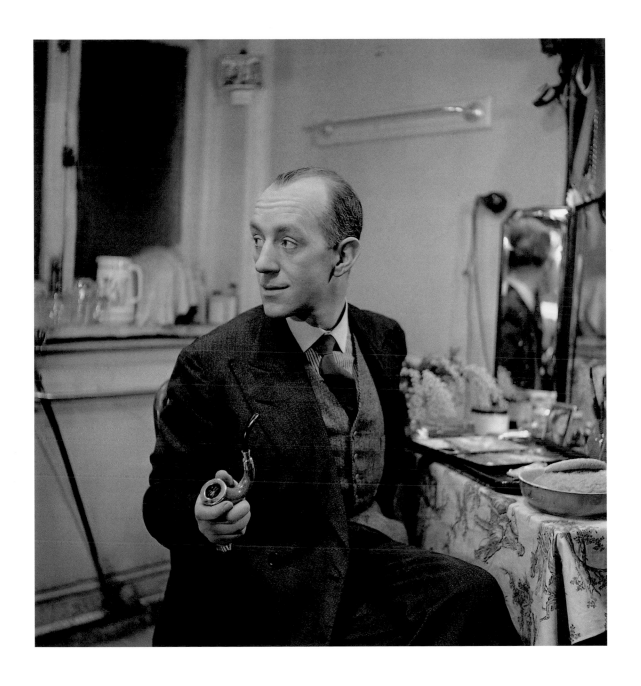

{opposite} **T. S. Eliot,** London, March 1947
This portrait of the American-born British poet was used
in *Vogue*'s 'Spotlight' column in November 1949. Eliot's
play *The Cocktail Party* had recently been premiered at the
Edinburgh Festival. Eliot was a director of the publisher
Faber and Faber for many years.

{above} **Alec Guinness,** London, February 1947
Miller photographed Guinness for the April 1947 issue
of *Vogue*. Guinness's film career had recently taken off
with his appearance as Herbert Pocket in *Great Expectations*
(1946). In 1949 he played opposite Irene Worth in Eliot's
The Cocktail Party at the Edinburgh Festival.

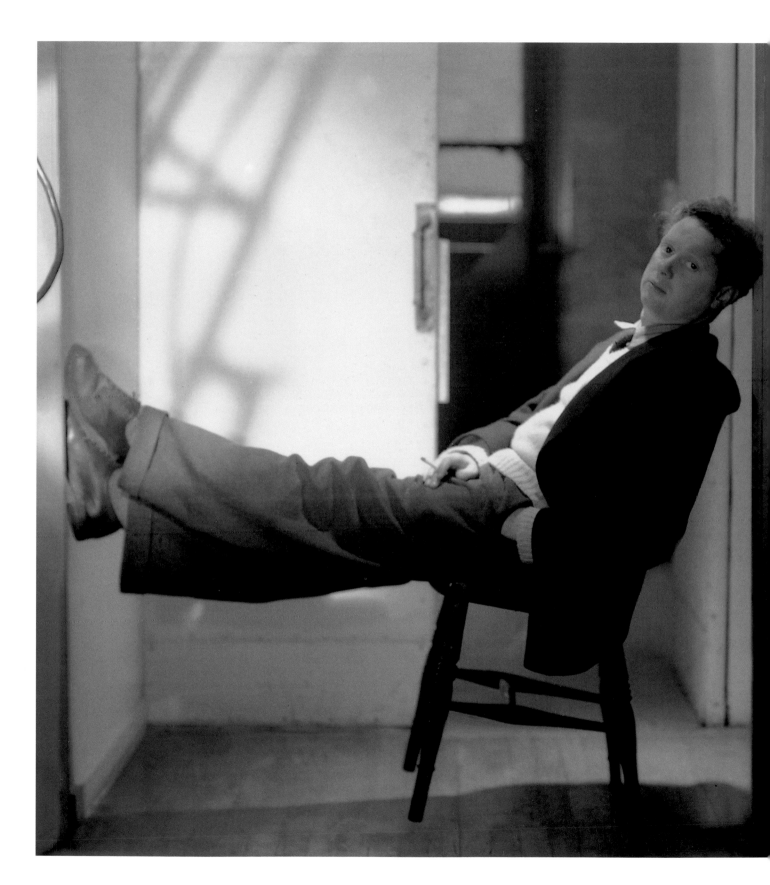

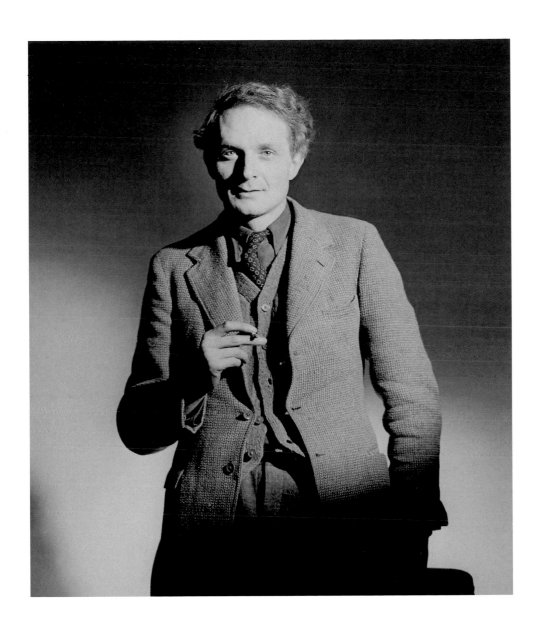

{opposite} **Dylan Thomas,** London, December 1946
The heavy-drinking, bohemian poet and broadcaster
was photographed by Miller at *Vogue*'s studios. Thomas's
collection *Deaths and Entrances,* which brought him
widespread attention, had just been published. He would
later gain fame with his radio play *Under Milk Wood.*

{above} **Stephen Spender,** London, February 1947
The poet and critic, who served in the Spanish Civil
War, had been co-editor, with Cyril Connolly, of the
literary and artistic review *Horizon* from 1939 to 1941.
During the war Spender was a member of the National
Fire Service in London.

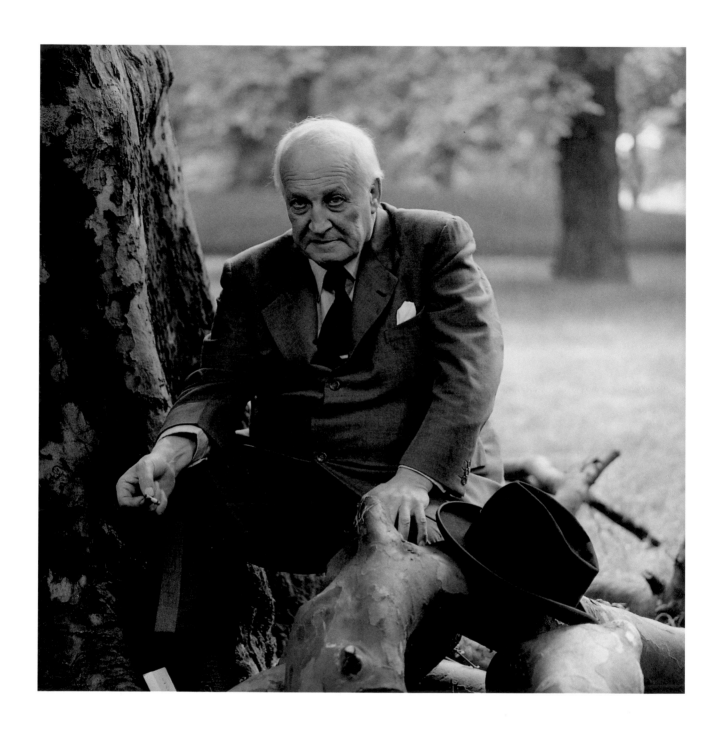

{above} **Robert Flaherty,** Dublin 1949
Flaherty is regarded as the 'father' of the documentary
film; his best-known works are *Nanook of the North* (1922)
and *Man of Arran* (1933). Miller made this portrait study
of Flaherty in Dublin, where she was taking photographs
for a *Vogue* piece on 'Joyce's Dublin'.

{opposite} **Eduardo Paolozzi,** London, 1948
The young, Edinburgh-born sculptor had his first one-
man exhibition at the Mayor Gallery, London, in 1947.
In the same year he moved to Paris where he met Arp,
Brancusi, Braque and Giacometti. Based there until
1949, Paolozzi came under the influence of Surrealism

and of Dubuffet's 'art brut'. In 1952 he became a
leading member of the Independent Group, which was
responsible for the development of Pop Art in Britain.
The Independent Group's headquarters, the ICA, had
recently been founded by Penrose and others.

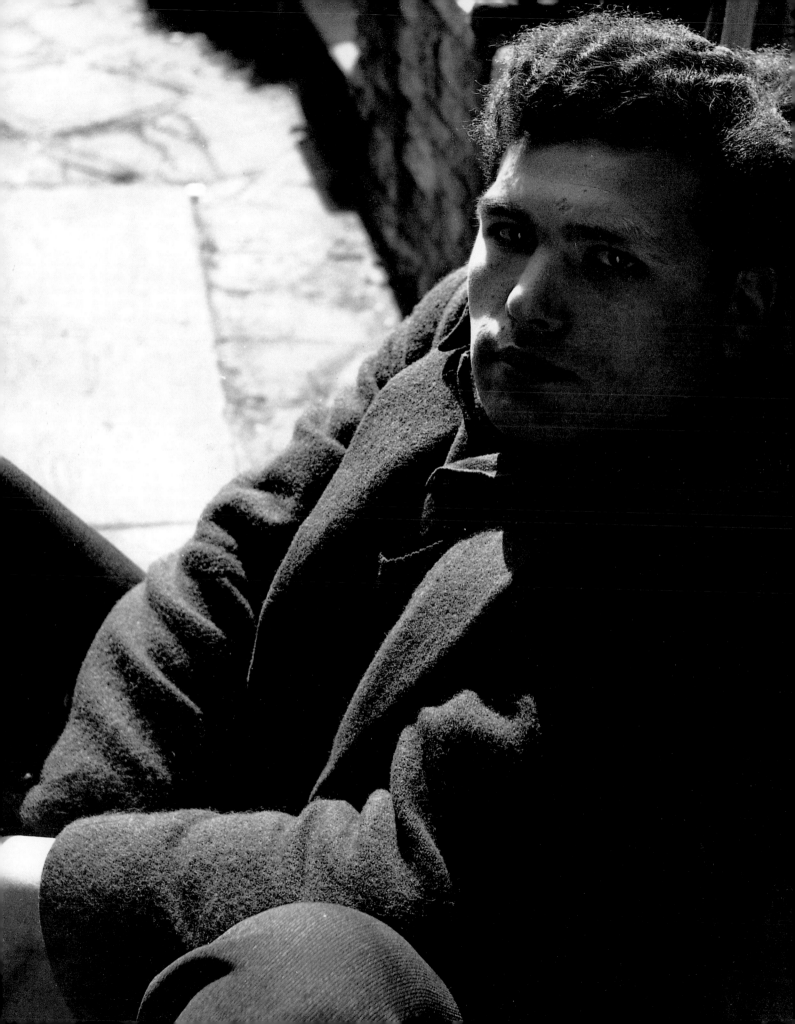

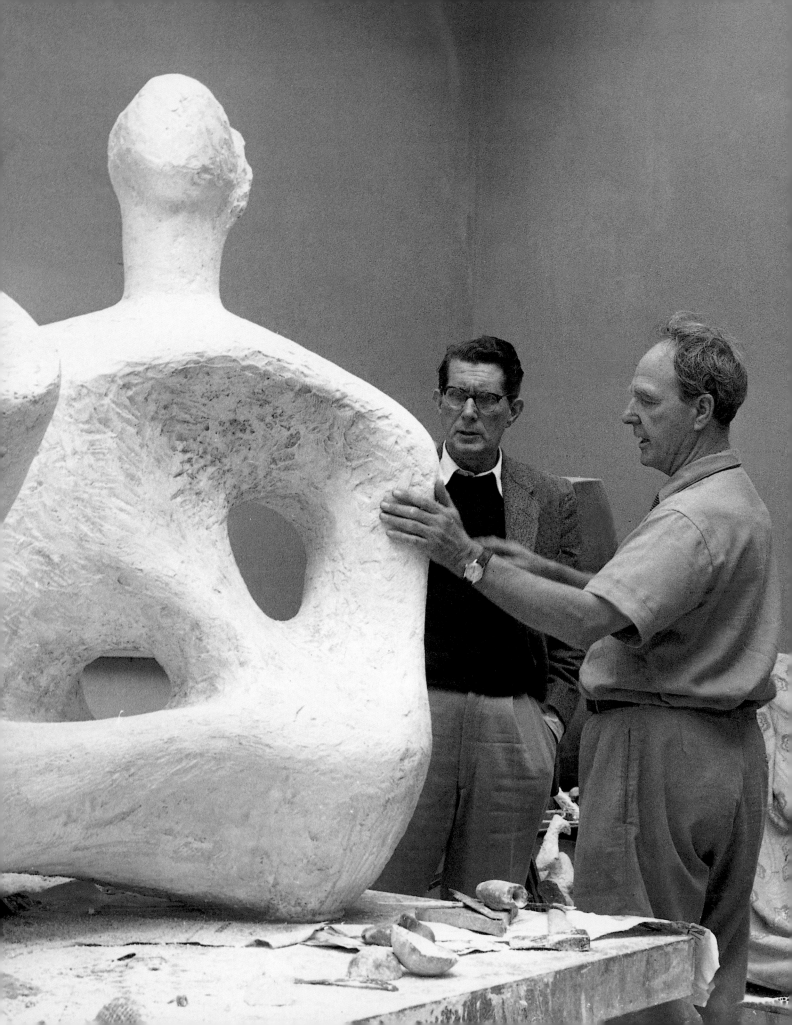

{*opposite*} **Roland Penrose and Henry Moore,** Hertfordshire, 1956
Penrose had been a friend of Moore since the 1930s, when he acquired two important works by the sculptor. In 1936 Penrose included work by Moore in the *International Surrealist Exhibition* in London. Here the two men are discussing the plaster study for Moore's UNESCO *Reclining Figure* in the artist's studio at Much Hadham. The final version, twice the size of this working model, was made of marble and completed two years later.

{*above*} **Georges Braque,** Paris, 1956
One of the creators of Cubism, Braque was close to Picasso from 1909 to 1914. He was badly wounded in World War I. In 1948 he won the top painting prize at the Venice Biennale and began his large, spatially complex series of 'studio' paintings.

{*opposite*} **Oskar Kokoschka,** London, 1950
Kokoschka had fled to London from Prague in 1938. After
the war he was commissioned by the art collector Count
Antoine Seilern, another Austrian émigré, to paint a large
triptych for a ceiling in his house at 56 Prince's Gate,
where Miller photographed the artist at work.

{*above*} **Giorgio Morandi,** Venice, 1948
This was one of ten photographs of artists by Miller used
in the review of the Venice Biennale that she wrote for
Vogue. Other subjects included Moore and Kokoschka. She
described Morandi as 'tall and monk-like in appearance...
much honoured by the younger generation'.

Picasso and other Friends

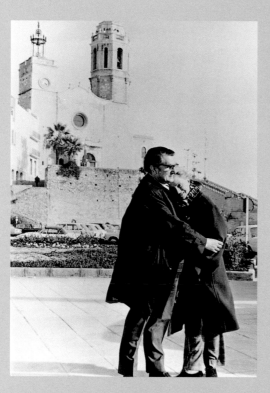

{*above*} **Roland Penrose and Lee Miller,**
Barcelona, 1972 (Unknown)

{*opposite*} **Picasso,** Cannes, 1958
In 1955 Picasso acquired La Californie, a spacious villa above
Cannes, which became his home and studio for the next
few years. Miller photographed him there on a number of
occasions, while accompanying Penrose on research trips
for his biography of the artist and for the Picasso
retrospective that he was organising for the Tate Gallery.

For Picasso's seventieth birthday in 1951, Penrose organised an exhibition
of his work at the Institute of Contemporary Arts in London, which a
few years earlier he had helped establish. Miller was a loyal supporter
of the ICA; she had published an informed and enthusiastic review in
Vogue of one of its first exhibitions, *40,000 Years of Modern Art* (subtitled
'A Comparison of Primitive and Modern'). She also collaborated with
her husband on another cross-cultural exhibition held at the ICA in 1953,
Wonder and Horror of the Human Head. To both exhibitions she and
Penrose lent important works from their collection of modern art.

To coincide with the Picasso exhibition in 1951, Miller wrote
a personal tribute to the artist in *Vogue*, based on her and Penrose's
observations of his working and living habits over many years. Her
portraits of Picasso were included in an exhibition at the ICA in 1956 to
commemorate the artist's seventy-fifth birthday, while several of her
photographs were reproduced in the book that Penrose wrote to
accompany the show, *Portrait of Picasso*.

Since 1949 Miller and Penrose had been spending more and more
time at the 120-acre dairy farm they had acquired at Muddles Green
in East Sussex. Farley Farm gradually became a place of pilgrimage for
friends, artists and art lovers the world over as improvements were made
to the house and garden and the rooms filled up with masterpieces of
modern art. As she moved away from photography, Miller developed
new interests in cooking and classical music. However, she continued
to photograph her friends, and her last pictures of Picasso date from
a few years before the artist's death in 1973.

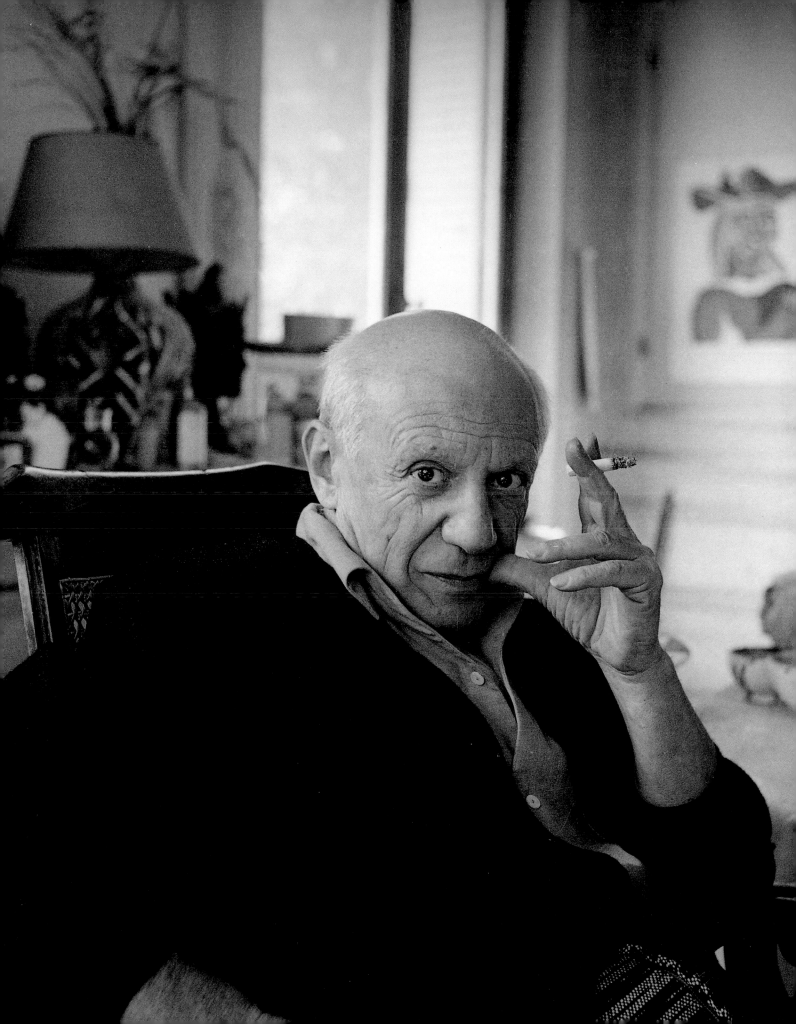

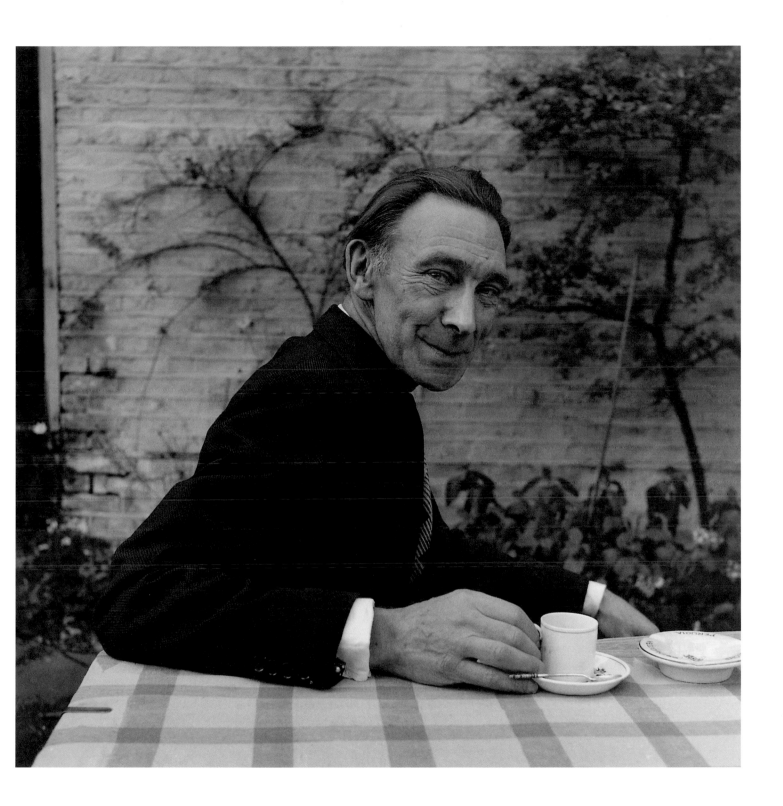

{opposite} **John Craxton and Tony Penrose,**
Sussex, 1951
The English artist John Craxton was a frequent visitor to
Farley Farm, the Penroses' home near Chiddingly in East
Sussex, which they purchased in 1949. He is seen here
painting with Tony Penrose, Miller's four-year-old son.

{above} **Eric Newton,** London, 1953
Newton, the author of *European Painting and Sculpture*
(1941) and *Tintoretto* (1952), was art critic for the
Manchester Guardian from 1930 to 1947 and the *Sunday
Times* until 1957. Newton lost the latter post when he
began to champion the cause of young artists.

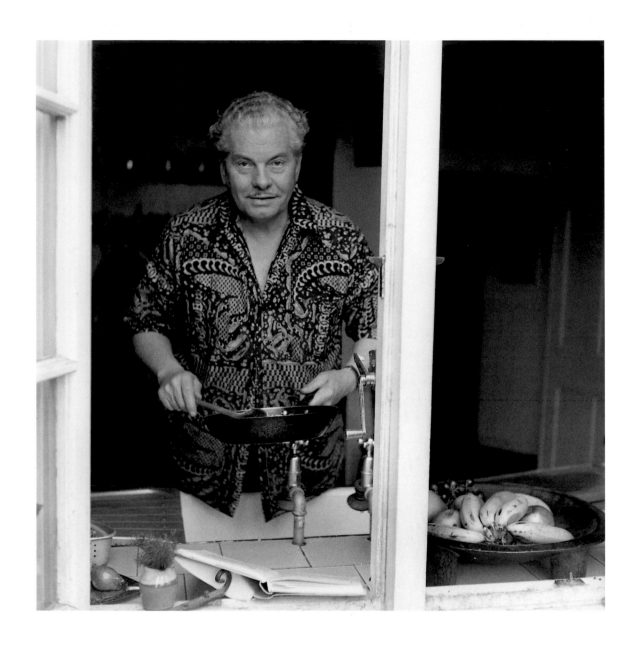

{*above*} **Wells Coates,** Sussex, 1954
The Canadian-born modernist architect Wells Coates,
founder, in 1933, of MARS (Modern Architectural
Research Society), shared Miller's love of cooking,
especially Chinese dishes. Miller photographed him
from outside the kitchen window at Farley Farm.

{*opposite*} **Freddie Ayer,** Sussex, 1951
A. J. Ayer, who was Professor of Philosophy at Oxford
at the time, is best known for his first book, *Language,
Truth and Logic* (1936). Miller liked her weekend guests at
Farley Farm to engage in useful tasks as she and Penrose
gradually made improvements to the house and garden.

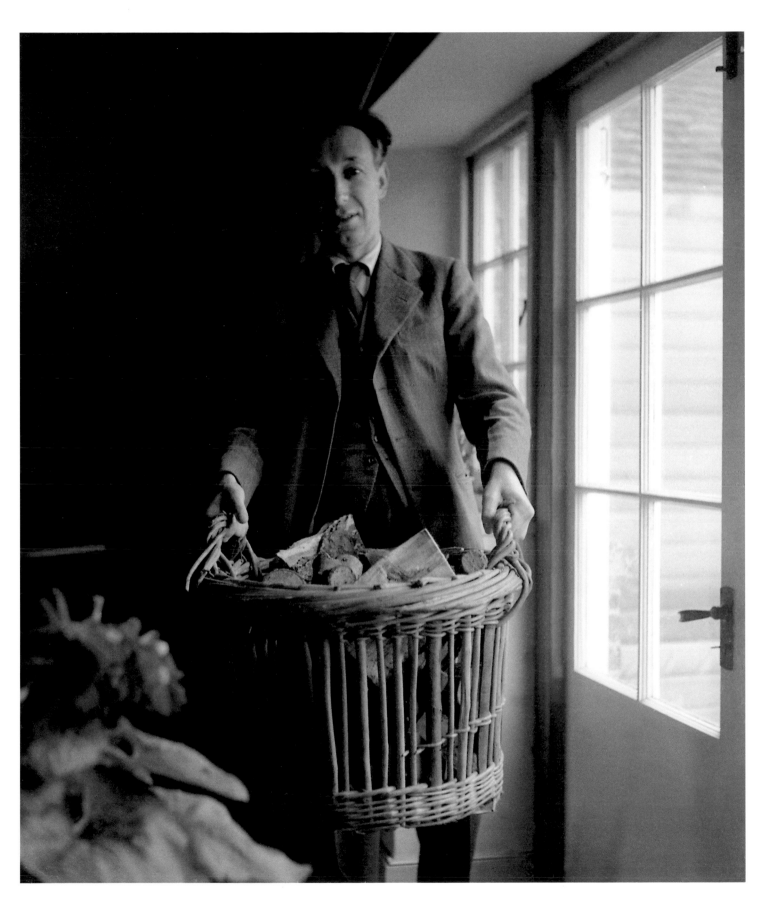

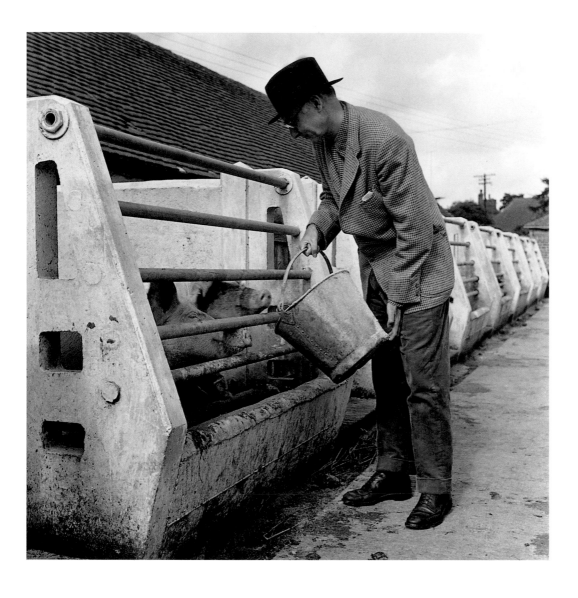

{above} **Alfred H. Barr,** Sussex, 1952
Barr was the first Director of the Museum of Modern Art in
New York. Penrose's visit to MOMA, during his trip to the
USA in 1946, reinforced his view that a centre for modern
art should be established in London.

{opposite} **Grandpa White and Fred Baker,** Sussex, 1953
Fred Baker and his wife's grandfather Bill White were the
gardeners at Farley Farm. White had previously worked
in a tannery, a sawmill and as a ploughman with oxen.

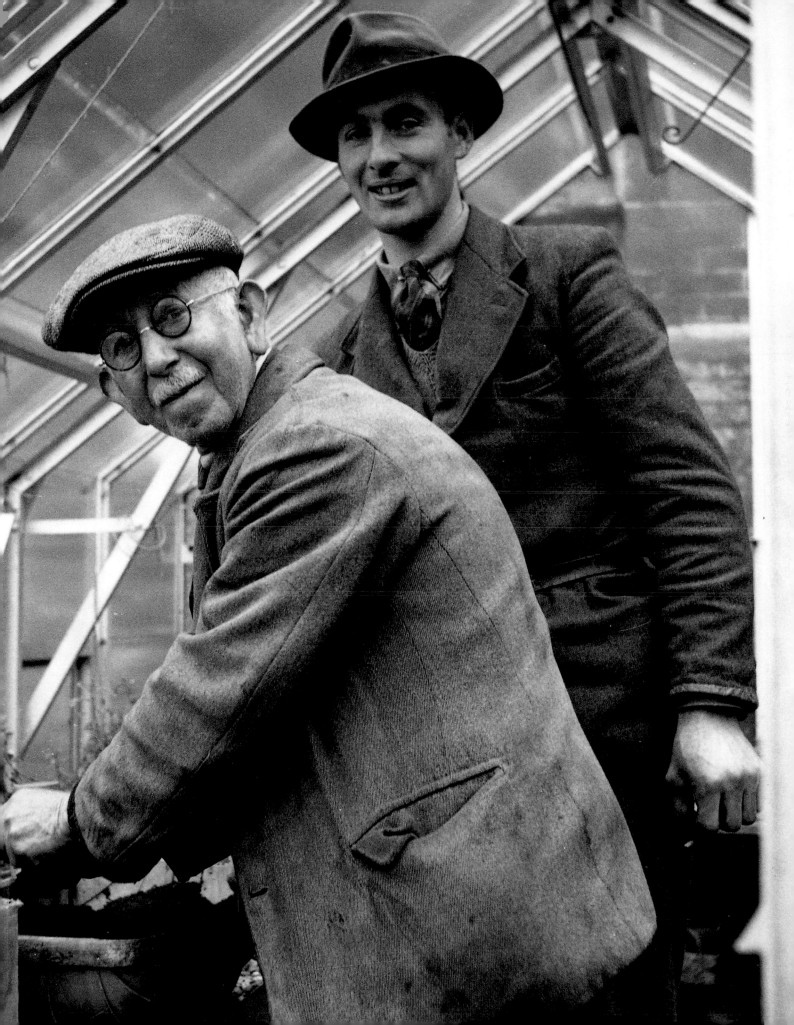

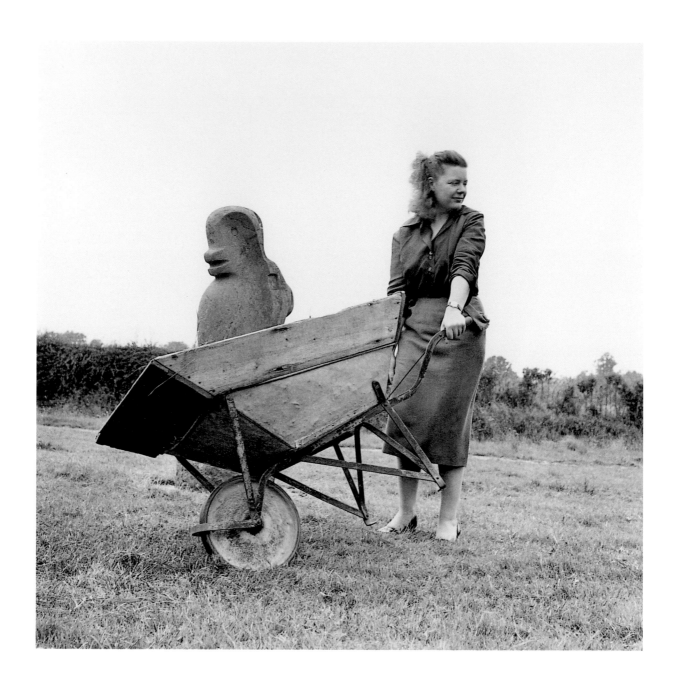

Sonia Orwell, Sussex, 1953
Sonia Brownell, who was an editor on the magazine
Horizon, married George Orwell a few weeks before
his death in 1950. Behind the wheelbarrow is Henry
Moore's stone *Mother and Child* (1936), which the artist
had recently installed on the lawn at Farley Farm.

Matta, Sussex, 1950
Matta had originally trained as an architect under
Le Corbusier, before becoming a surrealist painter in
the late 1930s. This photograph of the Chilean artist
erecting a house-painter's ladder was published in
Miller's *Vogue* article 'Working Guests' (July 1953).

{*above*} **Reg and Jo Butler**, Sussex, 1952
Miller's photograph of the British sculptor Butler and
his first wife Jo, slicing and salting beans, was included in
her article 'Working Guests'. Soon afterwards, Butler won
first prize in the 'Unknown Political Prisoner' competition,
which was organised by the ICA.

{*opposite*} **Richard Hamilton**, Sussex, 1951
Hamilton organised the *Growth and Form* exhibition at the
ICA in 1951. The following year he was a founder member
of the Independent Group, with Eduardo Paolozzi and
Nigel Henderson. In 1947 Hamilton had attended life
classes, run by *Vogue*, for potential fashion designers.

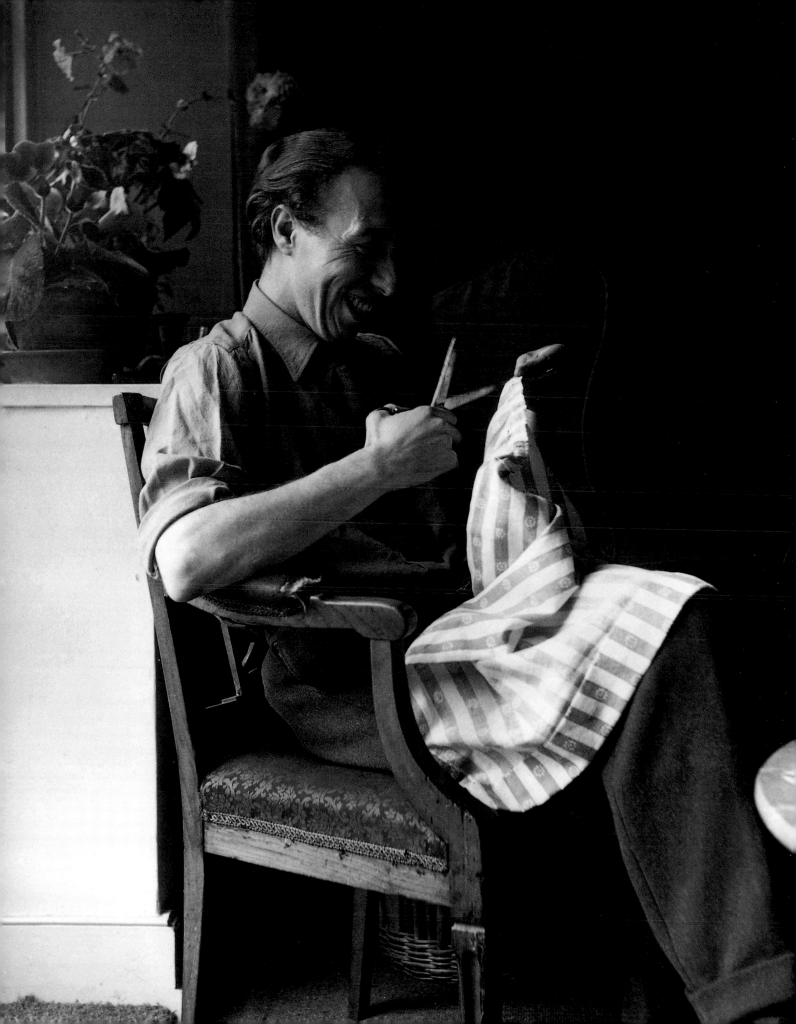

Saul Steinberg, Sussex, 1953
The Romanian-born American illustrator and cartoonist
for the *New Yorker* was in England for the opening of
an exhibition of his drawings at the ICA. Miller posed
Steinberg with the ancient chalk drawing of the Long
Man of Wilmington in the background.

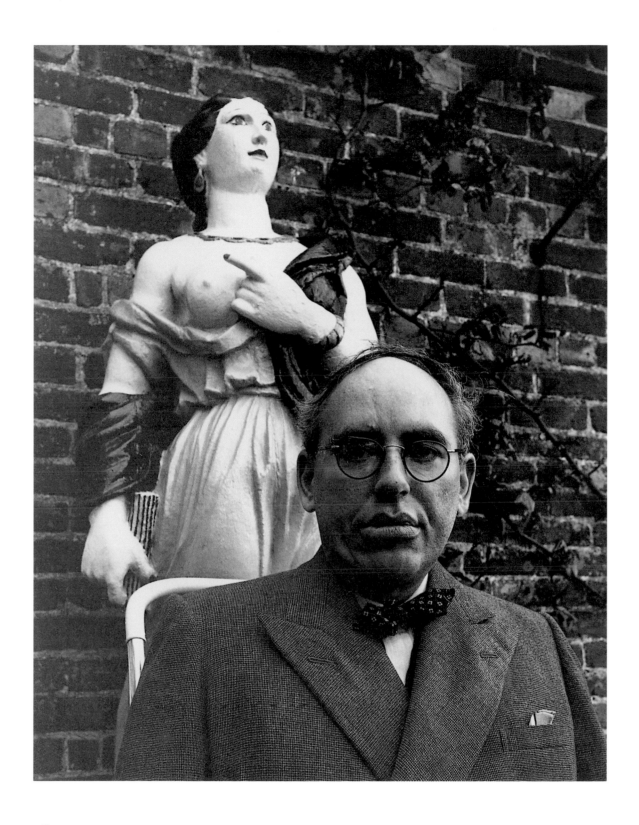

{opposite} **Moura Budberg,** Sussex, c. 1952
Moura Budberg, the former Countess Benckendorff, was a White Russian who had been the mistress of Maxim Gorky and H. G. Wells. She was rumoured to have spied for the British and the Soviets. Her influence led to the celebrated meeting between Stalin and Wells in 1934. After the war she was employed by the film producer Alexander Korda and worked as a translator and editor.

{above} **John Hayward,** Sussex, 1955
Hayward was a literary scholar, editor and bibliophile, who was a frequent guest of the Penroses at Farley Farm. Wheelchair-bound, he shared a flat in London overlooking the Thames with T. S. Eliot until the latter's second marriage in 1957.

André Masson, Sussex, 1955
Masson's work was included in the *International Surrealist Exhibition* in London in 1936, after which Penrose acquired an important early oil painting by the French painter. Masson's pioneering use of chance effects and various 'automatic' techniques was highly influential.

{opposite} **Joan Miró with Hornbill,** London Zoo, 1964
The Catalan painter visited London for a retrospective
of his work at the Tate Gallery, which Penrose had
selected. Desmond Morris, who was then Keeper of
Mammals at London Zoo, took Miró on a private tour
and arranged for him to handle some of the animals.

{above} **Miró and Friends at the Zoo,** London, 1964
On his outing to the zoo, Miró (second from right) was
accompanied by Desmond Morris (far left), Tony Penrose,
Ian Barker and Roland Penrose. In 1970 Roland Penrose
published a monograph on Miró.

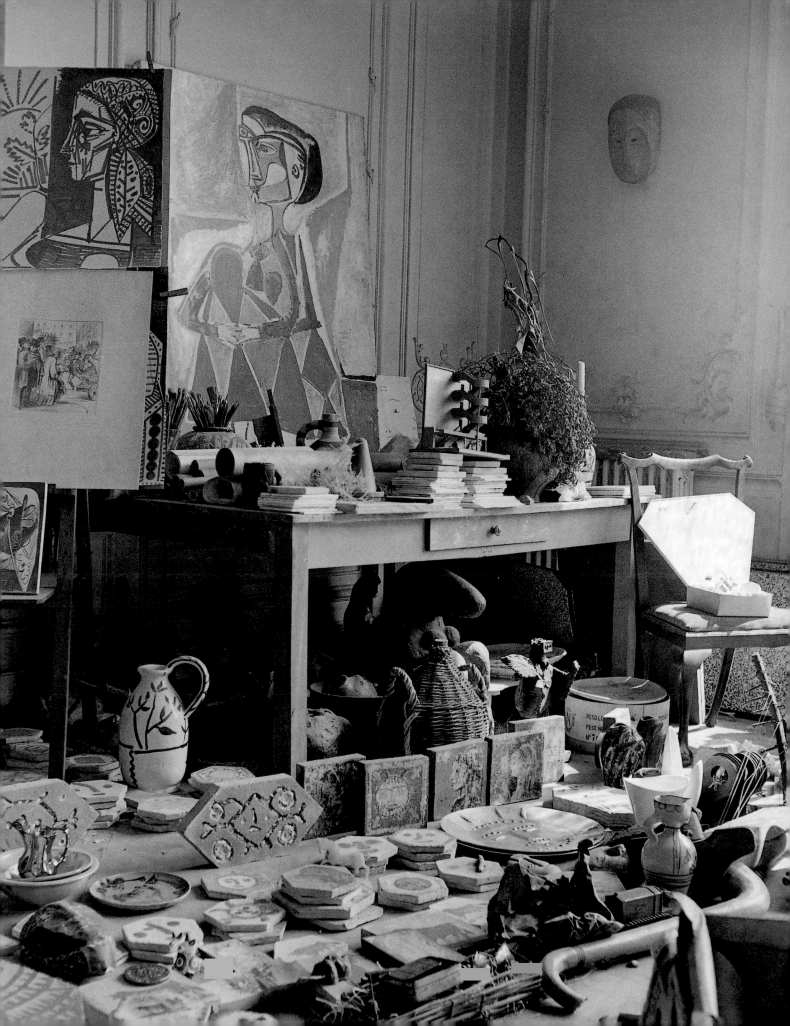

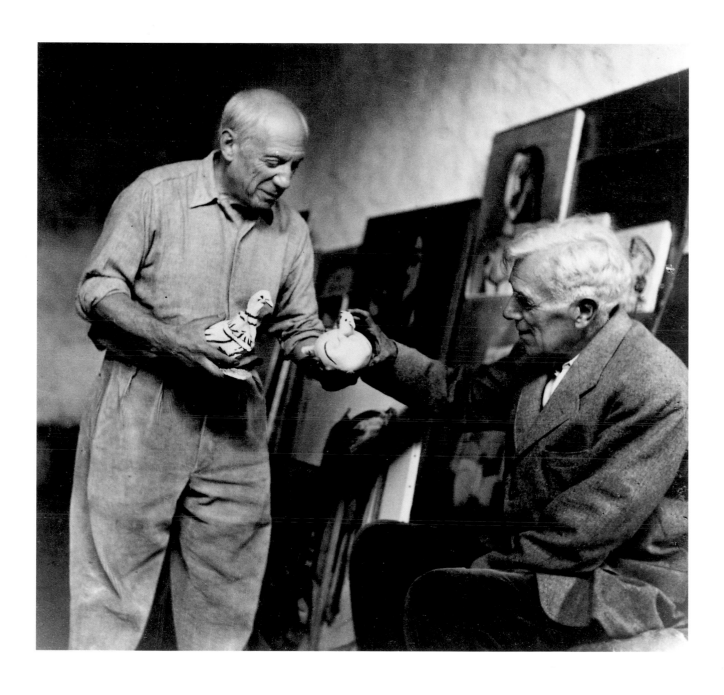

{*opposite*} **Picasso's Studio,** Cannes, 1958
'Picasso doesn't collect like a collector,' Miller wrote in
Vogue (November 1951). 'Things just seem to come home
with him to roost and wait patiently, gathering dust,
until he turns his attention to them again.'

{*above*} **Picasso and Braque,** Vallauris, 1954
When Braque visited Picasso at his studio in an abandoned
scent factory at Vallauris, the pottery-making town near
Antibes, the two artists had not met for many years.
Braque particularly admired the ceramic doves
that Picasso was making.

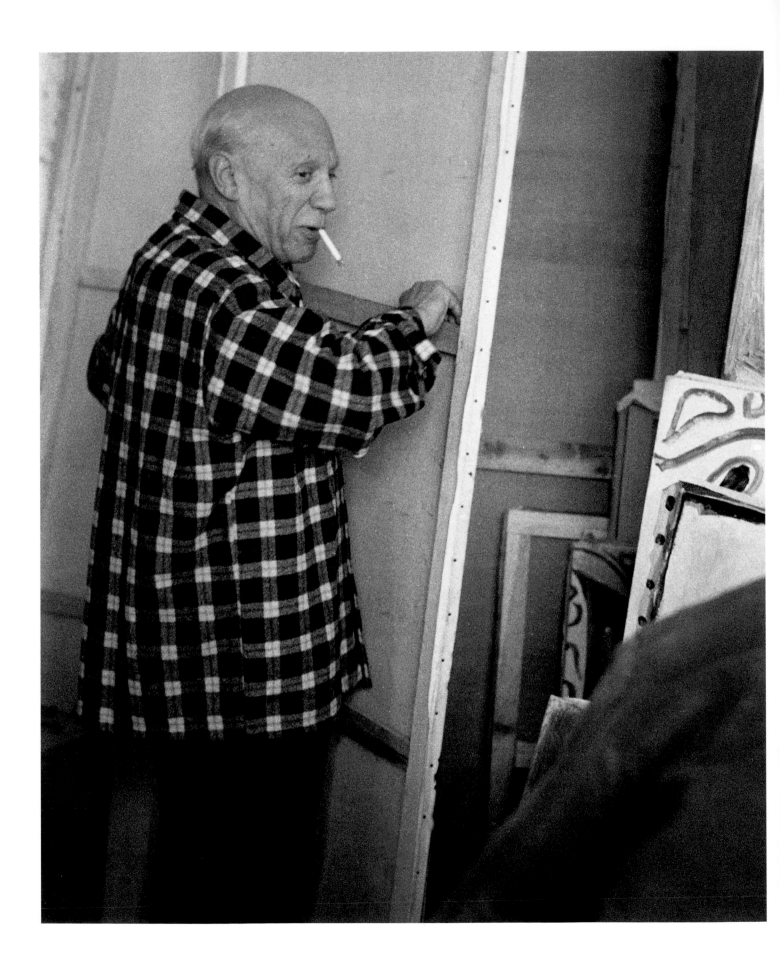

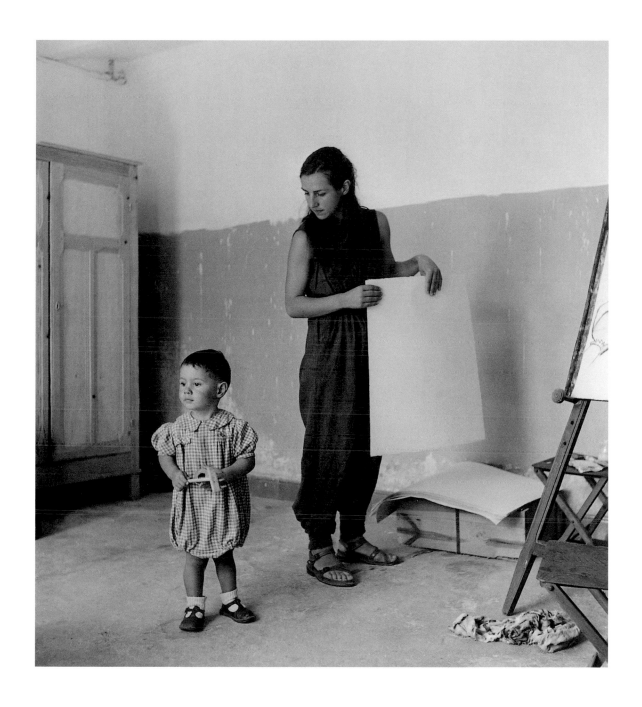

{*opposite*} **Picasso,** La Californie, Cannes, 1956
The majority of Miller's portraits of Picasso capture
an informal moment when the artist is only dimly
aware of the photographer's presence.

{*above*} **Claude Picasso and Françoise Gilot,**
Vallauris, 1949
Picasso met the painter Françoise Gilot in Paris shortly
after the Liberation. They had two children, Claude
(shown here) and Paloma. Miller photographed
mother and son at Picasso's villa in Vallauris.

Picasso, Château de Vauvenargues, *c.* 1960
In 1958 Picasso bought the Château de Vauvenargues
near Aix-en Provence. 'After two summers however he
began to find that the remoteness of this noble site
was too complete,' wrote Penrose. Miller and her husband
continued to visit Picasso, at his last home near Mougins,
until a few years before his death in 1973. Miller's
portraits of Picasso are among her most enduring images.

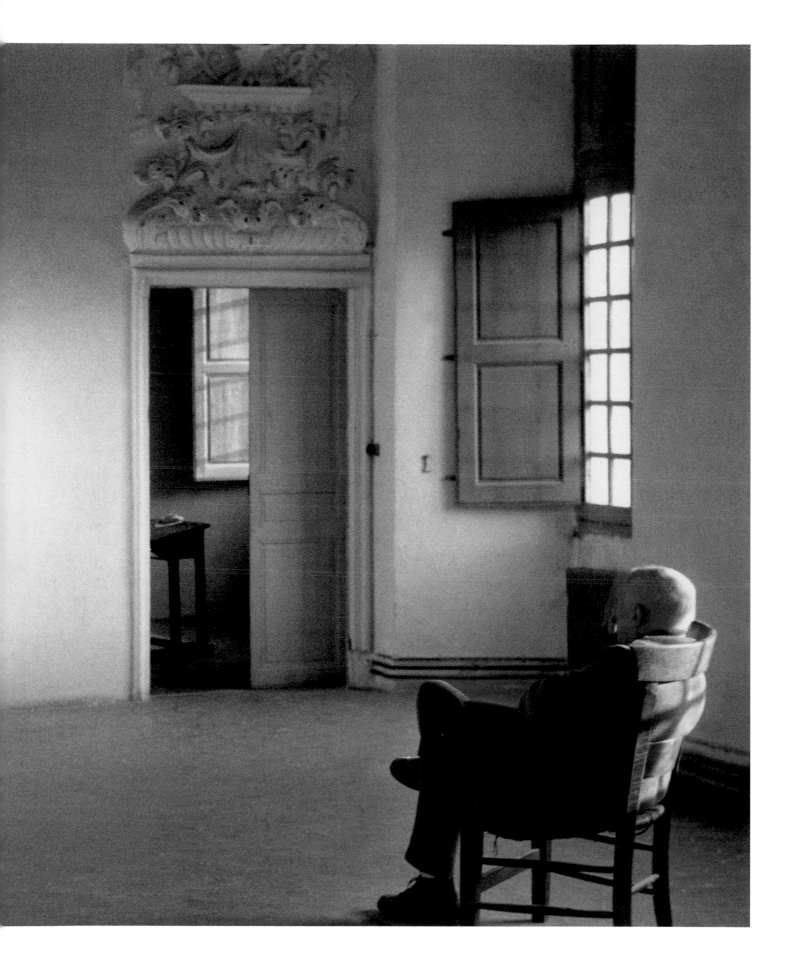

Notes

p. 7 '...fashion pictures...portraits...': Miller quoted in Mario Amaya, 'My Man Ray', *Art in America*, May-June 1975, p. 55

p. 8 'wanted to be an artist...': interview with Ona Munsen, *In Town Tonight*, CBS Los Angeles, 1946

'We passed litter-bearing jeeps...': *Lee Miller's War*, p. 26

p. 9 'The hero was the intrepid cameraman...': 'What they see in cinema', British *Vogue*, August 1956, p. 46

'...melodrama, ambiguity, inaccuracy...': *ibid*

'There is a flash of poetry...': *ibid*

p. 10 'I don't usually take pictures of horrors...': American *Vogue*, June 1945

p. 11 '...strictly department store...': *Lee Miller's War*, p. 198

'I drove through Germany...': 'In Denmark Now', British *Vogue*, July 1945, p. 77

'We are committed to alliance...': unpublished Vienna notebook, Lee Miller Archives, Sussex

'beautiful children's hospital...': original typescript (p. 11) cabled to British *Vogue*, Lee Miller Archives, Sussex

p. 12 'For an hour...': *ibid*

'We've all been conditioned...': *Lee Miller's War*, p. 143

'Germany is a beautiful landscape...': *ibid*, p. 161

p. 13 'evil machine-monster': *ibid*, p. 188

'no visible signs...': *ibid*, p. 111

'they are ill...': *ibid*

p. 14 'almost human habits': *ibid*, p. 188

p. 72 'She has become a cult...': Lesley Branch, 'Spotlight on I. Compton-Burnett', British *Vogue*, April 1943

p. 90 'the most exciting journalistic experience...': quoted in Antony Penrose, *The Lives of Lee Miller*, p. 118

'In Rennes today...': *Lee Miller's War*, p. 65

p. 94 'A group came single file...': *ibid*, p. 24

p. 97 ' A bad burns case...': *ibid*, p. 17

p. 98 'We fell into each...': *ibid*, p. 77

p. 100 'These last months...': 'Brussels – more British than London', British *Vogue*, February 1945, p. 76

'All Paris had been talking...': *Lee Miller's War*, p. 97

p. 103 'Against the cold light...': *ibid*, p. 105

p. 105 'Picasso and I...': *ibid*, p. 73

p. 106 'He has abandoned...': 'Brussels – more British than London', British *Vogue*, February 1945, p. 76

p. 108 'Chevalier looked just like...': *Lee Miller's War*, p. 78

'The design is so subtle...': *ibid*, p. 97

p. 111 'The pattern of liberation...': *ibid*, p. 113

'Kids sat patiently...': *ibid*, p. 117

p. 116 'The small canal...': *ibid*, p. 182

'Leaning back on the sofa...': *ibid*, p. 176

p. 119 'the girls were on one side...': original, unedited typescript, (p. 12) of 'Report from Vienna', British *Vogue*, November 1945, Lee Miller Archives, Sussex

p. 120 'Perched on a plank...': *ibid*, p. 1

p. 122 'learned courage and endurance...': 'Hungary', British *Vogue*, April 1946, p. 92

p. 123 'food supplies on the table...': *Lee Miller's War*, p. 196

p. 124 'a graceful, beautiful woman...': 'Roumania', British *Vogue*, May 1946, p. 98

p. 126 'a world of crooks...': letter to Roland Penrose, quoted in Antony Penrose, *The Lives of Lee Miller*, p. 147

p. 147 'tall and monk-like...': 'Venice Biennale', British *Vogue*, August 1948, p. 89

p. 172 'After two summers...': *Portrait of Picasso*, p. 98

Bibliography

Beevor, Antony and Cooper, Artemis, *Paris After the Liberation 1944–1949*, London, 1994

Billington, Michael (selected), *Stage and Screen Lives*, Oxford, 2001

Burke, Carolyn, 'Framing a Life: Lee Miller', in *The Surrealist and the Photographer: Roland Penrose and Lee Miller*, National Galleries of Scotland, Edinburgh, 2001

Cooper, Artemis, *Cairo in the War 1939–1945*, London, 1989

Hammer, Martin, 'More Grim than Glorious: Photographic and Artistic Representations of the Second World War', unpublished lecture, *The Surrealist Eye* Symposium, Scottish National Gallery of Modern Art, Edinburgh, May 2001

Jeffrey, Ian, *Lee Miller and Picasso*, The Photographer's Gallery, London, 1984

Livingston, Jane, *Lee Miller Photographer*, New York and London, 1989

Penrose, Antony, *Lee Miller in Sussex*, Gardner Centre Gallery, University of Sussex, Brighton, 1984

Penrose, Antony (ed.), and Scherman, David E. (foreword), *Lee Miller's War: Photographer and Correspondent with the Allies in Europe 1944–5*, London, 1992

Penrose, Antony, *The Lives of Lee Miller*, London and New York, 1985

Penrose, Antony, *Roland Penrose: The Friendly Surrealist*, Munich, New York and London, 2001

Penrose, Roland, *Portrait of Picasso* (revised edn), London, 1981

Penrose, Roland, *Scrap Book: 1900–1981*, London, 1985

Sorel, Nancy Caldwell, *The Women Who Wrote the War*, New York, 1999

Acknowledgments

My first debt of gratitude is to Antony Penrose, for originally proposing to me the idea of a book on his mother Lee Miller's portraits. The Lee Miller retrospective which I selected at the Scottish National Gallery of Modern Art in 2001 contained a high proportion of portraits, including several that had not been published or exhibited before. It seemed, therefore, that a study focussing on this fundamental aspect of Miller's work might yield fresh insights. To Tony Penrose and his team at the Lee Miller Archives – Carole Callow and Arabella Hayes – I am profoundly grateful for making the task of selecting the photographs for this monograph, from the thousands in their care, both a smooth and an exhilarating one. I am especially indebted to Carole Callow for sharing with me her extensive knowledge of Miller's work and for printing the photographs for this book. My visits to Sussex were made even more enjoyable by the generous hospitality of Roz Penrose and Patsy Murray.

At *Vogue*, Robin Muir went out of his way to locate material in the magazine's archives. At the Scottish National Gallery of Modern Art, Alice O'Connor provided much-needed secretarial help, and Alice Dewey made valuable suggestions while working with me on the Lee Miller retrospective. At Thames & Hudson, Karolina Prymaka has designed the book with great sensitivity and Clive Wilson has offered wise editorial advice throughout. To all of them my thanks. Finally, I would like to thank members of my family: my son Thomas Calvocoressi, who did biographical research for a number of the captions, and my parents Katherine and Ion Calvocoressi, whose vivid memories of Miller's subjects from the world of stage, screen and fashion deepened my appreciation of the richness and variety of her life.

RC

Index